P9-EMO-838

The Federal Art Project in Illinois

1935–1943

GEORGE J. MAVIGLIANO

AND RICHARD A. LAWSON

Southern Illinois University Press *Carbondale and Edwardsville*

92 91 90 89 4 3 2 1

Library of Congress Cataloging-in-Publication Data

Mavigliano, George J., 1941–
 The Federal Art Project in Illinois, 1935–1943 / by George J.
Mavigliano and Richard A. Lawson.
 p. cm.
 Bibliography: p.
 ISBN 0-8093-1580-7
 1. Federal Art Project. 2. Federal aid to art—Illinois. 3. Art,
American—Illinois. 4. United States—Economic policy, 1933–1945.
 I. Lawson, Richard A. II. Title.
N8838.M38 1989
353.0085'4—dc 19 89-6112
 CIP

To the late John Walley

and all of the artists

who participated in the

Illinois Art Project

CONTENTS

FIGURES AND PLATES

Figures

Plates

The writing of this history of the Illinois Art Project has been protracted, beginning as a master's thesis in 1967 by George Mavigliano entitled *The Federal Art Project: A Governmental Folly?*. It was undertaken as an investigation into the little-known area of American art and politics during the Great Depression. Chicago was chosen because the project in that city was large, and it presented a wide range of problems and activities common to most projects across the country. Significantly, there were a large number of artists who were still alive and actively pursuing their careers. For that reason, an "oral history" approach to identifying the particular characteristics of the Chicago Project was a valuable research methodology, one that proved to be effective in corroborating the archival research. The same approach is utilized in the present study.

Most of the Chicago Project documents are located in Washington, D.C., in the National Archives and the Archives of American Art. While much work has been done to isolate materials pertaining to individual states, our research was complicated by the fact that publications appeared that dealt with the operation of the Federal Art Project (FAP) from a national perspective. Most scholars now agree that a broad overview has been an incorrect way to approach such a vast treasure of untapped and undocumented materials. Be that as it may, surveys of the various art projects continue to come forth from primarily a national point of view, while work on a statewide basis has only appeared recently and often in conjunction with exhibits of project art. A number of publications have dealt specifically with the Mural Project, which was unquestionably the most visible and controversial.

Our early research was aided immeasurably by John Walley, who was associated with the Chicago Project throughout its existence. For some time, Walley had been an educational fixture at the University of Illinois. In spite of his numerous duties and responsibilities, he found time, often hours, to answer questions. These sessions became

an additional source of information on the scope and complexity of the Chicago-based Illinois Art Project (IAP).

Mavigliano's master's thesis focused on four stumbling blocks to IAP operations: a conservative press, administrative turmoil, communist infiltration, and political patronage. It did not present a detailed analysis of individual project activities, aesthetic judgments of the art, or the extent of art activities outside the city of Chicago in the other six districts. The scope of the Illinois Art Project was such that a larger investigation was needed.

Despite similarities among the state programs and a certain homogeneity in Holger Cahill's organizational strategy, the fact remains (and we believe this book will prove) that the Illinois Art Project was singular in many ways and its problems were addressed administratively and artistically in an independent fashion. During its eight-year existence, the IAP had three directors: Increase Robinson (1935–38), George Thorp (1938–41), and Fred Biesel (1941–43). They nurtured the departments/divisions[1] of the IAP, some of which (Easel, Mural, Sculpture, Poster, and Graphic Arts) achieved national recognition. In addition, the IAP developed an effective Index of American Design Division, and in 1939 it created the Design Workshop/Unit, which organized nine disparate craft workshops located throughout the state into a smoothly functioning, highly skilled design program.

Our hope is that the history of this state-run project, its artists and the works they produced, will reveal the true richness and depth of their role in the history of Illinois. Most artists continued to work at their craft, and those whom we have contacted have credited the IAP with sustaining their careers. In fact, after this eight-year experience with federal patronage, many went on to enjoy long and distinguished careers in art. So this volume serves two purposes. It provides those readers who are unfamiliar with the period a readable history of the people, events, and accomplishments of the IAP. It also offers students of the New Deal information in the form of charts and statistical data presented in the appendixes with which to further their own research interests.

ACKNOWLEDGMENTS

We wish to thank the following Illinois Federal Art Project artists who contributed to this work by sending correspondence, by responding to our questionnaires, and by offering their kind hospitality when we taped interviews: Frances Badger, Rainey Bennett, Aaron Bohrod, George Carr, Edward Chaissaing, Eleanor Coen, Bernard Goss, Avery Johnson, George Josimovich, Max Kahn, Camille Andrene Kaufman, Paul Kelpe, David McCosh, Kurt Melzer, Harry Mintz, Arthur Osver, Merlin Pollock, Stewart Purser, Felix Ruvolo, Erminio Scapicchi, Anthony (Cooper) Skupas, Paul Stoddard, Donald Vogel, John Walley, Emerson Woelffer, and Nicola Ziroli.

We are indebted to the following people for assistance in researching this book: Mildred Holzhauer Baker, Barbara Bernstein, Garnett Biesel, Margaret Burroughs, Louis Cheskin, E. Kendell Davis, Robert McKeague, Hildegarde Crosby Melzer, Creilly Pollack, Mrs. Esther G. Robinson, Miriam Tane Siporin, Charles Umlauf, Mrs. Charles Umlauf, Jano Walley, and Karel Yasko.

In addition, we are indebted to the following institutions and people for special documentary assistance: The Archives of American Art, Garnett McCoy and Betty Blum; The National Archives, Robert M. Warner, Aloha P. South, Jim Rush, and Richard Crawford; The Office of Personnel Management, Philip A. D. Schneider and John Sanet; the St. Louis National Personnel Records Center, Charles Pellegrini, Delbert Bishop, Thelma Martin, and the many microfilm researchers; The Chicago Historical Society, Nancy Hunt; The Chicago Public Library, Susan Scholwer; The Art Institute of Chicago, the Ryerson and Burnham Libraries, Susan Barksdale and Cecelia Chin; The University of Illinois, Chicago Circle Library Manuscript Collection, Mary Ann Bamberger; The University of Illinois Krannert Museum, Muriel B. Christison; and the Southern Illinois University at Carbondale Morris Library, Alan Cohn.

We are indebted to the following for research, logistical, and financial support: the Smithsonian Institution's Travels to Collections

Program Grant; Southern Illinois University, the Office of Research Development and Administration, Michael Dingerson; the College of Communication and Fine Arts, C. B. Hunt and Keith Sanders; the College of Liberal Arts, James Light and John Jackson; the School of Art, Brent Kington; the Department of English, William Simeone, John Howell, and Richard Peterson; Learning Resources, Dale Brown; Photo Services, Jack Holderfield; additional photographic documentation of the Lane Technical Project, Duane Miller; and graduate assistants Dawn Gurnsey, Takako Oshima, Kevin Casin, and Guy Tieman. Carole Lawson aided in microfilm reading at the National Archives.

We acknowledge the assistance of the Department of English's Pauline Duke and Catherine Shorter in transcribing the taped interviews, and of Lynne Davis, Patricia Weiss, and Margot Schilpp in typing the manuscript. Thanks are also due to Brenda Yucas of the College of Communications and Fine Arts for typing the list of artists, and the mural and sculpture lists in the appendixes. We are indebted to Susan H. Wilson for her exceptional editorial assistance in fusing two authorial voices into one.

Finally, we express our gratitude to our wives Reneé and Carole, who encouraged us on our second venture.

ABBREVIATIONS

AFL American Federation of Labor

CAC Community Art Center

CIO Congress of Industrial Organizations

CWA Civil Works Administration

ERA Emergency Relief Administration

FAP Federal Art Project

FERA Federal Emergency Relief Act

IACP Illinois Art and Craft Project

IAD Index of American Design

IAP Illinois Art Project

IERC Illinois Emergency Relief Commission

PWAP Public Works of Art Project

RA/FSA Resettlement Administration/Farm Security Administration

RFC Reconstruction Finance Corporation

TRAP Treasury Relief Art Project

UOPWA United Office and Professional Workers of America

WPA Works Progress Administration

WSP War Services Program

Our intention is not to rehash events surrounding the Great Depression of 1929 nor to reiterate the history of the major art programs that were initiated to subsidize unemployed artists throughout the United States. Many well-documented books have already neatly laid out the details of the Public Works of Art Project (PWAP), the Treasury Section of Painting and Sculpture (Treasury Section), the Treasury Relief Art Project (TRAP), and the Federal Art Project (FAP).[1] On the other hand, we realize the need to set the scene and briefly explain the programs that preceded the Illinois Art Project (IAP). Our objective here is to paint a broad outline of the time, of artists' struggles to continue their careers, and of the ways in which the federal government's art programs met those artists' needs.

Two aspects of the Great Depression of 1929 were particularly frightening. First, there was the rapidity with which the economic impact spread from Wall Street into the farthest reaches of the country. The losses in jobs, the failure of banks, and the widespread disillusionment were bitter to accept. Second, there were no immediate signs of recovery. Earlier depressions had run their course rather quickly, but that of 1929 deepened for three and one-half years, affecting not only the United States but Europe as well.[2]

According to David Shannon, "of the nation's major cities, Chicago was one of the hardest hit, and had one of the worst records for relief. The city of the World's Fair of 1933, and the Century of Progress Exposition allowed its unpaid teachers to supplement the inadequate diets of its children from their pocket."[3] It was estimated that several hundred homeless and unemployed were sleeping nightly in Chicago parks.[4] Even more poignant was the controversy in the summer of 1932 when General Charles C. Dawes resigned as president of the Reconstruction Finance Corporation (RFC) and returned to head the Central Republic Bank of Chicago. The RFC granted the bank a ninety-million-dollar loan, yet it refused the mayor of Chicago's request for a loan to pay teachers and municipal employees.[5]

During the first two years of the depression, President Herbert Hoover's administration tried indirect relief strategies, such as " 'non-productive' public works, including roads, buildings, river and harbor improvements," which would "provide little subsequent employment," and individual "reproductive" works, such as construction, the costs of which were met "either by private enterprise or by government loans when the works would repay the loans and furnish continued employment."[6] Direct relief strategies, such as the President's Committee for Unemployed Relief and later in 1931 the President's Unemployment Relief Organization,[7] were tried in an effort to combat unemployment, banking failures, and industrial and commercial inactivity. As a result of these activities, state relief resources were depleted by 1932, and a new thrust, the Reconstruction Finance Bill of 22 January 1932, held to traditional banking and financial policies by promoting secured credit and loaning funds to states at interest-bearing rates.[8] Later in the year, the Emergency Relief and Construction Act extended the provisions of the RFC. It came closer to the kind of direct federal relief programs that were to be the hallmark of the Roosevelt administration in 1933. "Hoover's people were placed in the awkward position of administering a program to which they were philosophically opposed."[9] This act had only a slight effect on each state's ability to handle unemployment, so in 1933 it became President Franklin Delano Roosevelt's task to deal with the ever-growing numbers of unemployed.

Work relief for artists began on 12 May 1933 when President Roosevelt signed into law the Federal Emergency Relief Act (FERA), which continued President Hoover's policy of direct monetary relief to the states. FERA sought to alleviate the hardship of nearly fifteen million unemployed nationwide. Later that same year Roosevelt created the Civil Works Administration (CWA), which was meant to aid specifically white-collar workers. The CWA established nearly one hundred professional and white-collar job classifications and founded the first program for artists, the Public Works of Art Project (PWAP). The Treasury Department, which had traditionally administered the construction and embellishment of public buildings, received $1,039,000 from the CWA in December 1933 to operate the PWAP. Edward Bruce, a businessman turned painter, accepted the position of head of the New Deal's first art project.[10]

Bruce laid the groundwork for the development of the PWAP into a

national program by soliciting the assistance of museum directors and other professionals active in the arts throughout the country. He also decided to utilize the CWA's preexisting organizational and administrative network. The CWA had divided the nation into sixteen regions (Atlanta, Boston, Chicago, Cleveland, Dallas, Denver, Los Angeles, New Orleans, New York City, Philadelphia, Pittsburgh, Portland, St. Louis, San Francisco, Santa Fe, and Washington, D.C.) and had appointed regional directors and established sixteen volunteer committees.

The PWAP was a program of art production for public buildings. The artworks, approximately 15,663 pieces by 3,749 artists nationwide at a final cost of $1,312.177.93, were earmarked to embellish federal, state, and municipal buildings and parks.[11] PWAP projects across the country were originally slated for termination on 15 February 1934 but were granted an extension to 28 April and finally ended on 30 June 1934 (PWAP artists were allowed to complete works underway after the project was terminated). The regional boards, with the cooperation of state and local officials, facilitated reemployment of some PWAP artists in FERA's statewide emergency work programs. However, many states felt that they could not continue cultural projects under the existing FERA rules, and programs were abandoned.[12]

The success of the PWAP reinforced the notion that continued patronage of the arts was feasible, but doubts about federal involvement still existed. For instance, does art provide for the common good as does the construction of roads.[13] It also became apparent that proof of professional artistic ability and financial need were at times difficult to establish simultaneously in the same individual.[14] As a result, two separate art programs were created.

The Treasury Department set up the Section of Painting and Sculpture in 1934 specifically to employ the best available professional nonrelief artists to decorate government buildings. Edward Bruce organized and directed the Treasury Section of Painting and Sculpture (Treasury Section). He administered the program in much the same way as he had the PWAP. His aim was to obtain the best art possible. The Treasury Section, through competitions and outright commissions, sought only highly qualified artists who were guaranteed the opportunity to decorate public buildings. Bruce never had to secure congressional appropriations; his source of funding was con-

stant and assured. Funds for the program were allocated from the construction costs of new federal buildings, about one-half of one percent.[15]

During the winter and spring of 1934–35, Roosevelt's administration sought additional means of meeting the ever-increasing need for nationwide relief. On 6 May 1935, the president created, by executive order, the Works Progress Administration (WPA).[16] In July 1935, under the authority of the WPA, the Treasury Relief Art Project (TRAP), was established to employ relief artists. TRAP operated from 1935 to 1938 under a one-time grant of $530,784 allocated to the Treasury Department by the WPA.[17] It was tied administratively to the Treasury Section because its commissions were awarded on a competitive basis, and the works were specifically earmarked for federal buildings, old and new, which had no money set aside in construction costs for murals or sculptures.[18] The program, which was limited in scope (employing a total of 328 artists), was controlled by WPA guidelines, which required that 90 percent of the artists hired (later 75 percent) had to be selected from relief rolls.[19] Bruce was a natural choice to head this program, too. Although he declined because the emphasis was placed on relief rather than on competency, he did recommend Olin Dows, his assistant director of the PWAP. Together they managed to secure highly competent artists from relief rolls.[20]

It was apparent from the beginning that TRAP would not be able to accommodate the large number of unemployed artists, so in August 1935, Federal Project Number One (Federal One) was underwritten directly by the national office of the WPA. There were originally four programs (projects) under Federal One:* the Music, Theater, Writers, and Art projects. These projects began functioning in October after Roosevelt released the necessary funds. A fifth, the Historical and Records Survey Project, was added later, on 16 November 1935.[21]

Of the five programs under Federal One, we are concerned only with the Federal Art Project (FAP) under the national leadership of Holger Cahill. As outlined in its manual of organization, the FAP operated in four general areas of artistic activity: the creative arts, art education and recreation, art applied to community service, and

Programs and *projects* are often used interchangeably for purposes of style, with the latter referring primarily to the larger administrative unit.

historical/archaeological research. "The aim of the project will be to work toward an integration of the arts with the daily life of the community, and an integrating of the fine arts and the practical arts."[22]

Influenced by John Dewey's views of art as experience, Cahill was able, through the FAP, to apply the philosopher's theories in the field.[23] William McDonald states that "the integration of art as an experience into the life of the community, which was the concept of the neighborhood house raised to a higher and wider level, was fundamental in Cahill's thinking; and he rightly conceived that that purpose could be better achieved by those who had already shown their devotion to it than by professional artists, however competent, who thought in terms of the private entrepreneur or the wealthy patron."[24] With Cahill's strategy in hand and congressional funds appropriated, the FAP set forth on a national objective to put thousands (90 percent relief and 10 percent nonrelief) of unemployed artists to work maintaining and developing their skills.[25] This book chronicles the federal effort in the state of Illinois.

I. *History*

CHAPTER ONE

Federal Art in Illinois

THE BEGINNINGS

A small article appeared in *The Chicago Tribune* on 15 December 1933
stating that all interested artists should sign up for the Public Works of
Art Project (PWAP) in room 1135 of the Field Building, 135 S. LaSalle
Street.[1] But news of the impending program had spread first by word
of mouth, and artists lined up in front of the LaSalle Street office
before the article appeared.[2] Avery Johnson, a project artist, recalled,
"In December a musical friend, Mrs. Edgar Miller, told me that her
ex-husband was organizing a new art project and wished to get artists
who could be depended upon for quality paintings. I submitted some
of my water colors and was put on the payroll."[3] Chicago artists intent
on producing "fine art" had faced growing problems concerning
where to exhibit and sell. They had asked the few independent art
dealers to lower their commission rates, but dealers no longer had the
customers they had enjoyed earlier.[4] They either had to raise commis-
sion rates or go out of business.[5] So the creation of the PWAP offered
these and other artists a partial solution to their dilemma.

Walter Brewster was named director of PWAP's Region Ten (Illinois,
Minnesota, North Dakota, South Dakota, and Wisconsin), which used
Chicago as an administrative base. Brewster, a Chicago stockbroker and
advocate of the arts, was assisted by a committee consisting of architects
Thomas E. Tallmadge and John Holabird; artists Jean Crawford
Adams, Frances Foy, Edmund Giesbert, and Edgar Miller; and local
art dealers Chester Johnson and Increase Robinson. Of the group of
artists, only sculptor Edgar Miller enjoyed a national reputation.[6]

Increase Robinson's prominence in the Chicago art world, owing to
a stable of major Midwest artists in her Diana Court Gallery on North
Michigan Avenue, led to her responsibility for job applications and as
project publicist. She succeeded Brewster in early 1934 and served

through June 1934 as head of PWAP's Region Ten.[7] Robinson defined
the artistic and operational goals of the new project in light of Bruce's
national policy that PWAP artists paint "American Scene": "Ideas on
the subject of 'The American Scene' appropriate for the embellish-
ment of federal buildings will be presented by the new recipients of
government aid during the first week. Afterward, a general 'weeding
out' process will then permit those painters and sculptors who show
decided talent and sincerity in the development of the subject to
remain on the payroll."[8] The Region Ten committee "permitted about
700 artists to register and employed about 145."[9] George Josimovich, a
project artist recalled that

> the PWAP consisted of picked better-known local artists who were
> invited by the project committee for the project and the pay was
> $42.50 per week. There was opposition to it right from the start,
> from artists left out, as not being inclusive enough for the many
> needy artists Miss Robinson demanded one painting every
> week, subject matter "American Scene." The story went round the
> project that she rejected Ivan Albright's canvas of a football game
> as not being American Scene. Sometime in January we were asked
> to bring in our canvas "as is" to the downtown project office for
> review. I'll never forget taking my rather large composition just
> started, down to cold, windy Chicago. When I got there I ran into
> Edgar Miller, whom I knew very well, and was one of the project
> committee members. He said, "What the hell are you doing here
> with that canvas?" I showed him the card I received from Robin-
> son: he shook his head and said, "George take it home and paint
> and take your time." I didn't stop to see Robinson.[10]

Basically, quality control was achieved through the sponsorship of
new artists by others already on the project. A project artist's recom-
mendation seemed sufficient,[11] although volunteer committees were
technically charged with the selection and employment of artists.
William McDonald wrote, "On many project units it took time,
patience and a certain hardness of heart to eliminate workers who, if
the initial screening had been more careful, would never have been
accepted."[12] Those artists who made the cut received a tolerable wage.
Class A artists received $38.50 per week, and Class B artists received
$23.85 per week, usually in return for a completed work of art each
month.[13] However, there was some flexibility regarding the amount of

time required to complete a work. The availability of materials, the size of the canvas, and the complexity of the composition were taken into consideration.

Region Ten's art production, most of which came from Chicago, totaled 513 oils, 736 watercolors and drawings, 200 sketches for larger projects, 73 murals—48 of which were not completed by the time the project closed—56 sculptures, 4 bas-reliefs for mural projects, 90 editions of prints, and 9 miscellaneous works.[14] During the month of May 1934, works that had not already been allocated to public institutions were displayed in the LaSalle Street offices of the PWAP where they were viewed by hundreds of people who were curious about the project and who wanted to see what the government had bought with their money. The response was supportive and generally favorable.[15]

Criticisms were, however, leveled against certain administrative practices. Art critic C. J. Bulliet charged "open favoritism" on the part of Chicago PWAP officials.[16] Washington, D.C., officials hoped to forestall the spread of this problem in the states by selecting committee members outside the art world, thereby avoiding the appointment of professional artists or representatives of particular art societies or stylistic points of view. For example, five of the nine members of the Region Ten committee were not artists, but these appointments did not put to rest the continuing criticism of the PWAP in Illinois and additionally across the country.[17]

The PWAP in Illinois came to an end on 28 April 1934. The regional boards, with the cooperation of state and local officials, facilitated the reemployment of some PWAP artists into FERA's statewide emergency work programs. When Federal One began, under the administrative control of the Women's Professional and Service Projects (see figure 1-1), it was relatively easy to transfer artists from FERA relief programs to the WPA.

Increase Robinson became a state consultant on art in August 1935. She was made an advisor to Indiana, Minnesota, North Dakota, and South Dakota in October 1935 and was named state director of the Illinois project in the same month. She was also advisor to Iowa, Kansas, Missouri, and Nebraska by 5 May 1936.[18] In addition, Robinson continued in her capacity as assistant to Cahill. As the other states developed programs, and as their personnel were identified, they too received their own directors, and Robinson remained in charge only of Illinois.

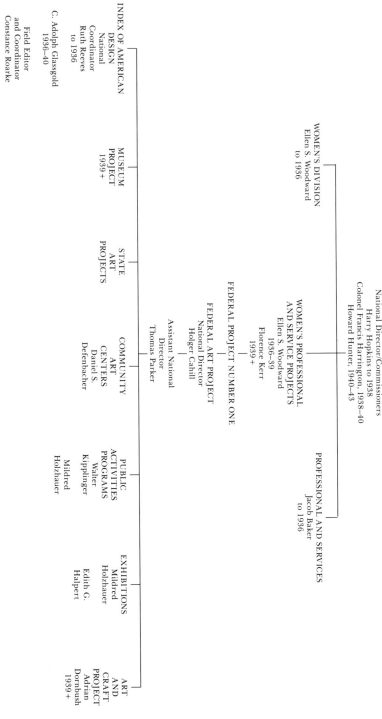

WORKS PROGRESS ADMINISTRATION
National Director/Commissioners
Harry Hopkins to 1938
Colonel Francis Harrington, 1938–40
Howard Hunter, 1940–43

WOMEN'S DIVISION
Ellen S. Woodward
to 1936

WOMEN'S PROFESSIONAL
AND SERVICE PROJECTS
Ellen S. Woodward
1936–39
Florence Kerr
1939+

PROFESSIONAL AND SERVICES
Jacob Baker
to 1936

FEDERAL PROJECT NUMBER ONE

FEDERAL ART PROJECT
National Director
Holger Cahill

Assistant National
Director
Thomas Parker

INDEX OF AMERICAN
DESIGN
National
Coordinator
Ruth Reeves
to 1936

C. Adolph Glassgold
1936–40
Field Editor
and Coordinator
Constance Roarke

MUSEUM
PROJECT
1939+

STATE
ART
PROJECTS

COMMUNITY
ART
CENTERS
Daniel S.
Defenbacher

PUBLIC
ACTIVITIES
PROGRAMS
Walter
Kipplinger

Mildred
Holzhauer

EXHIBITIONS
Mildred
Holzhauer

Edith G.
Halpert

ART
AND
CRAFT
PROJECT
Adrian
Dornbush
1939+

Figure 1-1. Federal administrative structure: Works Progress Administration and Federal Art Project.

The IAP divided the state into seven districts: District 1, the northwestern counties surrounding Rockford; District 2, the satellite suburbs around Chicago; District 3, the metropolitan Chicago area; District 4, the middle counties above Springfield and surrounding Decatur; District 5, the Springfield area; District 6, the western counties surrounding and including East St. Louis; and District 7, southern Illinois from Harrisburg south to Cairo.[19] For efficiency of operation, IAP personnel were not assigned to specific districts, although artists were temporarily loaned as needed to assist specific programs in the districts.

Personnel statistics for the IAP suggest that approximately 775 artists and administrators participated in the project between 1935 and 1943 (see appendix A). Cahill's office in Washington, D.C., required weekly statistical reports, which were supplied by Illinois WPA business manager Robert McKeague. McKeague was well suited to this position. He had started with the WPA as a volunteer in 1935 and, without pay, had soon become the Genevese County chairman. In 1936 he accepted a full-time, salaried position as head of the WPA's Professional and Service Division in the Rockford District,[20] the same year that the FAP in Illinois was looking for a director of business operations. Increase Robinson wanted someone to manage the IAP's fiscal affairs without becoming involved with the artistic end of the project. McKeague was hired, and he served in that capacity until 1940.[21]

McKeague's office and that of WPA personnel were located one floor above the offices Robinson and her staff occupied at 433 Erie Street. His responsibilities to the WPA paralleled Robinson's to the FAP (see figure 1-2). Neither was supervisor over the other. According to McKeague, he and Robinson worked well together: he knew little about art, and she was very businesslike in her operation.[22] McKeague's job was multifaceted and involved all aspects of the IAP's business operations. One of his major responsibilities was to maintain IAP quotas regarding the total number of artists employed and to insure that the ratio between 90 percent relief and 10 percent non-relief artists was maintained. He and Robinson constantly made adjustments in the rolls in order to meet federal guidelines that reflected shifting Congressional appropriations. This issue cannot be overemphasized since it became the focal point of conflict between Robinson and many IAP artists.

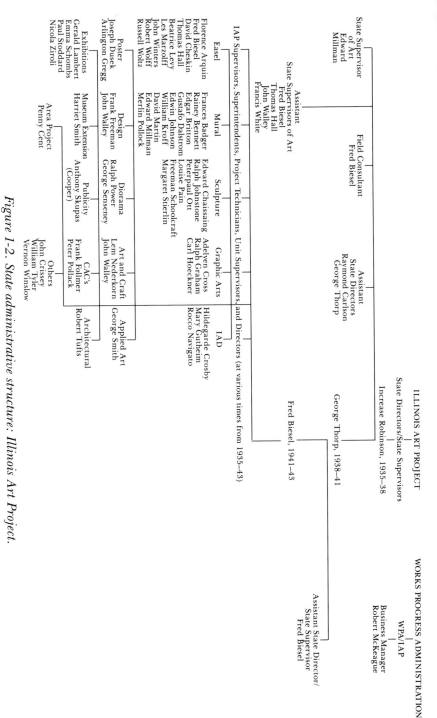

Figure 1-2. State administrative structure: Illinois Art Project.

By and large, Robinson stayed below federal guidelines (IAP employment exceeded federal quotas, once in August 1937 and intermittently in September and October 1937), whereas her successors George Thorp and Fred Biesel tended to exceed them. Federal quotas increased dramatically, in some instances by as many as 150 positions, by 1 September 1939 because there were needy artists to be hired. On a regular basis to the end of the project in 1943, and unlike Robinson, Thorp and Biesel asked Thomas Parker, Cahill's assistant national director, to secure supplemental funds and increase quotas (see appendix E and figure 1-3 for specific weekly and monthly breakdowns of quotas and figure 1-1 for administrative flow of authority).

Major hiring discrepancies appeared between relief and nonrelief quotas. From the very beginning, the 90 to 10 percent ratio caused problems. States found it difficult to hire a contingent of artists to fill the 90 percent relief allocation. For example, in May 1936, when the first federal quota figures were available, Illinois hired 323 artists of the 334 allocated. Originally, the allocation of 10 percent nonrelief artists was intended to provide adequately for such skilled and supervisory personnel as could be found on local relief rolls.[23] Harry Hopkin's Administrative Order No. 35 of 26 November 1935 exempted only Federal Project Number One of the WPA programs from the 10 percent quota.[24] At the same time, it raised the level of nonrelief artists permitted on the project to 25 percent of the total employed. It is interesting to note that Illinois designated 222 artists as relief, while the remaining 112 were designated nonrelief.[25] This created a ratio of 1:2 nonrelief artists who could participate on the IAP instead of the allowable 10 percent. In Illinois the percentage reached as high as 33 percent from March through July 1936. Thereafter, from August 1936 through December 1936, it was maintained at around 25 percent.

When a 5 percent nonrelief rule was instituted as Administrative Order No. 52 on 20 February 1937 by FAP officials because of a shortage of funds, Illinois complied. Despite the fact that Administrative Order No. 57 of 8 May 1937 relaxed by an additional 5 percent the earlier order, thereby bringing the quotas back to 10 percent, Illinois by 9 July 1937 had 11 artists of 225 employed as nonrelief, or 4.9 percent.[26]

Other aspects of figure 1-3 merit discussion. During the first months of the project, Robinson was unable to meet federal relief

1936–1937

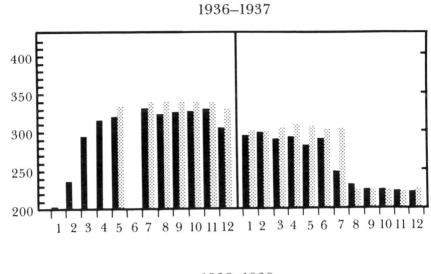

1938–1939

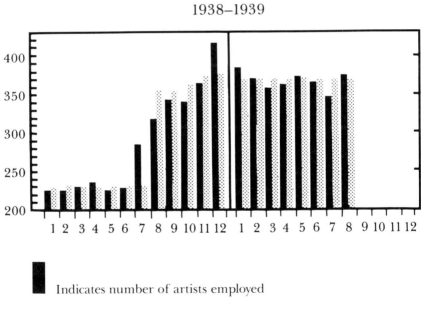

■ Indicates number of artists employed

▨ Indicates government quotas

Figure 1-3. Federal Art Project hiring quotas.

quotas. Some artists refused to submit to a "means test" to determine their eligibility, thus disqualifying themselves. In addition, there were available unemployed individuals who were qualified by FERA for relief, but she felt that many of them were not artistically capable. Within the first year of Robinson's administration, after the Chicago Artists Union had been formed, the union wrote the national office to complain about her practices. The national office of the FAP threatened to take back IAP funding if Robinson failed to meet appropriate quotas.[27]

Another observation of note is that the federal quota continued to hold its own in the first year of the project until 18 December 1936, after which the first significant drop occurred. The IAP had gone from a high of 335 artists hired in the first week of December 1936 to a new low of 298 in order to fall in line with the new federal quotas. Hopkin's earlier increase in the percentage of nonrelief quotas in November 1935 reflected the insufficient number of relief artists who were available. This exemption continued through 18 December 1936. In addition, statewide exemptions for nonrelief employment were reduced from the 25 percent high back to the original 10 percent.[28] States like Illinois, which had taken advantage of the 25 percent exemption, were forced to furlough many artists.

A further drop in federal quotas occurred on 25 August 1937, when the national FAP office reduced them again to 225. Illinois anticipated the impending reductions. On 7 August, 276 artists were employed. By the following week, this number fell to 234 artists; by 25 August, IAP artists were down to 231, only 6 above the federal quota; and by 22 September, they finally reached the quota line with 224 artists, 1 below the federal requirements. This reduction resulted from a shortage of funds for Federal One which cut the nonrelief exemptions to 5 percent.[29] All positions were frozen, but any IAP workers who were dismissed had the right to be reassigned to other WPA projects. Artists who wanted to work at their art found that available WPA jobs, some located in other parts of the state, were not tempting.[30] The reductions were due primarily to the widespread belief that the depression was nearly over, that the United States was returning to normalcy, and that programs such as the WPA would be rapidly phased out.

Spurred on by recovery, Congress cut appropriations. The economic upswing was short lived, and many historians refer to 1937 as a

watershed that initiated another depression. Roosevelt responded
appropriately by instituting what has come to be known as the second
New Deal.[31] By 13 July 1938, FAP quotas jumped dramatically from
232 to 332 (282 artists were employed in Illinois). This number
continued to rise to a high of 375 throughout the rest of 1938 and on
into 1939.

By 1 September 1939, the fortunes of Federal One were again
severely challenged when Congress instituted new guidelines for
employment. By 31 August 1939, Illinois had reduced its rolls to 280
artists. The number of artists continued to dwindle as the threat of
war loomed, as Congress focused its attention on more pressing
international concerns, and as artists entered the armed services or
used their artistic talents in the homefront war effort. In December
1941, the IAP became part of the War Services Administration. By
May 1943, Roosevelt signed an executive order terminating the FAP.

While four federally funded art programs (PWAP, Treasury Sec-
tion, TRAP, and the FAP) were in operation at some point between
1934 and 1943, Illinois had additional art projects sponsored locally
by the Park District, the Board of Education, and, in Chicago, the
Jane Addams Hull House program. All of these local projects had
WPA support, but each was independent of the other.[32] IAP adminis-
trative personnel reported directly to Holger Cahill, and the local city
programs reported to District WPA Director H. K. Seltzer.

The Park District conducted programs for children and adults. The
adult program was under the leadership of Louis Cheskin, director of
the Board of Education's Arts Division. Approximately ten IAP art
teachers were placed in Park District recreation centers, about twenty
were in settlement programs such as Hull House, and ten were
assigned to local churches. Most IAP personnel had little academic
education, so they did not meet the board's standards for hiring
professionally trained teachers. The Park District had never estab-
lished educational requirements for teaching. If people did not have
the educational qualifications to work for the Board of Education but
were eligible for jobs by the local relief board, Cheskin would send
them to the Park District where they might end up teaching crafts to
children. Some hired in this manner were very good teachers despite
a lack of credentials.[33]

Twenty-six art centers sponsored by the Board of Education were
distributed throughout the city in community centers, churches,

fraternal halls, clubs, and halfway houses. These centers offered courses in painting, sculpture, dress design, weaving, art history, and sponsored tours of the Art Institute of Chicago. The centers were under the jurisdiction of Louis Cheskin who brought the teachers together for weekly, one-day, in-service training sessions at the Newberry Library.[34]

By the time the IAP began, there was a variety of job opportunities available to Chicago area artists. Those who qualified as art teachers could work for the Board of Education or in Park District programs. One must remember, however, that the Board of Education and Park District programs employed a relatively small percentage of the artists subsidized at some point between 1934 and 1943. Professionally trained relief artists who were not academically certified could work for the IAP, and there were those few artists of high creative talent who could support themselves through sales and periodic commissions from the Treasury Section.

Increase Robinson, 1935–1938

GROWTH AND TURMOIL

Increase Robinson, born Josephine Reichmann, spent her childhood within an artistic household and among creative individuals.[1] After graduating from the University of Chicago with a major in art, she continued her education by studying with Hans Hoffman at the University of California. She returned to Chicago to marry Increase Robinson, a fellow artist, and upon his death adopted his first name. She did this to distinguish herself from her mother, Josephine, who was still active as a painter.[2]

During the 1920s, Robinson lectured and conducted art tours for women's clubs, businessmen's organizations, colleges, and local public schools. Eleanor Jewett, the *Chicago Tribune*'s art correspondent, described Robinson as possessing "a charming presence and clear voice with a wealth of information to broaden the artistic vistas." Jewett went on to say that Robinson was "a clever and illuminating speaker. She had knowledge and a decisive utterance that turns that knowledge to best use. Her talks are keen, instructive, amusing and stimulating."[3]

Robinson occupied, at different times, studios at 7136 Crandon Avenue and 410 S. Michigan Avenue. In 1929, she opened a gallery on Michigan Avenue at the then fashionable Diana Court. The Increase Robinson Gallery was devoted to selling the works of young American artists, particularly midwesterners. Grant Wood and Aaron Bohrod were representative of those whom she encouraged. Wood had his first solo show there, and Bohrod reflected years later that he was very pleased at the favorable notices he received from his exhibits. He appeared on a regular basis in group shows and viewed her as one who was "in a cool and detached way, a supporter of my work."[4]

Robinson closed the gallery in 1933 to take on her new roles with the federal government. In succession, she served as regional director of

PWAP's Region Ten in 1934, advisor to the Illinois Treasury Relief Art Project (TRAP) from 1934 to 1935, and director of the Art Department of the Work and Rehabilitation Division of the Illinois Emergency Relief Commission (IERC) in 1935. By 17 August 1935, she was a project technician during the formation of the IAP. Following these assignments, she became first the regional director of the FAP and then the Illinois state director of the FAP on 7 October 1935.

It is interesting that Cahill selected Robinson, a practicing artist and art dealer, to head one of the largest state projects. Other administrators, like Audrey McMahon in New York, had come from educational backgrounds and others, like Robert Morrison of Boston, were museum administrators. Robinson, on the other hand, had proved herself on the job. As the director of the PWAP in Illinois, she operated economically and met obligations to the national office completely and on time.

As an advisor to TRAP, Robinson saw her primary duty as keeping the TRAP and IAP projects distinct. She wrote to Cahill, "It would be most important to maintain friendly relations with our associates on the TRAP, and above all, to cooperate on the relief art projects in such a way that no sense of competition between two federal groups should creep in to disrupt the harmony we have established."[5] In sum, Cahill was a friend who evidently felt she deserved a chance to run the IAP,[6] and Cahill's backing allowed her administrative talents to grow.

The Easel, Mural, and Graphics divisions flourished under each IAP director. But Increase Robinson's connections with quality artists in the private sector before the depression and their presence on the IAP helped set the course for these divisions.

The Easel Unit employed more than half of the IAP artists who were involved in producing art. It also served as an entry-level position for an additional 15 percent who went on to specialize in such divisions as Mural, Graphic Arts, Poster, and the Index of American Design (IAD). Its size and lack of consistent hiring standards, however, made the unit a target for accusations of poor quality. But many of its artists gained national reputations, to name a few: Aaron Bohrod, Edgar Britton, Julio DeDiego, Edwin Boyd Johnson, Edward Millman, Archibald Motley, Mitchell Siporin, and Charles White (see plates 1, 2, and 3).

About one-quarter of the IAP easel artists chose to work in their own studios.[7] The remaining artists preferred the camaraderie of

project studios, which were large, spacious rooms created to accommodate groups of artists and their supplies. Artists kept their own time sheets and were responsible for putting in thirty hours of studio time per week. "This was not difficult to do, for most of the painters I [Donald Vogel] knew worked easily twice that much or more."[8] In 1937, supervisors were supposed to pay unannounced visits to artists' studios to see whether they were working, but this requirement was loosely enforced. If an artist did his or her work, there was no need for the visit. Supervision was applied to only those artists who did not produce the required painting each month.

Many artists, regardless of the medium, produced more than one work per month. Their productivity posed an interesting dilemma. Which of the works should be submitted to the project? Many artists chose their best work hoping to maintain their good standing with the project. Others submitted the first canvas they completed. Still others, knowing that the painting no longer belonged to them and that the government was getting inexpensive art, selected their poorest pieces. All other works completed during a given month remained the artists' property. IAP artists were not prohibited from exhibiting at commercial galleries. Edith Halpert, director of the Downtown Gallery in New York, wrote to Mitchell Siporin, "It is to be understood, that aside from the work turned over to the FAP, the Downtown Gallery has exclusive agency of your work."[9]

Once artworks were tagged, they were sent to the Exhibition Division to be placed on exhibit or purchased by sponsors. The IAP established galleries in Chicago and throughout the state for the purpose of gaining exposure for Illinois artists. On 22 June 1939, a new Federal Art Gallery on Michigan Avenue (see plates 4 and 5), under Fred Biesel's direction, was opened with the express purpose of holding exhibitions "so that the best work of every artist on the Project will get a public hearing. An attempt will be made to plan group exhibitions where artists with similar or congenial conceptions will be shown together. Thus, it is hoped that the gallery, and through the gallery the public, will serve to encourage and foster the free development of work of all project artists. Private patronage will be directed to the artists' studios."[10]

State colleges also exhibited work, as did public schools, hospitals, and other nonprofit institutions. Galleries were established in Thebes and East St. Louis. The Exhibition Division of the IAP distributed

and hung the works. Artists were notified where their works were hanging and under what conditions. Nicola Ziroli, who was in charge of the Exhibition Division in 1938–39, remembered having problems satisfying the IAP artists. "Everybody wanted to know why they weren't being shown in this exhibition or that one. . . . I selected works according to stylistic schools and what I felt was the finest examples of that school. . . . I felt I had to include all kinds of styles, even things that were semiabstract."[11]

In America painting is firmly based upon the concept of the easel picture. Americans have never enjoyed a mural tradition such as Europe's. But federal subsidy of artists called upon them to create one. Many artists educated themselves by studying the works of the great Italian masters, including Giotto and Piero della Francesca. They also learned from contemporaries, such as Puvis de Chavannes, Thomas Hart Benton, and the Mexican muralists Orozco, Rivera, and Siqueiros. This practice frequently resulted, however, in a hodge-podge of imitation.[12]

The Chicago-based muralists, especially Edward Millman, Mitchell Siporin, and Edgar Britton, who dominated the Chicago school, were greatly influenced by the Mexicans, who were the most identifiable muralists of that generation. Millman developed the monumentality and heavily drawn forms that he claimed were directly inspired by Diego Rivera. He had worked with Rivera during his, Britton's, and Siporin's annual visits to Mexico.[13] Siporin, in his painting, hoped to unite Mexican social ideals with Walt Whitman's view of the American democratic tradition. He stated that "both Whitman and Orozco have in an epic manner revealed to us the face and meaning of their place and people."[14] Siporin wrote that the three of them "perceived the possibility of artists collaborating in the decorating of public buildings [as] similar to the manner in which the Mexican muralists had worked together,"[15] as Siqueiros had described. In this effort, they "developed a mural art that was to be identified with Chicago during the next eight years."[16]

Treasury Section commissions of murals nationwide numbered 849.[17] Except for the three major mural painters, Britton, Millman, and Siporin, very few Chicago muralists received Treasury Section commissions. But the Mural Program was the showcase of the IAP, capturing both public imagination and official endorsement. "Whenever taxpayers complained about boondoggling, bohemians loung-

ing around their studios or artists painting unrecognizable Cubist abstractions, the Mural Project was trotted out in rebuttal."[18] By executing their work in public, the mural artists did much to dissipate the "halo of mystery" surrounding the federal works of art. "This accomplishment alone was of great value to the future of American art."[19]

Muralists for the IAP were chosen from the pool of easel painters (see plates 6, 7, and 8). Gustaf Dalstrom, the first supervisor of the Mural Unit, stated, "The artists for the Mural Project were selected from the larger Easel Project on the basis of either previous experience or special interest in murals. Since it was considered an honor to do murals, the artists worked conscientiously and did not need constant supervision."[20]

Unlike the Treasury Section, which automatically had a commission every time a federal building was erected, FAP muralists had to seek out potential sponsors. In the beginning, IAP personnel surveyed public buildings for suitable mural-, sculpture-, and easel-painting spaces and negotiated with the persons in charge to do the work. Later, when the project's work became known, it was often approached with commissions for artwork by qualified artists.[21] Dalstrom, and Merlin Pollock who succeeded him in 1940, would meet with a potential sponsor who would supply the money for materials, and the two would agree upon a suitable subject or theme for the work. Dalstrom would then select one or more artists whose skills suited the proposed subject from the twenty to twenty-five muralists working under him. These artists would do sketches from which the sponsor chose the one that he or she liked best.[22]

Some Illinois murals were painted by artists from other states who were commissioned by the Treasury Section. Likewise, Chicago muralists such as Millman and Siporin received Treasury Section commissions to work in other states.[23] Thomas Parker, assistant national director of the FAP, requested that Dalstrom paint murals for the University of Wyoming's Student Union. Dalstrom did not want to leave Chicago, so he recommended that another Chicago muralist, John Walley, a native of Wyoming, do the work.[24] In retrospect, Walley's Wyoming murals immortalized the American scene and still radiate the optimism and determination of the era in which they were created.[25]

The PWAP had set the tone for later New Deal art programs, at least in terms of subject matter. The government strongly preferred representational subjects over abstract ones. Any type of landscape, urban

or rural, or any industrial activity, or any interpretive work having social significance was welcome.[26]

Social-realist murals such as Mildred Waltrip's *American Characters* at Hatch School in Chicago are surprisingly rare among the IAP output. IAP murals were, by and large, more idiosyncratic and charming and less doctrinaire than the usual American Scene.[27] One can point to Rudolph Weisenborn's cubistic, Picasso-esque mural, *Contemporary Chicago,* at Nettlehurst School as an example of the experimentation that was going on in the division. Florian Durzynski painted "sensuous, undulating landscapes," and Ralph Henricksen's work was recognized by its "cheerful, stolid primitivism." Mitchell Siporin's *Teaching of Art* at Lane Technical High School or Harry Sternberg's *Chicago: Epic of a Great City* at the Lakeview Post Office have the same "massive, planar shapes and scope" associated with the art of the 1930s. Clearly, art historians who talk about the "Chicago Mural School" may not fully realize just how diverse and personal the murals really are.[28]

Midwest murals tend to show a cornfield, the town founders, and maybe the arrival of the railroad. The forward-thinking artist would call on the local officials and ask what important events occurred in the area. Merlin Pollock used this approach before painting his mural for the O'Fallon, Illinois, Post Office.

> The subject matter was the result of an exploratory visit to O'Fallon. I talked to the Postmaster who was very cooperative and somehow learned about the first Postmaster whose house still stood on the outskirts of town. I visited the house and spoke to the occupants who showed me through it. The pigeon holes for sorting and retaining letters, etc., still were in place beside a large fireplace. I made sketches and took some photographs for reference. The mural was done in oil in my Chicago studio. When the painting was finished, it was removed from the work frame support, rolled up, paint on the outside, and then transported by me to O'Fallon for installation myself or with local assistance.[29]

Treasury Section head Edward Bruce, in a letter to Avery Johnson, summed up his philosophy of mural art. "Avery, forget about Rembrandt, Leonardo da Vinci and the like. Just design something that will make the local people proud of their community—and it will make them proud of themselves. A small town post office is the one

place where everybody goes. After a time they won't even look at the painting, but their lives will be enriched simply by being in the presence of excellence and quality."[30] Edgar Britton made the same point when he discussed the value he hoped would be seen in his Lane Technical High School murals (several artists had their murals at that school). "If my murals convey a feeling of optimism for the future of man's achievement, they shall have succeeded."[31]

Some artists wished to do something beyond communicating a sense of Americans' feeling pride in themselves and in their achievements; they wished to create art. The essential problem for these muralists was how to portray more than the merely physical aspects of America. Edward Millman felt that it was necessary to develop a representative symbolism of his time and experience so that daily realities could be abstracted to illustrate the meaning of American life. The American mural school could then develop what was social in content and national in form to make its statement. Millman went on to say, "An example is the concern felt by the midwestern mural painter to express the 'squint' in the eyes of the prairie farmer, for generations accustomed to gazing beyond the prairies. These squinting eyes, a weather-beaten face resigned to the constant struggle with the soil, gnarled, knotty hands ready to seize the plough for an assault on the earth—these are the elements which truly symbolize agriculture."[32]

Although muralists could philosophize about their art, they had to reach an accord with notoriously unappreciative clients, such as high school principals and prison wardens. A few of the more socially critical murals were toned down, and one of Millman's murals at Flowers Technical High School, entitled *Outstanding American Women,* was covered over. A mural in a Winnetka, Illinois, school, painted by Raymond Breinin, a young, liberal Chicago artist, suffered a similar fate. After published reports identified one of the panels as possessing communist overtones, the school board decided only four months after the mural's completion to build a false wall over it. The painting was forgotten until 1956 when the false wall was torn down. But construction crews plastered over the wall, and the mural was not uncovered again until 1982.

Malcolm Hackett painted one of the most controversial IAP murals for the Abraham Lincoln School in Oak Park, Illinois, in 1936. Eighth-grade students criticized the mural in 1941 for its abstract stylization and bright colors, and Mrs. John Morrell, a board member,

insisted the mural be removed. George Thorp, head of the IAP at that time, sent John Walley, Peter Pollack, and Edgar Britton to Oak Park to deal with the school board. The IAP members recommended that a psychiatrist be called in to view the mural along with a few impartial experts. No agreement could be reached between the IAP and the school board. Finally, Holger Cahill intervened and decided that the school board should remove the mural at its own expense. The school board objected, saying that it was the IAP's responsibility because art objects such as the mural were not meant to be a part of the school's permanent collection—even though they had paid for it.[33] The mural was eventually taken down, and its whereabouts is unknown.

As early as 1939, the American Scene style became passé. With the onslaught of World War II and the arrival of European artists to these shores, American artists were forced to confront the fact that no "American art would develop logically from the matrix of the American Scene," and the presence of these artists "helped to reestablish the links between American artists and the European avant garde."[34] Traditional artistic values had been overturned in the 1920s, so to venerate the older visions of America was to betray the new thrusts in art. American art was in the process of abandoning the masses for the rarified world of intellectuals. The wrecking ball that destroyed the buildings and their murals and the neglect by post–World War II America were bitter pills for the artists to swallow.[35] But before the war's end, IAP muralists, like the easel painters, channeled their energies to the war effort. They introduced methods of duplicating murals for wider distribution, such as the Scott Air Force Base mural depicting the history and scope of aviation (see plate 9).

In 1976, Mitchell Siporin reflected on the optimism that he and other project muralists felt. His $28.00 per week pay was of minimal concern. The point was that they were young artists who were excited about the opportunity to have a wall to paint on. "Well, we painted!"[36] Cahill wrote to Siporin that he and Mary Gillette Moon had talked about the Chicago Mural Division and especially the St. Louis Post Office mural. Chicago had seen a "period such as she has not seen before in her art history, and . . . the windy city's cultural development has been extraordinary . . . because of you and Eddie Millman and Eddie Britton."[37]

Between 1935 and 1943, approximately 300 murals were completed in Chicago (see appendix B). About 150 of these murals survive today

in the Chicago area, but they represent about one-half to two-thirds of the total number of murals completed in Illinois.[38]

The Mural Division may have created the most public attention because of its high visibility, but it was the print medium that was the most democratic art form.[39] Whereas the poster projects "were directed to practical ends . . . to a public message," within a form that "emphasizes the message,"[40] the print offered other qualities; namely, the directness of the statement, the multiple nature of the process, and the affordability of the product, which made it a desirable commodity to the people. In addition, the print medium fused the efforts of artists and craftsmen.[41]

IAP Graphic Arts Division artists, under the direction of Carl Hoeckner, set up workshops at Jane Addams Hull House in Chicago. There, working conditions varied for the artists, depending upon the medium being used. All prints were made by a laborious and painstaking hand process, usually in editions limited to twenty-five or fifty copies. Florence Arquin as supervisor established guidelines for the IAP graphic artists: "Plates must be turned in with the completed edition; and the title of the print, the number of the print, and the number of the edition, as well as the artist's signature must be so placed in each print as to be easily visible when the print is matted."[42] After printing, the block, stone, or plate was destroyed so that no more prints could be made. The artists were given three artist's proofs for their portfolios, with the stipulation that they would not try to sell the pieces while they were affiliated with the IAP. "If exhibited at any time, the fact that it was produced for the FAP must be so indicated."[43]

In 1935, etching was still the major print medium in the United States. All of the prominent print societies were made up of artists who worked in the copperplate media alone. Due to the support of the FAP in materials, well-equipped workshops, and an emphasis on experimentation, every known branch of the graphic arts flowered: lithograph, lithotint, etching, aquatint, woodblock, linoleum cut, and wood engraving.[44] New techniques developed by project artists included the carborundum process, the refinement of color lithography, color woodblock printing, and the stylotint process. The Chicago Project experimented with manufacturing murals in quantity by preparing sections through the silk-screen process.

The silk-screen process held great potential. While it could not approach the chiaroscuro effects of offset printing and lithography, it

made up for this by the richness of its pigment layer and the highly valued effect of its personal touch. For the project artists, the silk screen had two additional advantages: its initial cost was minimal, and it could be printed on various substances.[45] Carl Hoeckner experimented with the process at Hull House in Chicago. He developed a formula that allowed for fine tones and sensitive gradations of color, which was hailed as an advancement in the development of the serigraph.[46]

One project that utilized the silk-screen technique was the publication of a handbook by the Chicago Board of Education to be used in conjunction with the radio series, "Let the Artist Speak." The concept behind the broadcasts was to bring art lessons to the audience through radio and introduce the "Pan Americana Series" for an understanding of "what the artists of the Americas have produced."[47] The silk-screened pages, presenting examples of different art works, were produced by project graphic artists and were intended to help the students understand the broadcasts. The text included one or more pictures for each show. Elizabeth Wells Robertson, director of art for the public schools, was in charge of the art selection for the handbook and worked closely with IAP administrators in choosing the appropriate illustrations.

The various divisions functioned well, and artists and friends attributed the project's successes to Robinson's intensity. She talked, walked, and painted fast. Her energy and capacity for work were admired as well as resented by many who came into contact with her. Some artists felt that she ruled the IAP with an iron fist and played favorites with her own stable of artists. Andrene Kauffman viewed Robinson as "one of the finest executives I have ever known: a good artist; had excellent taste in art and in the works of other artists; had understanding of people; a really outstanding person; strong organizing force for both PWAP and WPA."[48] By contrast, her detractors were no less vigorous. Aaron Bohrod commented:

Personally, I considered her to be a forbidding New England WASP type. She was tall, handsome, dignified, austere and somewhat unbending. The only time *I* thought her unfair was in those early days of the Guggenheim fellowships when great attention was paid to the selections and the newspapers publicized the fact I had received a grant. Though the benefits of the grant for me

were not to begin for several months, I was *immediately* thrown off
the project on the theory that I did not need its economic
support.

I know that Mrs. Robinson wasn't well liked, but I think it was
principally a matter of her symbolizing the kind of authority
most artists never had to contend with. She was, naturally, in the
position of making arbitrary decisions, and I don't believe she
had the intellectual capacity nor the human warmth to operate
successfully in this area.[49]

Robinson was aggressive in advocating the type of subject matter
she thought appropriate for the project. "One of my major interests
for years has been to stimulate the American artists to look to his own
environment for subjects worthy of his consideration, to make a lively
record of the life of our own time and place."[50] This aesthetic sense
was translated into a brief but emotionally charged statement attrib-
uted to her: "No nudes, no dives, no social propaganda."[51] Generally,
artists on the PWAP and the FAP were free to paint the subjects they
liked, and the subject matter most preferred was American Scene.[52]

Out of touch with the current aesthetic sensibilities of the New York
art scene, artists in the Midwest were often considered provincial.
Robinson wrote to Cahill:

One of the most discouraging phases of this Nationwide program
to those of us who are back in the provinces (as some New Yorkers
put it) is that we have no way to make comparisons with the
accomplishments of other sections of the country and, therefore
cannot truly evaluate our own. We work under tremendous strain
and criticism, taking bows smilingly when compliments come our
way, but always with the sickening fear that we are too unin-
formed to be aware of our short comings.[53]

American Scene was "the order of the day" for the FAP (see plate 10),
and she pursued it vigorously.

Nevertheless, artists felt a unique sense of freedom. Mitchell Siporin
stated in 1976, "There was more freedom on the WPA in a stylistic
sense than there was in the open free-market of art at the present
time. There seems to be a conspiracy of one-ness, both by museums
and commercial galleries. The Projects were very Catholic in their

taste and art was very pluralistic. You had paintings of every persua-
sion. . . . No group was allowed to achieve any sort of hegemony."[54]
Donald Vogel, another IAP artist, agreed: "There was always a feeling
of total freedom, and we were permitted to produce whatever we
wished. My own work was most personal and never gave way to
existing trends. . . . However depressed times were, I was determined
to paint pleasant and happy pictures. I felt a great need to paint
pictures that make people feel a bit better, and perhaps even smile
from having seen them."[55]

Some project painters, such as Rudolph Weisenborn and Myron
Kozman, flirted with abstract expressionism (see plates 11 and 12) and
other nonrepresentational styles, but the majority of painters accepted
abstraction's validity and then ignored it. One of the roots of the
abstract expressionist style was surrealism, which grew out of the
dadaist movement. Some IAP artists, including Julio DeDiego, worked
in the surrealist mode. Elements of that style still exist today in the
work of some Chicago School painters.[56] Laszlo Moholy-Nagy and
Naum Gabo brought the constructivist style of nonobjective art to
Chicago, but it had little impact on IAP painters.

During the difficult months in 1935 when the FAP was being
organized, tensions surfaced between IAP personnel and Federal
Number One officials over the sharing of administrative authority.
Robinson resented any interference from FAP administrators. The
problem was solved on the federal level by Hopkins's directive that
state art programs should be run autonomously.[57]

Robinson finally resigned her directorship in 1938 under contin-
ued pressure from her critics,[58] but she stayed with the federal
program for three years as Cahill's assistant. Her personal concepts of
art and narrowly applied New Deal social ideas conflicted with the
desires and aspirations of many Chicago artists as well as with the
basic thrust of FDR's relief programs. The greatest indictment of all
seemed to be her inability to implement the broad social, political,
and cultural attitudes and policies that prevailed in Washington.
Numerous letters were written to Cahill about her directives and most
of the artists we interviewed support the claim that Robinson herself
was considered "provincial."[59]

Within the context of her administrative difficulties in implement-
ing the national intent of the FAP and dealing with individuals, two
cases illustrate Robinson's dilemma: one was the manner in which she

dealt with the organization and administration of the Index of American Design Division, and the other was the way in which she responded to the formation of the Artists Union.

When the *Index of American Design Manual* was published, it stated that "typical examples of an indigenous American character will be made available for study. It is hoped that this material will stimulate the artist, designer, and manufacturer of articles of everyday use to build upon American tradition and that it will offer an opportunity for the student, teacher, research worker, and general public to become familiar with this important phase of our cultural pattern."[60]

IAD units were set up in twenty-five states to put artists to work making watercolors or photographing ceramics, costumes, coverlets, embroideries, furniture, glass, pewter, silver, textiles, toys, wood carvings, and "other things which were made in America between 1620 and 1900 (see plate 13 and appendix D)."[61] Some aspects of American folk art were inventoried through other means. American Indian objects, for instance, were not included because they were assigned to the Department of the Interior. Architecture was also not included because it had already been "adequately covered" in the Historical American Buildings Survey. Finally, one other federal effort, the Resettlement Administration/Farm Security Administration (RA/FSA), photographed American culture in the context of the rural poor, the relief efforts of the RA/FSA, the urban blight, and the mobilization for World War II.[62]

Cahill was originally skeptical about having the IAD developed nationwide because the FAP did not have the administrative structure to coordinate such an effort. Furthermore, he estimated that it would take twenty years to complete, but he was not certain that the FAP itself would last six months to a year.[63] Nonetheless, he did endorse first the New York City's project activities and then the formation of the IAD programs in twenty-five states.

With Ruth Reeves in charge of the IAD in Washington, D.C., Polly Goodheim came from the Washington IAD office in January 1936 to establish one in Chicago. IAP personnel, including Robinson, knew little about the program, which was looked upon simply as a project that had been imposed by Washington.[64] In spite of that, Increase Robinson wrote in 1936, "The Index of American Design is now a part of the Federal Art Project of the WPA. There is a big need for it. Our short and complicated heritage of design lies in our lap in pieces. It

doesn't make sense unless it's put together. The Index is an instrument which will correlate our knowledge of American design, organize our ideas in the field of design, trace currents and establish relationships within it."[65]

Hildegarde Crosby Melzer was chosen to head the Illinois IAD.[66] She believed that the IAD was not central to Robinson's plan for the IAP because the IAD nationally did not concentrate on hiring the best artists. "Many artists who, although they were not qualified to achieve creative work, were capable of exact copying, or at least could be trained in its techniques. In this way the conflict between the demands of relief and the desire for professional competence could be, in part, resolved; and many project workers could be equipped, if not for a career in the fine arts, at least for commercial employment."[67] So Melzer had been hired primarily to get the IAD in operation quickly with artists, twenty-six at any given time, who needed much training for the kind of work the national office expected.[68]

In the beginning, finished IAD plates were sent from Washington to show Illinois IAD artists what and how they were done. By and large, these artworks were done in watercolor with dry brush, creating very sensitive, refined, and precise work. The techniques had been "worked out by Joseph Lindon Smith on an Egyptian expedition."[69] The technique was used by the IAD because the object could be rendered more precisely, accurately, and quickly than by Kodachrome color photography, which had been introduced in April 1935.[70] The watercolors would last. There was no way to estimate the durability of the color print. Where possible, black-and-white photographs were made with satisfactory results, but Washington found that the more minutely accurate pictorial copies could be produced only by the sensitive hand of an artist.[71] One exception was the oil-painting copies by Orrie McComb of Olaf Kran's Bishop Hill community paintings. Primitive painting was ignored except for the Illinois Bishop Hill colony.[72]

The completed plates were submitted to Reeves and C. Adolph Glassgold (the latter replaced her in 1936) for review, consistency, and quality control. Substandard plates were returned to the state IAD directors with letters explaining the problems. Glassgold's letters often included strongly worded advice on how to correct any deficiencies in the plates. In a letter dated 5 October 1936 sent to Increase Robinson, he began by complimenting the quality of the work that

had been produced in Illinois: "Needless to say, the renderings maintain the very fine level of quality established on your project." He then described some perceived flaws in a particular body of work and proposed solutions. "Mr. Aberdeen's color seems less satisfactory than before. The quality of gold and silver in these plates is not the equal of his previous ones. Also, the sense of solidity of the watches seems less certain. Please advise him against enlarging the watches unless they are so minute as to warrant it."[73] Glassgold's comments give some indication about how the plates were rendered. There were two patterns in achieving faithful reproduction of the objects. "For example, some artists emphasized realistic details—the flaws in the antique, the actual texture; others idealized the specimen, adding only those details necessary for authenticity."[74] After Crosby became head of the IAD, Glassgold's letters were routed to her to discuss the problems with the artist. Plates that were acceptable to the national office were assembled and grouped into portfolios to be made available upon request to educational and public art institutions.

Throughout American history, many people migrated to Illinois or traveled through the state on their way to the West. These pioneers brought items with them and manufactured more after settling the land. The Index artists in Illinois made renderings of the crafts from old French settlements like Fort de Chartres and Cahokia, from the pioneers at New Salem, and from the Scandinavian colony of Bishop Hill, which flourished in northern Illinois before the Civil War. In addition, they documented the slip pottery manufactured in Old Galena. Appeals also went out to locate specific wood sculptures such as cigar-store Indians, figureheads from Great Lakes schooners, miners, Punches, soldiers, and store signs.[75] While the Illinois program was additionally interested in pottery and crafts made by slaves, as they were in all kinds of musical instruments, iron work, old embroideries, pieced coverlets, and scrimshaw made by others, Kathleen Calkins, director of research, suggested it focus its efforts on the 1850 to 1900 period and concentrate on costumes, textiles, and furniture. She also suggested that "there were several iron furnaces in Illinois about 1840 but the iron industry didn't gain a substantial foothold in Chicago until 1857. Stoves made in Chicago from 1850 to 1900 would be an interesting addition to our compilation of early stoves and stove plates."[76]

Index personnel occasionally encountered difficulties persuading

individuals or institutions to lend objects for rendering. Many of the objects were too fragile to move or were considered by their owners, who feared theft or forgery, too valuable to lend.[77] IAD artists, in these cases, had to travel throughout the state to render the pieces. If materials were not loaned, similar pieces were sent from the East Coast to be rendered.[78] Some objects were permanently located in such communities as Bishop Hill or Nauvoo in northwestern Illinois and had to be examined on-site. Much of Crosby's time was spent traveling throughout the state to locate items that were of sufficient importance and quality to render.

When artists needed to go into the field, Crosby aided them by renting a trailer that she outfitted with a kerosene lamp and a stove and hooked up to her Plymouth. That was the beginning of "art on wheels" in the Midwest, and it paralleled the activities of the FAP traveling workshops in New York.[79] Artists in the field made detailed dimensional studies, notes on texture and eccentricities of the pieces, color swatches, and photographs. Quite often, with elaborately wrought pieces, they made templates and finished the renderings in Chicago.

Contrary to the notion that IAD artists were without artistic gifts, Crosby believed that it took special talent to become an IAD artist. She stated, "Index work demanded of the artist a special mental tour de force or, perhaps the regeneration of the imaginative impulse of children: when imagination is most unalloyed and can take hurdles directly. But the sight of a thoroughly male artist laboring tenderly over a little hickory-nut grandmother doll is not as funny as it is impressive, and if the doll turns out with all its quaint idiosyncrasy, it will be due not only to his skill, but to the extent of his imaginative understanding."[80]

The fruition of the Illinois IAD's program came in March 1937 when the Marshall Field Company opened a large exhibit of 750 IAD renderings.[81] This exhibit was so successful that it was held over and received national media attention. It proved that the history of American design, despite its brevity and eclecticism, was worthy of public notice. The IAD provided students, teachers, and the general public with opportunities to familiarize themselves with this important aspect of their cultural heritage.

The major administrative crisis for the IAD occurred in 1937 as a result of problems in the Poster Division. Marshall Smith had been in charge, but his administration was not successful. Robinson replaced

Smith with Ralph Graham. Robinson wanted Smith, a close friend and confidant from the PWAP, to take over the IAD because Crosby and Robinson had had strained relations in the first year of the IAD. The problems came to a head when Robinson questioned Crosby's operation of the IAD, including the accuracy of her fiscal records. Cahill traveled to Chicago for a conference with Crosby at the Drake Hotel, but Robinson had not been invited. IAP timekeepers were called in and verified Crosby's operations to Cahill's satisfaction. Cahill made it clear to Robinson that it would be unwise to move Smith into the supervisory position of the IAD, and Crosby remained in charge until October 1939, when she appointed as her successor Ingrid Linden, who had been her secretary and had known the operation well.[82]

The other area of difficulty for Robinson concerned her relationship with the Chicago Artists Union. Its roots reached back to activist groups of the late 1920s and early 1930s. When the WPA/FAP was established, the Artists Union grew in membership and devoted itself to ensuring work benefits for its members. By the time the Chicago Artists Union was formed, sixteen locals had sprung up in cities from Baltimore to Los Angeles; and their membership had reached thirteen hundred.[83]

The first meeting of the Chicago artists took place in November 1934, at John Stenvall's studio.[84] Artists in attendance included Edward Millman, John Walley, Wallace Kirkland, Jan Fabion, and John Groth. The agenda was to discuss the need for local organization and the advantages of cooperating with union counterparts in New York and San Francisco. Some artists feared the organization of a union would be interpreted as a personal attack on Increase Robinson. Others voiced concern that union members would be blackballed from project work. Most of the artists had not come from union backgrounds and found unionism a foreign notion. By contrast, another group of artists, those who had become interested in socialism from a philosophical point of view, were the most organizationally and politically astute. Their primary concern was the establishment of a better artistic climate for working. So the union was divided from its very inception into conservative and activist factions.[85]

The majority of Artists Union members were not strictly dedicated to political objectives. "As long as they had their art projects to work on and got their monthly $94.00, they were willing to leave the political

aspects in the hands of the few more dedicated souls."[86] Some artists, though, "being idealistic, looked to the theories of socialism and communism as a source of hope and for a personal solution to a better culture and, like people from other walks of life, needed to believe in something."[87] But for the majority, food, shelter, and time to produce their art were paramount.[88] Donald Vogel, "a very poor young man with a burning desire to paint," was most grateful for the assistance that the IAP and the Artists Union gave him, and he pinpointed a solution for the artist with non-political leanings. He wrote that the union "periodically would call me to have me meet at City Hall or someplace to pick up a banner and march for a day. As they had never seen me, and knew me as only a name, I always said I would be there and continued my work in the studio. I avoided all their functions for I was too selfish to give up my studio for any cause."[89]

Robert Wolff was the spokesman for the radical wing of the union. Although espousing Marxist philosophy, he was not a communist. He was more a "middle-roader" politically who could work with the radical and conservative factions of the union, so much so that he later became president of the Artists Union and a spokesman for the communists. The radicals and conservatives sought political control of the union; both groups called for the creation of a more progressive art program; and, finally, both fought for the removal of Robinson. The confusion over diversity of labels and political positions is best summed up by John Walley who recalled that "the funny thing is that some of the biggest pushers for the Marxist movement were the most conservative artists. Some of the more radical painters couldn't stand still to be Marxists."[90] So an artist working for union goals could be considered a communist or at least a sympathizer. As Walley pointed out, "If you worked with one Marxist group, then people assumed you were a Marxist. I suppose if you were working with a Catholic organization, then you were assumed to be Catholic."[91]

The differences between the two groups came to a head during a union meeting when a debate was scheduled between Robert Wolff and John Walley. Walley related the incident with great intensity.

Well, he came in and he really had no finesse because he had a set course [to follow]. If you threw him a curve, he was lost. So I took the viewpoint that instead of debating the social aspects of Marxism, we ought to analyze how art could create social change.

The people I chose were Naum Gabo and [Antoine] Pevsner. I challenged Wolff over the fact that communists had run them out of Russia for what they were doing; that the Marxists had missed the whole point. What the Marxists wanted was a new generation of romantics to appeal to the agrarian peasants. Men like Gabo and Pevsner were the illustrators of the new age, the new mystics. Look at their influence in fashion magazines, architecture, and visual communication. Well, finally Wolff got so angry that he wanted to call the debate to a halt and regroup three days later. I said, "It's perfectly all right, but why don't you bring somebody that is able to keep up his end of the debate?" Finally, the party members pulled Wolff completely because this was very bad publicity.[92]

The union faced immediate opposition from several quarters, as Robert Wolff recalled:

Chicago had seen many art societies and groups come and go. . . . Until the appearance of the Artists Union no organization had had the forthright courage frankly to acknowledge and face the fact that the artist was a hopelessly maladjusted member of society. . . . By calling itself a union the organization identified itself with under-privileged. This shattered the old illusion of the lofty position of the artist and publicly put him in the ranks of the unemployed. The Chicago community deeply resented being jolted out of its comfortable evasion of the bitter truth. . . . That it should call itself the Artists Union was to most a display of bad taste.

He went on to say: "It was an easy matter to play the union against the Project and to use one to discredit the other. In this way word went the rounds that the unemployed incompetents on the Project sought to perpetuate their employment by forming a union. . . . Ironically, the artistic reputation of this community was being enhanced by those very artists whom it [Chicago] denounced and vilified."[93]

At first, the union affiliated with the American Federation of Labor (AFL). By late 1937, it was clear that the goals of the Artists Union were incompatible with the established trade union philosophy of the AFL. Artists were looking for tangible results (employment of more artists) for their grievances.[94] The AFL leadership was reluctant to initiate strikes or cause political upheaval, so it was cautious about

bringing a "radical union" into its fold. In addition, it was concerned about the Artists Union's tactics in its New York and Washington, D.C., demonstrations.[95]

Certainly, the Artists Union figured that affiliation with a national union would increase its leverage for expanding and stabilizing the number of artists and the actual relief and nonrelief hiring practices of the IAP. But there were misgivings on the part of some members who did not want to antagonize government support or patrons who they felt would be dismayed by the affiliation.[96] Because of its small size nationally, some two thousand members (250 were in the Chicago union by 1940, 40 to 60 were women),[97] the Artists Union could not justify a national charter of its own. Affiliating with Local 60 of the United Office and Professional Workers of America (UOPWA) of the Congress of Industrial Organizations (CIO) in 1938, however, clearly identified the union as leftist. The UOPWA was a communist-controlled, white-collar union.[98] For radical artists fully committed to the concept of the artist as cultural worker, joining the CIO was a popular and reasonable step. This affiliation aided the artists' cause of economic stability and participation in the mainstream of American life.

In the early stages, the union was mainly concerned with increasing the employment of artists in Chicago. The union operated from a series of offices from 31 W. Kinzie Street, to 2406 N. Clark Street, to 205 E. Superior Street, to 1118 S. Michigan Avenue. The union obtained copies of federal directives sent to other states to compare them with Robinson's policies. In many instances, they were able to prove that national quotas were not being met in Illinois (see appendix E). In this regard, Robinson had been interpreting FAP guidelines by substituting her own notions of quality rather than by accepting the program for what it was — relief for artists in need. In addition, in November 1935, a group of eleven prominent artists (Ivan Albright, Rainey Bennett, Fred Biesel, Aaron Bohrod, Edgar Britton, Gustaf Dalstrom, Sidney Loeb, Edward Millman, Gilbert Rocke, William Schwartz, and Mitchell Siporin), calling themselves the Chicago Artists Committee for WPA Jobs, criticized Robinson for not putting talented relief artists on the project.[99] Further, they issued a series of recommendations to enhance the artists' employment:

1. THAT available funds be released immediately for setting into full operation the W.P.A. Art Project. Since the liquidation of

the P.W.A.P. and the I.E.R.C. the W.P.A. is the one existing agency to which the Chicago Artists may look for the employment necessary to his continued existence.

2. THAT the existing 90% relief and 10% non-relief ratio on W.P.A. Art Projects be changed, because this ratio does not represent a true relationship between the unemployed non-relief artist and the artist on relief in Chicago; a fact proven by the presence of but few competent artists on the present relief rolls; the total number of these artists on relief plus an additional 10% of non-relief artists falls far short of the real number of unemployed artists in need of work.

3. THAT Art Projects be of permanent value, socially useful to the community, that they utilize the best creative abilities of the artists, and that artists be selected from the standpoint both of artistic qualification and of need.

4. THAT, by elimination of the pauper's oath, relief qualification be adjusted to expedite the opening of relief rolls to a greater number of unemployed artists; that these artists, then and all artists on relief be placed on W.P.A. projects immediately.

5. THAT unemployed artists formerly working on the P.W.A.P. and the I.E.R.C. projects be given automatic transfer to the Art Projects of the W.P.A.

6. THAT the technical scope of W.P.A. Art Projects be broadened to include not only commercial art signs, and the painting of murals by groups of artists, who execute the ideas of the mural designer, but also individual and independent mural, easel, graphic, sculpture, and art teaching projects, making it possible for the artist to express his ideas in that field of work for which his talent, training and temperament have specifically fitted him.

7. THAT artists of Chicago be granted representation on administrative boards concerned with W.P.A. Art Projects and that this representation should also be extended them on any project planning commission working on an Art Project; that these representatives be duly elected by a large body of the Artists of Chicago.[100]

Charges and countercharges over artistic competency were leveled by artists and administrators. IAP administrators felt that screening was necessary after assignment to the WPA. A competency review,

when and if it did take place, resulted in the immediate dismissal of some project workers.[101] The Artists Union fought for the retention of dismissed artists. First, the union wanted to know who was to determine competency. Was it to be based upon some objective, identifiable standard of taste? Second, if it were, who was to administer it; Increase Robinson unilaterally, or a panel of artist-peers? Third, if the project was indeed meant to aid unemployed artists on relief, then what was the point of having a competency standard at all? The unpleasant alternative was that, without some established standards, incompetent artists could be carried on the project for months or even years.[102]

Artists Union members believed that it was better to err on the side of having a fully employed program, which included a few incompetent artists whom the newspapers, general public, and Congress might attack as corrupting the quality of the program, than to have a smaller program of certified artists. Drawing upon his own experience, Nicola Ziroli, a project artist and exhibitions coordinator who served on the screening committee, stated:

> The union in many respects did get a lot of people, deserving people, on the project. With some of them I felt they deserved it, and with others I felt they didn't. Here again, I must add, are two sides to the story. Some, I felt, really needed the money. They were no good as artists, and they still aren't today. Others, I felt, were pretty good, and they did very well. Some of them are some of your best artists today. But they needed the money, and of course I went along with it. . . . Some of these people we just thought— well, they will be all right. Their stuff isn't good now, but if they join up, get something to eat, some paint and stuff, and go to school nights to attend classes, well, they would do pretty well. That was the reason behind all this. You see, the government itself set it up for two reasons. Ninety percent for absolute need and 10 percent for quality, that is for administration and quality artists. Some of these people would forget this idea, including the union, and sometimes Increase Robinson too would forget that this was set up for a certain purpose because people were hungry.[103]

One case that serves to illustrate both the issue of competency and the greater need for survival was recalled by Paul Stoddard, a mem-

ber of the Graphic Arts Division who worked on both the PWAP and the IAP. An artist who painted in a primitive style would come to the main office on Erie Street once a month to bring in his allotment of paintings in return for his monthly check. Many artists would gather at that time to see what had been produced in the last month by other artists. There was always great excitement over seeing this artist's paintings. He would be there, and Stoddard remembered that the man said very little, but studied all of the paintings in the room with great intensity while he puffed on his cavendish pipe. He would shake his head in approval or disapproval, and that was the extent of his evaluation. One day a supervisor from the IAP office paid a visit to this artist's home. (Periodic visits to artists who were working at home rather than in studios provided by the project were required.) He found that the artist did not paint the pictures at all. Instead, a boy of fifteen or sixteen was the artist, and the older man paid the boy a dollar per picture before he signed his own name and brought them to project headquarters. This went on for several months before it was discovered.[104]

Some time after this affair, and after Increase Robinson had left the project in 1938, the screening committee was modified to consist of two members of the Artists Union's Grievance Committee, with full voting power, and the IAP departmental supervisors. According to Merlin Pollock, a muralist and IAP supervisor, "Mrs. Robinson could never have worked under those circumstances. She would have considered union involvement an infringement on her right to make the ultimate decision."[105]

Hiring artists was a central problem for IAP directors and supervisors. In early 1938, near the end of Robinson's directorship, and despite her objections, a screening committee of project supervisors and Artists Union members was formed to review each case. The Artists Union's screening membership was composed of Florence Arquin, Fred Biesel, David Cheskin, Thomas Hall, and Robert Wolff, and it took a flexible approach to hiring. Rainey Bennett, a project artist, recalled how he was introduced to the Easel program. "I ran into Aaron Bohrod on the street one day, and he told me to hurry over to the Field Building and audition for the new artists' program. I didn't know what he was talking about, but in those days I leaped at anything that came along. There were so many self-styled artists there that day. You had to prove you were an artist."[106] Nicola Ziroli recalled,

"You couldn't be too tough evaluating the 90 percent relief group, but the 10 percent professional or nonrelief group was different. I was strict! I would demand that that person have at least been accepted in some important national shows."[107]

Further, 5 percent of the project artists were outside the Chicago metropolitan area (see appendix A). They joined the project after appearing before their district WPA committees and sending samples to Chicago for evaluation. These applications were supported by recommendations from other project artists, acting as advocates.[108]

Some complaints about IAP artists' incompetence had merit. Arthur Osver, a project artist, recalled, "There were a number of people who got after me who weren't artists at all. They told me to give them some of my drawings or a painting so that they could get on the project."[109] Nicola Ziroli stated, "I had Harry Hopkins's sister apply. The word from Washington was to put her on. She did nothing. She wasn't an artist. She wasn't anything. Mainly, I would use these people in the office. I couldn't possibly use them anywhere else because they had no talent. Some could type."[110] Artists who were furloughed or received their dismissal Form 403 for "necessary reduction in personnel" would protest their discharges. Joseph Meyers's plight is a case in point. He wrote to the Washington, D.C., WPA office to compare his case with five other IAP employees. Frederick Foreman had no dependents and had parental support. A Vincent "— — —" was ordered dropped from the rolls for noncitizenship, but he was still working. Denice Green, like Foreman, was young, had no dependents, and enjoyed parental support. Her salary of eighty-five dollars had been raised to ninety-four. Herman Luetgens was noncertified, but he was working. Madeline Scott had no dependents and was a stenographer. Benjamin Kellman had sold a painting to the Chicago Art Institute for $450. Meyers's wife had left him, and he wanted work to "rehabilitate" himself. Being a veteran, he believed he was entitled to a job.[111]

One person per family was allowed on any unit; of course, this regulation was easily circumvented. Wives went by their maiden names or stated that they were divorced. There were exceptions, too. A couple who were married while working on the project were not terminated until the eighteen-month-furlough rule came into existence in 1939.[112]

If accepted, the artist received a Grade 2 standing and was paid $87.60 per month (see appendix F). Wages were lower in districts

outside Chicago. An artist's work continued to be judged until he or she was given a Grade 1 standing, along with an increase to a maximum of ninety-four dollars per month. Young artists lingering in the Grade 2 classification were assigned teaching duties during the first year of project participation or whenever an instructor was needed. Some artists looked upon their teaching duties with great excitement; others saw teaching as an infringement of their painting time. The teaching was done entirely in community facilities, such as Hull House and the Howell Settlement House, where most artists worked two half-days per week. Classes were divided into late-afternoon and evening sessions, and the project furnished all materials in abundant quantities. Awards of merit were given each month to the classes that displayed the finest works.

Once an artist achieved Grade 1 status, he or she received certain privileges. Models, for instance, were available upon request to IAP headquarters. All models posed nude if so desired by the artists, although during Robinson's administration the artists could paint nudes but not exhibit them. The artists kept the models' time sheets and made any comments about their work or recommendations for further employment they felt were necessary.[113] Assigned for two-week periods, they worked eight-hour days and were expected to bear the expenses of transportation to and from the artists' studios.

Supplies were easily obtained. Artists were given one canvas per month and more if desired. Canvases were stretched, sized, and primed by paperhangers employed by the WPA. Artists could also pick up pigments that were being manufactured in Chicago at the time by a good friend of project artists, Ramone Shiva. In addition, watercolor papers as well as copperplates, inks, rollers, brushes, and other paraphernalia were available.[114]

The Artists Union's involvement in IAP affairs extended far beyond the issue of quality control. The union issued an undated statement of six items for consideration for the "improvement in the conditions of employment of artists" under the WPA.

1. That the Artists Union of Chicago be represented on local Advisory Boards and Boards of Supervisors of the Government Art Projects where project policies are decided affecting the artists of Chicago and vicinity; and that these representatives be elected by the members of the Artists Union of Chicago.

2. That those artists who have been registered for employment on WPA Art Projects prior to March 6, 1936, be assigned to the project in their proper classification; that registered artists be assigned to the federal art project, if they so desire.

3. That all artists on the Park Board art projects be transferred to the federal project if they so desire.

4. That competent artists assigned to the Federal Art Project be retained for the full period of the project and those given furloughs be reinstated; and that this be effected by increasing the 25–75 quota or by modification of stringent relief qualifications or by any other feasible method.

5. That class A and class B artists be given a ten per cent increase in salary.

6. That the Artists Union of Chicago be informed on the first of each month of the number of artists, both in the relief and non-relief categories, employed on the Federal and Park Board Art Projects.[115]

One major accomplishment was the establishment of the union's gallery, which served as a meeting hall as well as a place to show members' work. By 24 November 1937, the union rented a dilapidated storefront at 156 E. Superior Street and, with members' labor, turned it into an attractive gallery.[116] Important national artists and political figures came to speak, and the union held Midwest artist conferences there. John Walley remembered the union's activities. "Each artist would take a delegate home to house and feed him. The personal contacts were warm and lasting. Writers, actors, and musicians came and presented their positions. The first presentation to the artists of Chicago of the work of the Bauhaus and the personal work of Moholy-Nagy was shown at the Artists Union Gallery."[117]

The union sponsored cocktail parties and artists' balls to secure funds for its activities, such as printing exhibition catalogues and informational brochures. There was always a need for money. "Financially, it barely made ends meet. Dues were kept as low as possible, and it was difficult to be strict about their collection, considering the incomes of the members."[118] In addition, it published the *Chicago Artist* newsletter to promote Artists Union views as well as to inform the members about national WPA and labor issues. The union's entertainment committee tried to garner public support by inviting

individuals from the business world who might be interested in contributing to the union or in supporting union-backed projects.

The union also represented the artists in grievances against the IAP and aesthetic disputes with the Art Institute of Chicago personnel. Dana Catton Rich, director of the institute at the time, was a sympathetic friend of Chicago artists. He was always willing to meet with union representatives in order to present their suggestions to the Art Institute Board.[119] An additional struggle had to do with perceived violations in the adult education program. Morris Topchevsky of the Artists Union's Grievance Committee wrote,

> We charge Mr. Louis Cheskin, Supervisor of the Art and Language Division of the Adult Education Project, with intimidation of workers in the production division of that project. It has been reported to us, that in a speech to that group, on September 22nd, Mr. Cheskin stated that he refused to be influenced by the Artists Union demands and if higher classifications are effected on the Adult Education Program, the result would be dissolution of the whole production department.
>
> In relation to this matter, we demand the following:
>
> 1—Immediate reclassification to proper rating for artists employed in District 3.
>
> 2—That a correct statement be made by Mr. Louis Cheskin to the same group of workers without qualifications reading from WPA regulations on the right to organize and recognition of workers' organizations for collective bargaining.
>
> 3—Immediate cessation of any form of intimidation, such as practiced by Mr. Cheskin and herein described.
>
> 4—If such practices continue, we will be forced to request the dismissal of Mr. Louis Cheskin and his replacement by another supervisor who will not act against the best interests of the project workers and WPA.[120]

The union's militant grievance committee handled cases promptly, responsibly, and vigorously. If satisfactory local solutions were not obtained, they immediately presented cases to the state office of the WPA and, if necessary, would take them to Washington. There were times, of course, when discussion was ineffective and more drastic measures had to be taken. At one time, the grievance committee

organized a sit-down strike in the Merchandise Mart on 12–19 December 1936, then the location of the Illinois state WPA office.[121]

In assessing the diverse activities of the union, it must be mentioned that the artists received a broad education in political activity, more than they had ever experienced. Beyond supporting the creation of art, the union was a forum for political ideas. It gave each artist the opportunity and the audience to speak about the relevant issues of the day.

As its membership increased, the Artists Union began demanding participation in the direction of project policy, despite Robinson's position that the union had no authority in the decision-making process of the IAP. Sidney Loeb wrote to Cahill that

> we have long given up hope that any agreement can be reached with Mrs. Robinson; and there is no need carrying on the project as it has been in the past year. It costs the project too much in quality, in production, and settlement of labor relations disputes. No matter what the program for the coming year may be, no matter how large or how small the appropriations are, the prime essential is agreement between artists and directors. In order to establish cooperation and agreement we offer the medium of elected representation on the Supervisory Boards to insure free progressive discussion of the needs of the project.[122]

Although she would not tolerate "any interference" with her authority, the Artists Union kept up its pressure on her and on Cahill's office. Reluctantly, Robinson acquiesced and agreed to meet with the union's grievance committee at agreed-upon intervals.[123]

These meetings were often acrimonious, owing to the great hostility on both sides. In a letter to Ellen Woodward, assistant administrator of the WPA, Kurt Melzer, secretary of the Artists Union, summed up the union's position: "In Robinson's refusal to answer to the Chicago Artists Union for her actions, it is clearly shown that democratic procedure is replaced by a subversive dictatorship, in which the function of the project is seriously endangered."[124]

Shortly after this letter, the Artists Union filed for formal charges against Robinson with Holger Cahill. She was accused of intimidation, discrimination against project artists, and discrimination against union members in general, so the union called for her removal as director. She defended her position on hiring practices in a letter to Cahill stating, "Wouldn't you say I am responsible to the States for my

action, if I should be questioned for having made a change in classification [of a particular artist]. But the question is, am I responsible to this group [the union] for making this change?"[125] Ultimately, her greatest offense was that she tried to shape the character of the IAP to mirror the structure of her Diana Court Gallery stable of artists.[126] She viewed project artists as her elite group and responded to her antagonists, "If I hired all of the people you want, I'll just be raising the union." John Walley went on to say about her conduct in handling quotas, "she'd cut their [the artists'] salary in half to forty-five dollars and do what they wanted."[127] A case that points to her inconsistency in hiring was that of painter and muralist Mitchell Siporin. As Cahill recalled the story, "Robinson turned him down and he showed me some of his drawings of Chicago and they were wonderful."[128] After Siporin was hired, he was acclaimed for his work on the IAP mural unit. (Siporin and Edward Millman received the largest mural commission from the Treasury Section for the new post office in St. Louis, Missouri.) Another letter to Jacob Baker, assistant to Thomas Parker, stated, "Mrs. Robinson's treatment of Midwestern artists has been unfortunate. Those with any ability worth attention, even though on relief, have been turned aside."[129]

The strife between the Artists Union and Robinson intensified on aesthetic grounds and on working conditions. More letters were written to Cahill calling for her removal. "I didn't feel work there (Erie St. Headquarters) was productive. . . . While I was working, there was no end of interference on Mrs. Robinson's part. Every time she saw me at work she was always telling me how I should paint and if I didn't do things her way, there were plenty of others to take my place."[130] Robert Wolff continually referred to her as "dictatorial."[131]

If the union letter campaign were not enough, Robinson had administrative problems that also called into question her leadership abilities. The Raymond B. Carlson scandal in December 1937 was particularly devastating as it weakened her credibility in making administrative judgments. Carlson was in his late thirties when he went to work for the Rockford office of the IAP. Previously, he had served as an instructor at a Rockford private school and as a CWA clerical worker for the Rockford water department.[132] Robinson became acquainted with Carlson upon the recommendation of Mogens Ipsen, head of the IAP district in Rockford. She formally asked Cahill if she could hire someone to handle such personnel matters as

reclassifications, dismissals, transfers, and any adjustments involving contact with project artists. Cahill agreed, and a job description appeared announcing the following qualifications: "Must be able to handle men and situations efficiently and tactfully; must be able to cooperate in business details with office procedure; must have approval of National Director."[133]

In her haste to distance herself from the union, she hired Carlson as her assistant before he was given a payroll designation,[134] and this position was just the buffer she needed. Following a conference between Robinson and Cahill, Raymond B. Carlson was hired as assistant state director of the IAP on 6 August 1937.[135]

The *Rockford Register-Republic* reported on 2 December 1937 that Carlson had been arrested by Rockford police on morals charges, following an October grand jury investigation. During testimony, Carlson's homosexuality was revealed. Carlson pleaded guilty to the charges, but he asked some of his friends from the project to act as character witnesses on his behalf. McKeague recalled, "I hadn't known anything bad about him. He was a very good employee, and very regular. I didn't know him socially, but certainly all I did know about him was good. So I testified, but the judge wasn't paying any attention to any character witnesses."[136] Ipsen testified, "I never had any man who did a better job," first as the CWA district projects director and later as assistant state director of the IAP.[137] Carlson was sentenced to from one to ten years and placed in the Winnebago County Jail to await a transfer to a state penitentiary. Robinson sent Thomas Parker, Cahill's assistant, a letter stating that Carlson was "released from active service on November 26 and that he [would] be on annual leave until January 19th."[138]

On 13 December 1937, "Raymond Carlson, age 44, Illinois Supervisor for the FAP, was found dead in his cell a few hours after he had been sentenced to prison on morals charges."[139] Robert McKeague remembered his final meeting with Carlson just hours before he took his own life. "Ray said to me, 'Well Bob, I'll be saying good-bye.' I said, 'Well, you'll probably be here for awhile before they transfer you. . . .' He said, 'No, I won't be here after tonight. I know these guys in prison. For this kind of sentence life would be hell, and I'm not going to put up with it.' "[140]

Robinson's detractors were not slow to take advantage of the situation. E. H. Wold, an artist dropped from the rolls after eighteen

months, and whom Carlson said was incompetent, wrote a letter to
Eleanor Roosevelt on 11 January 1938. It did not matter that Carlson
had died one month earlier. "This is only one example of political
intrigue sneaking up on honest workers in Chicago. This man, Ray-
mond B. Carlson, is now in jail, convicted and charged with immorali-
ty."[141] Parker on 2 February 1938 responded to Robinson's earlier
letter by saying that he had discussed the entire affair with Cahill and
that Robinson was to take no action "relative to reclassification of
artist personnel and terminations until the appointment of a new
assistant state director is effected."[142] Shortly thereafter, George
Thorp became Robinson's new assistant.

An earlier incident that plagued Robinson's tenure as state director
had to do with a sit-down demonstration by union members of the
WPA main offices at Chicago's Merchandise Mart. Four men demon-
strating were identified as IAP artists. Robinson was notified by
Cahill sometime between 5 and 12 May 1937 that it had been brought
to his attention by Dr. Eugene Murray-Aaron, who was doing research
on the New Deal, that members of her project, artists on government
payrolls, were actually engaged in picketing on company time.[143]
Robinson wrote a forceful yet cryptic response explaining that one of
the men, Karl Kahler, had been released without pay during the strike
and that three others, Mitchell Siporin, Morris Topchevsky, and
Adrian Troy, were doing the picketing on their own time, having
completed their assigned work and having been paid for it.[144]

A formal investigation of all charges leveled by the Artists Union
against Robinson was held in Washington in January 1938. The
findings of that investigation determined that the IAP was run like a
factory rather than as a creative relief-works program; that Robinson
was incapable of handling labor relations; that she had discouraged
sponsors and the efforts of her supervisory personnel in making the
facilities of the project available to regions of the state outside Chi-
cago; and that she had played favorites, which was not conducive to
the efficient operation of the project.[145]

Cahill and Florence Kerr, assistant director of Women's Professional
and Service Projects (see figure 1-1), had held many conferences
during the first part of 1938 pertaining to Robinson's handling of
labor relations and the type of direction she was giving to the IAP.
Both had foreseen for many months that it was going to be necessary
to remove Robinson from active charge. Yet they were disinclined to

take such a step because in many ways she had done an outstanding job.[146] Florence Kerr explained why she did not intercede on Robinson's behalf.

> "I have been reluctantly compelled to conclude that Mrs. Robinson has the vices of her virtues; that she is much more interested in some phases of her program than in others. Out of this probably springs what has appeared to be favoritism towards certain persons on her project, and neglect or failure to encourage others. She has evidently failed to develop certain activities which are an integral part of the national program. I cite particularly, the teaching of art to children and the development of community art centers. I believe it was only upon the personal insistence of Mr. Cahill that she set up the Index of American Design."[147]

As a result of the committee's report, Cahill had no choice but to relieve Robinson of her duties on 1 March 1938. He was reluctant to fire her, and she remained with the FAP for over a year as his assistant on the national level.

George Thorp, 1938–1941

A PERIOD OF NORMALCY

Robinson took her removal fairly well. She extended help to George Thorp, who replaced her on 7 March 1938, in what must have been a difficult transition for everyone concerned. Robinson was given a month's leave to eliminate any difficulty that might result from her presence during the reorganization of the project.[1] Upon Robinson's return, Thomas Parker sent her on field trips of several weeks' duration in an effort to keep her away from the office as much as possible.[2] But she officially resigned from the FAP on 30 June 1939. Robinson's main responsibilities during that final year were to act as a representative of the FAP, to be responsible for special assignments in connection with national exhibitions, and, ironically, to coordinate the IAD program. She also served as technical consultant to the new Illinois state art director, George Thorp.[3]

The Artists Union had won a victory. Robinson's Achilles' heel stemmed from her desire to maintain a quality group of artists, one that she could control. She often admitted she had been exceedingly severe with project artists, for she would accept nothing less from them than what she considered their best efforts. Many artists admired her. Nicola Ziroli recalled that "regardless [of] whether people liked her or not, Increase's tactics were sound. She had a certain responsibility. She was alone, and you can imagine the pressures that surrounded her. She was a businesswoman, and I admired her for that. I didn't agree with the union's stand against her. Actually, certain groups wanted control of power. Mrs. Robinson did a good job, as good as anyone, and did it for the benefit of the artists."[4]

Holger Cahill proposed that the person replacing Robinson should be brought in from outside the state. Since Thorp had already been reassigned to Illinois to replace Carlson and had earlier in 1936 been

sent to observe Robinson's administration of the IAP, he became a leading candidate for the job.[5] Thorp was born on the east side of New York, attended a number of private schools, and served an apprenticeship as an architectural sculptor. He was tall and lanky, fast moving and bright, and he got along with both the artists and the union. No one doubted his leadership abilities, and his one important advantage was the kinship he shared with other artists, particularly sculptors.

When Thorp arrived on the scene, the Sculpture Division of the IAP was prospering under the leadership of Edward Chaissaing. During his tenure, the number of IAP sculptors reached sixty-one, a considerable achievement given that many smaller states had no sculpture units at all. The Sculpture Division consisted of units for clay modeling, plaster casting, cement casting, wood carving, and model making. Most work was done in inexpensive clay and cast in plaster. When an institution expressed an interest in a specific maquette, the work was produced at the appropriate scale and in a more permanent material.

Possibly more than any other fine arts units, the Sculpture Division offered legitimate employment to craftsmen who, though not meriting professional artist classification, possessed subordinate skills that were necessary and appropriate to the work. The division used its less-skilled personnel in the cleaning, repairing, and restoring of publicly owned statuary. Samuel Cashwan, an FAP sculptor, recalled, "From the certified relief lists of the WPA we enrolled modelers, carvers, plasterers and stone cutters—men who for years had not had the opportunity to practice their crafts."[6] The rehabilitation of these artisans was valuable and alone justified the existence of the Sculpture Division.

The division had inherent problems; the most severe was the substantial cost of materials and equipment. A project could not be undertaken unless a sponsor was willing to defray expenses. As a consequence, much IAP sculpture remained in the maquette stage of production. Sculptors made personal appeals to the public for help, and despite the costs and the shortage of sponsors, sixty-one IAP sculptors produced over twelve hundred pieces of art from 1934 to 1943 (see appendix A). Three hundred sculptures were allocated to public institutions, fifty in Chicago alone, many of which are still in their original settings (see appendix C).

While many IAP sculptures were intended from inception to be small-scale pedestal pieces, other examples of the division's work were

designed to harmonize with the architecture and stimulate demand
for sculpture in buildings. The commemorative nature of most IAP
sculpture did not foster the expected demand, so to counter this
problem, IAP administrators attempted to team artists and architects
who were sympathetic to one another's point of view. "In artistic
matters they [the architects] came from Missouri and have to be
shown that painters and sculptors not trained in Rome are capable of
real efficiency and promptness."[7]

The type of sculpture ranged from free-standing pieces to friezes,
and from relief pediments to carved architectural decoration. The
subjects usually depended upon the character of the location that was
to receive them. Stone fountains were popular for hospitals, parks,
and botanical gardens. Enormous eagles were designed to sit atop the
numerous National Guard armories across the country. Bronze paper-
weights, which were cast for bureaucrats' desks, replicated examples
of Babylonian seals. Tables, a fountain, and carved wooden direc-
tional signs were fashioned for the Brookfield Zoo (see plate 14).
Other less-glamorous work included the restoration of existing monu-
ments.

Winning a Treasury Section award was a great achievement for a
sculptor. The awards were extravagant compared to the IAP monthly
salary. The publicity that resulted from an award, as well as the
knowledge that one had been chosen from a large field of contestants,
seemed gratifying to an artist. Of course, if a sculptor did not want to
participate in a commission, he or she was not required to take part. If
one entered a maquette that was subsequently rejected, the sculptor
continued to do pedestal work with no loss of prestige or pay.

Working facilities were extensive in the states that boasted sculp-
ture units. Central workshops and storage space in Chicago were
located at the main Erie Street office, but many IAP sculptors,
whether working on pedestal or architectural work, maintained their
own studios. Their materials were supplied by the IAP, and they were
required to work a minimum fifteen-hour week on sculpture that was
to be turned over to the project. As opposed to the other projects,
Sculpture Division supervisors regularly visited the individual stu-
dios to check on the progress of the work.[8]

The central shop on Erie Street had facilities for casting in plaster
and concrete as well as for enlarging scale models in clay, plaster, and
stone. Large stonework was executed at the "Stone Yard," (see plate

15) a very large building located on South Kedzie Avenue.[9] This one-story structure boasted high ceilings and enough working space for the stone carvers. If a sculptor's model was to be enlarged in limestone or marble, it was transported to the Stone Yard where the stone craftsmen "pointed" it up to [full] size.[10] The IAP did not have a foundry or large ceramic kilns but on occasion did arrange to have bronze castings or terra-cotta architectural sculpture fired at commercial foundries.[11]

During the 1930s, Midwest sculpture embraced much stylistic diversity: modern figurative, pictorial, primitive, abstract, and cubist. Most Chicago sculptors worked in the "figurative" category. Sculptors like Laura Slobe, Peterpaul Ott, and Louis Linck tried abstract pieces, and a small number of academic sculptors, such as Mario Ubaldi worked in a classical, allegorical mode (see plate 16).[12]

In general though, there was little of the classical idealizing that had been so popular in American sculpture throughout the nineteenth century. Thanks to the exhibition in Chicago of the work of Robert Laurent and William Zorach, project sculptors had other sources to look to for inspiration: Lorado Taft, Albin Polasek, and Alfonso Ianelli, to name a few. Many of the IAP sculptors had done some of their earliest work for the Chicago World's Fair in 1933–34. In conjunction with the fair, the Art Institute of Chicago amassed a show of sculpture from various periods in the history of art, and Chicago artists, some perhaps for the first time, saw Early Christian and Pre-Columbian sculptures.[13]

Some project sculptors had come from Europe and brought with them the knowledge of experimental modern art: constructivism, cubism, and "engineered" sculpture that used modern, industrial materials, such as aluminum, plastics, and stainless steel. But the majority of IAP sculptors preferred to work in traditional, American Scene styles. Traces of the indigenous arts of sign carving, weather-vane modeling, and the making of children's toys can also be found. This influence derives, in part, from the work done by the IAD, and it clearly shows how the IAP educated and produced a new generation of Chicago sculptors.[14]

Sculptors made technical contributions to the medium as well. Edward Chaissaing, for example, experimented with poured stone, itself a variation of the process of poured concrete. Other contributions by Chicago sculptors included glass-aggregate surfacing of

sculpture and the creation of outdoor sculpture that could be used as climbing devices for children. Sculptors

> developed a plastic product called magnacit for small sculpture and mosaic work. Modernists used the welding torch to create forms impossible to cast or carve. Project artists cast pieces in aluminum as well as bronze and sometimes they achieved special effects by electroplating other metal to the casts. Stainless steel and coppersheets served some artists' purposes. FAP sculptors found time to work with the traditional marble, granite, and limestone, but the high material costs . . . encouraged wider use of precast concrete.[15]

Edgar Miller was the dean of Chicago sculptors during the 1930s. He sculpted one of his most impressive project pieces for the Jane Addams Housing Project. Olin Dows, TRAP director, said about Miller's work: "Just a word about the impressive limestone animals and decorative brick carving of that versatile craftsman, witty and ingenious artist, Edgar Miller. . . . His is the capacity for clothing a playful wit and sophisticated fancy in the carved trappings of a massive block of limestone, without losing either the lightness of the idea or the weight of the stone."[16]

Probably the most noted sculptor to work on the IAP, one whose reputation extended well beyond that period, was Charles Umlauf. He was well trained, talented, and poor. He had been living a hand-to-mouth life like many artists in the 1930s. Umlauf did some work for the Century of Progress, earned scholarships to the Art Institute, and had occasional teaching jobs. Most of his time was spent performing manual labor to earn a living. His first artistic success came when he won Treasury Section commissions for decorating the post offices in Morton, Illinois, and in Paulding, Ohio. In 1939, he joined the IAP as a supervisor in the Sculpture Division, which provided him with time to do his own creative work, including the fountain and mosaic pool for Cook County Hospital (see plate 17) and the two massive fountain sculptures for Kurt Melzer's Lane Technical High School project (see plate 18). He was greatly influenced by Rodin and by the Art Institute's collection of Early Christian art.[17]

Umlauf's Cook County Hospital fountain, entitled *Protection*, was set in front of a painted mural by Edwin Boyd Johnson, creating a panorama of the life of man and beast. In the foreground and

enclosing the fountain is a ceramic-tile retaining wall done in brightly colored surfaces by John Winters. The statue of *Protection,* an eight-foot-high female figure shielding two other people, is mounted on a two-foot base set in the circular water basin and is lined with Umlauf's mosaic design of different-colored crushed glass. It could be seen by patients and visitors on the balcony that surrounds the lobby on three sides.

Women sculptors held their own on the Sculpture Division. Mary Anderson Clark states, "All the stone carvers were my friends as well as the plaster workers and the other sculptors. I was so thrilled to be given the chance to work that I was very happy and thought nothing of being an invader into a 'man's art form.' "[18] Clark came from a prominent Chicago art world family. Her uncle was the well-known sculptor, John Storrs. School principals, particularly, asked for her work when they wanted pieces that children would enjoy (see plate 19).

In sum, the IAP Sculpture Division was as diverse as the talents and educational backgrounds of its artists, and the division participated in each of the federal projects that were developed from the PWAP through the FAP. Caught in the dilemma of requiring costly materials during a period when neither money nor wealthy patronage was available, and having no *raison d'être*—for who would commission a monument to the depression?—IAP sculptors, like their counterparts across the country, bided their time, making small maquettes, waiting in hope for better times.

But better times for artists never came. Thorp was confronted with a project that was badly divided. Those who knew of his work in New York with Girolamo Piccoli, supervisor of the New York Sculpture Division, were impressed. "Thorp was very able, and together they made a very good team, with Piccoli as administrator and general planner and Thorp in charge of most technical phases."[19] Hildegarde Crosby Melzer said of Thorp, "He was a businesslike person, but he was also one who restored pleasant social amenities."[20] The latter was absolutely critical to a program that had been ravaged by low morale from years of strife. Of course Thorp had his work cut out for him, and he had to face loyal Robinson supporters, who did not take kindly to an outsider. Andrene Kauffman, project artist, stated, "I did not know him well; he seemed mainly interested in keeping things running. He didn't have much rapport with the group."[21]

As project director, Thorp had very definite ideas about the nature of his own and his subordinates' and supervisors' roles and responsibilities. He confined his energies to the Chicago office, but encouraged Fred Biesel, his assistant, to continue to develop downstate programs and to strengthen political connections.[22]

Thorp used supervisors to direct and facilitate the work of project artists. Supervisors had to ensure that the art produced was of a high standard and made directly available to as many of the citizens of the United States as was physically possible. Meeting these goals was a full-time job, one that could not be accomplished between painting or sculpting. Thorp was emphatic about this issue and said, "In the past there have been questions raised . . . as to whether the supervisors, who are practically all practicing artists, should do creative painting and sculpture . . . in addition to their work as supervisors. . . . I do not believe that this procedure is in the best interests of the Project."[23]

Thorp was committed to seeking, certifying, and hiring qualified professional artists. Having been a supervisor himself, he was not in favor of the selection and certification process falling under the control of a single supervisor. Instead, he wanted widely based committees to shoulder this responsibility. Questions of technical ability and an artist's suitability for employment were also to be handled by the committees. As an Artists Union man himself, he encouraged project artists to serve as elected, but nonvoting, observers on these committees. In addition, he persuaded museum personnel and university faculties to assist in developing regional programs. The Museum and Visual Education Committee and the Museum Extension Program at Southern Illinois Normal University were examples of the success of Thorp's commitment. In sum, the committees were there to assist the supervisors, but in no way did they or the artists have the final say. Thorp felt strongly that "the supervisors are legally responsible for the activities of the project, the artists do not have a vote and the final decision is that of the project director."[24]

The difference between Thorp and Robinson was fundamental. Thorp approached his responsibilities from the point of view of a project worker. He had been an artist and could empathize with their plight. McKeague remembered Thorp as Lincoln-esque. "At one time he gave up his supervisory position in New York so he could go back to spending more time in sculpture. He was that type of person; greatly committed. I think he was reluctant to become the director in Illinois.

I know because he talked to me about it. He said, 'You are going to help me get through this thing. This is terrible.' I told him we would just take it easy and talk to people, and it will work out. It did!"[25]

Thorp's affability, his commitment to project artists, and his willingness to spend long hours at his job were no match for the mounting difficulties threatening the program nationally. Political as well as philosophical changing tides altered congressional views toward Federal Project Number One. By June 1939, Congress had severely reduced Federal One's operational capabilities.[26]

The makeshift Emergency Relief Appropriation Act was signed on 30 June 1939, but did not go into effect until fiscal year 1940. Effective 1 September 1939, however, Federal Project Number One could not continue without legal sponsorship from its respective states. After 1 January 1940, 25 percent local sponsorship was required. Furthermore, all relief workers (except veterans) who had been continuously employed on such projects for more than eighteen months would be removed (furloughed) for a period of thirty days and then recertified before returning to project rolls.[27]

Despite these setbacks, Cahill remained as director to organize state projects and line up federal support. His job seemed destined to failure. He could maintain high standards and high employment only by finding "a sponsor in each state who recognized that vitality depended upon national leadership and who had money to pay 25 percent of the projects' cost."[28] This was no easy task, and he failed in most states. But in large metropolitan centers like Chicago, sympathetic and committed arts supporters found the sponsorship, and project activities continued in one form or another.[29]

Those artists who felt abandoned by the federal government, particularly the Artists Union's rank and file, had lost sight of the government's real goals in creating such a program. The FAP was neither meant to be a permanent dole for the lazy nor was it meant to be a permanent job for careerists. In response, the Artists Union fought to retain some semblance of a program for the employment of artists by distributing leaflets calling for support. "We must by phone and telegram today continue to impress on the administration the fact that special considerations must be given the Art Project inasmuch as there is no private employment open to artists and craftsmen. We must stress also the community service as an important part of home defences."[30]

The original layoffs were to affect 58 percent of the artists working in Chicago, but prompt action on the part of the Artists Union delayed the mailing of the termination notices. Union members were encouraged to call or write WPA State Administrator George H. Fields. One positive note for Chicago artists was that Mayor Edward J. Kelly was extremely supportive of their efforts. He went on record in a public announcement by saying, "There is no time to minimize or lessen the cultural advantages the people have gained under the IAP. Apart from the purely aesthetic side, these projects have opened up vocational opportunities for many citizens who previously could not afford tutors or instructors. In time of crisis and peril, these cultural activities are a wonderful antidote for fear and indecision."[31]

As of 1 September 1939, Thorp had to contend with the furlough system. He and Fred Biesel held many meetings to discuss how to get the furloughed artists back on the project. They often manipulated grade levels (artists, artist 1, senior artist, artist senior, etc.; see appendix F) to get more artists working within federal dollar and quota restraints. For example, an artist designated as a senior artist would be reclassified the following month, without reference to artistic ability, to a lesser grade, only to be changed in grade several more times within the eighteen-month period.

Thorp devised another scheme. He initiated strategies for circumventing quotas by hiring more people than authorized and then negotiating with Thomas Parker in Washington to keep them on or to adjust the quotas. As negotiations dragged on, the artists continued to work.[32]

Such projects as the ornamental pool and sculpture garden for the Illinois Research and Educational Hospital in Chicago and the landscaping and design for reflecting pools and sculpture at Lane Technical High School were successful attempts by Thorp to interest state sponsors in beautifying the grounds surrounding their facilities. These and other projects engaged large numbers of personnel from both the IAP and WPA. Not only were artists and designers involved, but carpenters, masons, and general laborers helped to transform barren areas of earth into gardens and places of contemplation.

Despite Thorp's efforts, the June 1940 Emergency Relief bill implemented a new organizational setup that altered WPA and IAP activities. Mary Gillette Moon, director of the Professional and Service Division of the WPA in Illinois, wrote Florence Kerr in Washington

that Illinois was ready to comply. The WPA in Illinois was divided into three statewide projects: Welfare, Community Service, and Research and Records. Robert McKeague was named head of the Community Service Project that contained the classification Public Activities, and the newly structured Illinois Art and Craft Project (IACP) was placed under Public Activities.[33]

The primary aim of the IACP was to establish, promote, and coordinate art and craft production activities throughout the state. From 1935 to 1939, nine crafts shops had been organized throughout Illinois, employing between eight and ten thousand people. Local workshops specialized in the following: Canton, toys and furniture; Champaign, weaving and metal; Decatur, toys; East St. Louis, metal; Jacksonville, weaving; Petersburg, early American furniture; Quincy, furniture; Shawneetown, furniture and weaving; and Chicago, woodwork and weaving.[34]

These shops were set up independent of state involvement in technical procedures and professional standards. Workshop activities were extensive and varied. The Benton workshop designed furnishings for a local park and its lodge and for a Girl Scout camp (see plate 20). Palos Park designed furniture for a local WPA library building. Winnetka designed furniture, draperies, and rugs for two schools. Shawneetown activities included furnishing twenty offices and two courtrooms for the Shawneetown Courthouse and floor plans, color schemes, and shop drawings for a recreational center in Centralia.

The Decatur workshop crafted toys from wood, metal, and plastics (see plate 21). For example, it produced a toy lamb from a Plexiglas model. The plastic was transparent and could be shaped with woodworking tools; the eyes were made from a mahogany dowell. The same shop also made an elephant pet set. John Walley indicated that the problem in design was the application of research in child psychology to the finished toys. These products were directly in contrast with the intent of the sentimental animal designs popularized by the Disney studios, and children loved them.[35]

The craft shops functioned with available local talent. When the IACP was organized in 1940, part of the new administrative structure called for the absorption of the nine existing shops into a coordinated whole that voided the shops' original purposes.[36] To unify and organize the disparate craft shops into an efficiently functioning statewide entity, the IACP created a state staff and six district offices. A flow

chart was devised in Chicago and sent to the various districts explaining the chain of command. A district supervisor was selected to act as liaison between the Chicago office and district personnel—locally being divided into three branches: clerical, allocations, and production. The production branch could have as many as ten different departments: art, leather, photography, silk screen, needlecraft, pottery, weaving, woodworking, finishing, and metals.

The various districts of the Art and Craft Project were organized geographically somewhat differently than statewide districts under the IAP. District 1 comprised Rockford, Joliet, Aurora, and Elmhurst; District 2, Jacksonville, Petersburg, Canton, and Quincy; District 3, the Chicago Metropolitan area; District 4, Decatur, Bloomington, and Champaign; District 5, Shawneetown and Carbondale; District 6, East St. Louis; and District 12, the state staff located in Chicago and headed by John Walley.[37]

Prior to the implementation of the new administrative structure, Thorp was asked to loan three artists for design assistance in downstate craft shops. One of these shops was located in New Shawneetown, which was being replatted because the original town site had been devastated periodically by Ohio River floods. "This town needed new furniture, new fabrics, it needed new arrangements for old appetites. I [John Walley] found people along the river with fabrics that they had packed away in boxes that had been woven by them or their grandparents. They had been packed away because they did not look well with modern machine-made furnishings."[38]

Some state administrators at the Merchandise Mart and others in the Professional and Service Division of the WPA felt that design supervision from the IACP should be given to all of the shops. It was obvious to many that people working at the shops did not understand the problems they were encountering and that they lacked clear-cut statewide objectives. Walley was at first invited to serve as advisor when it became evident that the IACP and the local shops needed each other. Out of this mutual need came the central experimental workshop, and it seemed logical that the IAP, which was operating concurrently, should serve as the "blood stream of that unit"[39] in supplying artists and staff.

John Walley was placed in charge of a work force of eleven hundred craftsmen. Walley admitted that he was overwhelmed by the number of workers. "I was told I had to interview eleven hundred workers on

Monday. Thorp told me that I'd have to put them to work, useful work. Washington didn't want any standby stuff or anything time wasting. That meant I had to get some constructive action. I requested the power of signature and got it for space, and a place to sit down where there were bathrooms."[40] Walley worked eighteen hours a day out of Chicago and for two days straight interviewed and set up the workload for the craftsmen.

IAP artists wondered why the IACP was needed, especially if it threatened the positions of painters and sculptors by draining off funds from their departments. While the relationship between design and arts and crafts seemed obvious, the broader picture was not as clear. Walley answered these questions and bridged the gap between design and the fine arts in a speech to the Artists Union. "Before people can understand personal art expression, they must understand utility expression. We must find ways to manipulate the machine so that it will produce well-designed objects for all people. We must experiment in forms and discover how they aid in bringing social change. We must aid in freeing those rural people from their inhibitions in the use of common materials."[41]

Walley suggested that the Design Workshop control all the personnel of the craft workshops. They would be distinct from the fine arts by keeping personnel quotas separate. In an attempt to allay the fears of project artists, Walley invited well-known Bauhaus designer Laszlo Maholy-Nagy to deliver a lecture. Walley hoped that local German, Finnish, Hungarian, Swiss, and other craftsmen would identify with the European sources of these new ideas in design, thereby making a less painful and wasteful transition to the new thrust of the IAP.[42]

By FAP mandate, the function of the Design Workshop was to "restore, maintain and develop new skills in unemployed craftsmen through the production of useful equipment and environments for tax-supported institutions in the municipal, county, state, and federal governments and any combination of the four."[43] The sponsors provided a budget for materials and services, and the federal government funded labor and basic tools needed to operate the project. Walley saw "develop" as the signal word for his philosophy and his intended practice in the unit.

Our real and lasting approach will develop out of our willingness to assume our social responsibility. I feel it is our responsibility to

develop the most advanced type of contemporary design that our combined appetites are capable of creating. We must exploit the most advanced use of new materials. We have to understand and solve the problem of furnishing courthouses, school buildings, and all other public buildings. It is through those places we will exhibit to all of the people the enriched use of wood, fabrics, metal, glass and ceramics.[44]

The personnel of these workshops consisted of designers, draftsmen, and clerical workers. Designers on the Chicago staff selected forms, textures, and materials that could be shaped into functional objects with the aid of existing machines. The draftsmen made working drawings that would be sent on to regional shops for construction. The clerical staff, of course, processed the unit's records.

Many workers on the various crafts projects were unskilled, so they required close personal supervision. Also, authorities in the various fields of craft work were consulted and methods of work were formulated. This information was circulated to the various shops throughout the state for mass production.

On 1 July 1940, the IACP published a mimeographed newsletter called *Production News*. Scheduled to appear bimonthly, the newsletter appeared sporadically until the project came to an end. It covered current IACP news, gallery shows, and exhibit calendars. According to its inaugural issue, *Production News* was created to "provide information concerning the three statewide Art, Craft, and Museum Extension projects."[45] It was no doubt used as a vehicle to promote communication between art project personnel and the new arts and crafts project.

A series of twelve lectures given at the IAP Gallery at 1020 S. State Street also served to coordinate activities and disseminate information. Bauhaus cabinetmaker Hin Bredendieck delivered the first lecture as well as a demonstration on furniture design. Other guest lecturers included muralist Charles Freeman, designer Don Vestal, and John Walley.[46]

Bredendieck, an important figure in design circles, came to the United States with Moholy-Nagy to help establish the New Bauhaus. As a foreigner he could not be employed by the WPA, but he was allowed to participate as a special consultant and was paid from private funds. He exerted the most influence over the craftsmen by

supervising their work. All design jobs went to Bredendieck for evaluation of the design's quality, the technical feasibility, and recommendations for production. Further, he had a knowledge of experimental projects in plywood lamination then underway in the German aircraft industry and recommended that the Design Workshop establish a similar operation (the only one in the country). He created all of the devices for the hot and cold forming of plywood.[47]

Much of the credit for the Design Workshop's experiments was due to the influence of the New Bauhaus, established in Chicago in 1937. Director Laszlo Moholy-Nagy was a former associate of the Dessau Bauhaus. Moholy-Nagy's ideas were new to American artists and resulted in a series of creative explosions in Chicago. One such explosion occurred at the Artists Union Gallery. Walley remembered:

> As one of the officers of the Union, I recall a minority of the Executive Board insisted on inviting Moholy to present to the group the work of the German Bauhaus, the New Bauhaus, and his personal work. I clearly recall the debates at the Board meeting before we could get a tentative agreement for the invitation. I can still see Moholy's arrival at the Union headquarters with a large movie projector, two slide projectors, films, and large scale photo blow-ups. The shock—the impact of the new ideas created a turmoil in the group. What had been planned for a two-hour meeting turned into a marathon debate lasting well after midnight. Moholy was never at a disadvantage in a heated discussion even when completely outnumbered. The group finally shifted to a nearby bar and continued until closing time.[48]

The New Bauhaus closed its doors in 1939 due to a lack of funds. Undaunted, Moholy-Nagy opened the School of Design in April 1940 at the Chez Paree building on Ontario and St. Clair streets in Chicago. His students also continued to participate in Design Workshop activities. The list of these students is long and their work is impressive: Calvin Albert, Alex Corazzo, Adelyne Cross, Richard Koppe, Myron Kozman, Elsa Kula, Les Marzolf, and Theodore Torre-Bueno.

One Design Workshop effort merits elaboration as its impact could have been outstanding because it represents one of the few instances where Moholy-Nagy became directly involved. Louis Newkirk, head of the Chicago Public Schools industrial arts program, enthusi-

astically agreed to permit the Design Unit, with Moholy-Nagy as advisor, to redesign his program for the city. With the help of the Writers Project, Moholy-Nagy, John Walley, and other project members put together an industrial arts manual, which included learning how to use wood, metal, textiles, photography, and graphic arts, as well as how to create product, shelter, and transportation designs. However, once the manual was completed, the group was unable to convince the city's teaching staff to retrain or change their basic definition of industrial design. The program was never put into practice.[49]

Two exceptional designers were Lem Nederkorn and Don Vestal (see plate 22). Nederkorn designed a series of chairs in fir plywood and Plexiglas utilizing the concept of bending a rectangle into a series of complex curves to form the back and seat. The result was a simple, light frame that provided arms and legs and that demonstrated the successful adaptation of two disparate materials.

The workshop also experimented in urea-treated wood. Oak was cut from the tree two days before treatment. Bent members were formed immediately on being removed from the hot urea solution. Spline joints and butterfly joints were made four days later. They were observed for five years and showed no signs of joint separation or cracking of wood.[50]

The Design Workshop closed in 1943, and many of the male designers enlisted to participate directly in the war effort. Their legacy is somewhat obscured by time, "maybe because little of their work was wholly unique."[51] "Whether designing a set of furniture for a school building or inventing a new system of visual aids for the army, the group produced objects that were absorbed into the stream of everyday life, losing the customary sanctity associated with works of art."[52] For Burnett Shryock of Southern Illinois Normal University, the Design Workshop "woke people up, and if it did nothing else it brought color into various drab situations. So I think it was a turning point in interior design; I say design, not decoration. I think people became more aware of clean-cut, bright colors, and the simpler, more honest way of using various kinds of decoration."[53]

George Thorp was constantly reevaluating these craft workshops and the work that they were doing in hope of eliminating duplication of effort and stiff competition between the IAP units and the public marketplace. As funding and sponsorship decreased, Thorp continu-

ally rearranged each district's organizational chart to meet a shrinking budget. Often, decisions had to be made between elimination of one unit for the benefit of others that seemed to Thorp to be more valuable. He wrote in one proposal, "In both of these plans [to reduce personnel in District 5] it would entail less than normal reduction. It seems wise to favor this district thus at the expense of other districts."[54]

Some districts benefited from the relationship with a state university. This was the case in District 5 where the University of Chicago was sponsoring an archaeological excavation in conjunction with Southern Illinois Normal University at the present site of Kincaid Lake. The situation was similar in District 4, in that the University of Illinois sponsored museum-related projects.

That the IACP continued to run harmoniously was a testament to Thorp's ability and steady commitment to project artists. But stress and long hours took their toll. Thorp, unable to balance the demands of job, family, and his own creative needs resigned his position as state supervisor on 2 September 1941. He wrote Biesel from San Francisco on 22 October: "I hope that you have been able to make some headway in the rather messed up conditions I left things in. This business of my pulling out was brewing for a couple of months before I left and I am very much afraid the general state of affairs looks it."[55]

The letter attempted to make amends for his sudden departure, but only hinted at the reason. "I felt a clean break was called for primarily so that I could get some objective evaluation of myself. I haven't got it yet, but I still hope to . . . I haven't the slightest idea of where I'm heading." Thorp ended by thanking Biesel for his support and friendship, and he encouraged Biesel in the task ahead. "Fred, your feet are well on the ground and I do not feel that you will encounter much of any problems that you won't be very well able to handle."[56] With Thorp's departure, and the change in federal policy toward the FAP, another chapter of the IAP came to a close. (See appendix G for a summary of IAP accomplishments through 31 January 1940.)

Fred Biesel, 1941–1943

THE FINAL YEARS

George Thorp's departure in 1941 was a sad occasion for Fred Biesel. He and Thorp had worked well together and had become close friends. It was primarily Thorp who had recommended that Biesel replace him as director of the IAP. He complimented Biesel when he said, "I'm all for you in any way I can be. As far as I'm concerned you're my candidate for Eddie's [Cahill's] job if he ever decides to leave" (see plate 23).[1]

Biesel had served in various higher administrative capacities as assistant supervisor of art, assistant state director in 1939, and supervisor of the Art and Craft Project in 1941. Cahill, in turn, was more than willing to oblige Thorp's recommendation that Biesel become the next head of the IAP, since Cahill and Biesel had shared a studio in New York and had been longtime friends. By mid-October 1941, Fred Biesel became the director of the IAP and the IACP.

Biesel had a varied artistic background. As a graduate of the Rhode Island School of Design, he had spent time in New York studying with Robert Henri, George Bellows, and John Sloan. It was during this time that Biesel met Cahill. When Biesel moved to Chicago, he did postgraduate work in poster, design, and painting at the Art Institute of Chicago. Afterward, he spent six months painting and researching in France and Italy. By the time he went to work for the IAP in 1936, he had several solo exhibitions, including one at the Art Institute.[2]

John Walley qualified Thorp's enthusiastic stamp of approval by saying that Fred Biesel was

an unusual guy with a very broad view and tolerant of many schools of [artistic] thought. It's ironical to get an upper class man who had this genteel nature involved with this kind of project and

holding the respect of all of the artists. He was a confident artist, but never very productive. His wife, Frances Strain, was also a painter. These people were very sound, well-trained artists, but they just didn't happen to be involved in perfection or innovation in the sense of changing the art scene. But Fred was a very good element in the whole administration.[3]

Biesel became interested in administration when he joined the project as an assistant to Increase Robinson. "During the early days of the WPA Federal Art Project, since there was a need, I acted as contact person with colleges, schools, Federal, State, and local government agencies and the mural, sculpture, poster, and design units of the Project."[4] But Biesel's particular interest was in developing the craft portion of the IAP.[5] Under Thorp, and later as director, he emphasized the development of craft communities outside the Chicago area, especially in downstate Illinois.

Biesel spent large periods away from Chicago traveling throughout the state visiting cities, such as Quincy, East St. Louis, Springfield, Carbondale, and Cairo. Although these areas of the state constituted less than 5 percent of the total artistic work force in Illinois, Biesel felt that they were important.

Biesel, as had Robinson and Thorp before him, understood that even though the Illinois program had always been fundamentally a Chicago-based operation, competent artists and economic need could be found throughout the state.[6] Downstate IAP artists included painters Maude Craig of Elizabethtown and Vachel Davis of Eldorado, wood-carver Fred E. Myers of West Frankfort, and watercolorist George Carr of Harrisburg. These artists, many of whom were self-taught, were extremely talented individuals. Maude Craig was celebrated in Chicago with a solo show; Fred Myers was internationally known as attested by the many European visitors who while traveling through the Midwest, sought out his farm to view his work.

Penny Cent, another IAP artist, was assigned to Saline County from Chicago to direct the educational and communal experiment near Harrisburg. "In June of 1934 the 'College-in-the-Hills' opened in various tents and sheds in the foothills of the Little Ozarks. 'Theirs was a venture in education based on the theory that a worthwhile training for life can be made available to a group of students who are willing to live and work together on a thoroughly co-operative basis.'"[7]

After the "College-in-the-Hills" closed in 1936, Cent was assigned as a writer for the WPA from 18 February 1936 through 4 January 1938. From 20 December 1939 through 30 June 1941, he worked as a senior artist and as an area project supervisor in Saline County.[8]

None of these individuals chose to leave their homes and travel north to participate in the art project. When asked to move to Chicago to join the Illinois Sculpture Unit, Fred Myers responded that Chicago was "too far from the creek."[9] Instead, he was assigned to the Museum Extension program that worked out of Southern Illinois Normal University. Fred spent three years creating prehistoric animals out of black walnut for the museum to place on display and to circulate to area schools for children to view.[10] George Carr and Maude Craig remained in southern Illinois producing their work and sending it north once a month. Carr recalled in an interview that he was allowed to work in Harrisburg, and every month would send two watercolors to Chicago in return for a monthly check.[11]

Springfield was especially critical because the project had to be on good terms with state legislators after the 1 September 1939 transfer of IAP funding from federal to state control.[12] The reduction in quotas and the furlough system plagued Biesel as they had his predecessor. Biesel retained Thorp's strategy of hiring as many artists as possible within the constraints of quotas and dollar allocations. He was aided, however, by the United States' entrance into the war in 1941. Many furloughed artists enlisted or were drafted, thus reducing the number of artists waiting for reassignment to the project.

In 1940, through Biesel's considerable efforts, the IACP took on the additional responsibility of providing technical supervision for museum assistance, museum extension, and visual aid projects throughout the state.

> The aim of the project was to assist publicly owned and operated museums, Boards of Education of Schools and Colleges, in making knowledge available to the public by preparing material for publication; reconstructing and preserving exhibits; mounting, labeling, filing and cataloging specimens; organization of reference collections; keeping records of accessions; transcription of material description; laboratory assistance; preparing models and dioramas; cleaning, sorting and arranging specimens; and general clerical work.[13]

A project such as the museum extension was ideal in that it employed a variety of personnel from varying backgrounds. Artists, architects, and draftsmen were required to prepare designs, layouts, and sketches for the production of museum exhibits. Carpenters, painters, electricians, and machinists were needed to mount the exhibits, specimens, and visual aids. Scientists assisted in assembling data required for the installations. Researchers and editors prepared and edited text for exhibit specifications and for monographs used as reference material in museums and schools.

Another aspect of museum extension was an archaeological program that provided assistance to a number of institutions desiring to supplement their records and collections of Illinois archaeology. Anthropologist Moreau S. Maxwell is a case in point. His salary was funded by the state, but he worked for the Southern Illinois Normal University Museum in the capacity of the museum's sponsor's representative to local artists, and he was the supervisor of WPA workers in the Herrin region.[14]

The Illinois State Museum in Springfield shared technical responsibility with the Division of Architecture and Engineering of Illinois State Parks and the Southern Illinois Normal University Museum. Professional archaeologists trained at the University of Chicago supervised excavations and other phases of research. For example, the Kinkaid Lake Project and the WPA Fort Massac Project reported to Maxwell, although their funding originated in Chicago. Most of the archaeological expenses were paid by the state and not by the Southern Illinois Normal University Museum, which was always responsible for a fractional percentage of the costs for tools, photography, and so on. The museum was funded separately by the IACP for maintenance and development of its own programs.[15] The excavations provided museums and universities with a wealth of data that contributed to a better understanding of the cultural manifestations of the early inhabitants of Illinois. The University of Chicago and the Illinois State Museum compiled these findings into a book for classroom instruction.[16]

One project of note took place at the site of the Cahokia Courthouse near East St. Louis. Excavations revealed the foundations of an early French fort and a later American one in sufficient detail so that either could be reconstructed on its original foundations. Many cultural objects, such as uniform buttons and old glass and clay pipes, were recovered, identified, and classified for museum displays.[17]

Another example of the diversifying efforts of the FAP was the Community Art Center (CAC) program. It was established to provide space for exhibitions, gallery talks, demonstrations of art techniques, and art classes for children and adults in local communities. A *WPA Technical Series* art circular laid down the philosophy of the CAC. "The purpose of the Community Art Center is to correct the unequal distribution of cultural advantage through the organization of community art centers in regions and localities where no such agencies previous existed. In establishing these centers it is the objective of the FAP not only to provide the public with opportunities to participate in the experience of art, but also to provide useful work for unemployed artists and art teachers."[18] In addition, five purposes of community art centers were outlined in an IAP poster: "1. An Art Center is a Community Program, not a superimposed Federal Project; 2. New Integration of Art in community life; 3. New Audiences; 4. New Standards; and 5. New Opportunities for Art Participation."[19]

One of the real values of the centers rested on the children's classes. "If art instruction meant a leisure time activity to most adults, to children it represented a primary and, as the project soon discovered, a necessary form of expression." Some community art centers broadcast weekly radio programs in which the children participated. They formed an immediate audience for the announcer "who reviewed the work of the Art Center, told stories of great artists, and provided other instruction and entertainment."[20]

Beginning on 26 December 1939, and running sporadically for two years, WGN Radio in Chicago aired a series of broadcasts aimed at younger audiences throughout the city. This series was created in conjunction with the Illinois Writers Project and was sponsored by the Art Institute of Chicago. The broadcasts were fifteen minutes in length, and more than seventy scripts were written. Thirty-one programs were aired between December 1939 and December 1940, while twenty-four programs were produced in 1941 and fifteen in 1942.[21]

Each program followed a series format and included such titles as "Great Artists" and "Italian Masters of Art." Other programs, such as "Francisco Goya," "Masterpieces of French Art," and the "Thorne Miniature Rooms," were written in conjunction with special exhibitions at the Art Institute. The connection between the show's subject matter and the Art Institute's exhibitions is evident from a statement made preceding a program on Michelangelo: "Through this series of

dramatizations we call your attention to the magnificent exhibition of masterpieces of Italian Art lent by the Royal Italian Government to the Art Institute. You have only two weeks left in which to see these twenty-eight works of art. We urge you not to miss this opportunity."[22]

Programs were geared toward public school children between the ages of six and thirteen, but adults with little art background enjoyed them as well. The Chicago Public School system incorporated these weekly broadcasts into the art curriculum. Professional actors participated in various roles, and Art Institute staff and IAP artists served as professional advisors.

Probably the greatest step forward for the arts in the black community of Chicago occurred in 1939 when the South Side Art Center was founded. It flourished with the personal backing of Eleanor Roosevelt who came to Chicago for its dedication ceremony on 7 May 1941. With the support of the neighborhood's black community and the donation of the Charles Comiskey family's vacant brownstone mansion (see plates 24 and 25) located at 3831 S. Michigan Avenue, a gallery was constructed on the main floor.[23] The upstairs housed meeting halls, and the carriage house held various shops. WPA artists taught classes there (see plate 26). A number of white artists held solo shows in keeping with the belief that the center was an integrated attempt to stimulate cultural development for members of all races. "In those days it was one of the few places that brought the Negroes and whites together on a cultural basis. The center was for everyone; a true symbol for an interracial tolerance. Contrary to some beliefs at the time, it was not an attempt to segregate the Negro"[24] by excluding him from other IAP galleries. Attendance at the Artists and Models Ball was interracial.

Peter Pollack headed the center, and he expended much energy in developing neighborhood and citywide support. Pollack, who was white, had held an assortment of jobs (including that of a pickle salesman) before the depression. He developed an interest in the FAP and formulated the initial idea for a black art center. His enthusiasm compensated for his lack of formal art training. Holger Cahill quoted Pollack as saying, "You could stay in the slums of the city of Chicago on the south side, west side, or northwest side and not see any original artwork. The schools had no artwork to mention, and there was no place to see art unless you went to the Art Institute. And a lot of people didn't go there. My toughest job of all was to try to build an art

center in the very heart of the slum of the city of Chicago, which was a Negro neighborhood."[25]

Yet all was not well. Many of the black artists who worked with Pollack and later under him resented his patronizing attitude. They felt that they were being used, that he surrounded himself with only the black middle class (see plate 27), and that artists were not allowed to participate in the creation of center policies: "The grass roots never had a chance for expression there because all the decisions were made at the top and with the society Negroes."[26] Nicola Ziroli recalled, "Peter had a tendency to use anyone as an errand boy. He didn't know how to do anything himself, so naturally he would ask someone to do it for him. He asked a lot of favors of everyone."[27] A. L. Foster wrote Florence Kerr indicating that Mr. Charles Miner and the South Side Art Center's board of directors "agreed to permit me to serve as an advisor on a per diem basis, pending the time a full-time person would be employed. I was never called in and neither was anyone appointed to his staff."[28] When Pollack left the center in 1943, Margaret Burroughs, wife of IAP artist Bernard Goss, stated that "quite a few people were glad."[29]

Pollack, in turn, felt that the blacks were prejudiced. He had succeeded in acting as a liaison between the IAP and the black community, and they had established the center. But Pollack received much recognition for the center's progress. He went on to the Art Institute as director of public relations and later to New York's Museum of Modern Art, where he helped establish its photographic library.[30]

Jobs for blacks in cities like Chicago were scarce. Few commercial jobs were available, and black artists found it almost impossible to sell their work or find a gallery willing to promote it. Blacks could not easily participate in the IAP while Increase Robinson served as director.[31] Only Charles Sebree was assigned to the Easel Department. After 1939, many blacks were affiliated with the Art and Craft programs throughout the state, but 90 percent were assigned to textile jobs; most were women who were loom and fiber artisans (see plate 28). Black artists could be found in IAP studios, but they were not generally assigned to their particular area of talent. Rather, they occupied less visible areas of responsibility, such as assisting muralists or doing manual labor. This situation changed through the support of the Artists Union and when George Thorp replaced Robinson as the director.[32]

Black artists were sought after to join the Artists Union, and eventually many served on the union's executive board. "Unfortunately, there were many who didn't join because they were lazy and uninterested in the fact that someone other than themselves had exerted pressure in getting them their jobs. Some Negroes didn't like white people, and others knew of the communists in the union and didn't want to be affiliated with them."[33] Black artists, who had the greatest social grievance, were not particularly interested in union politics or socialism beyond the maintenance of a job. Many blacks respected the Communist Party because of its help during the depression. When a black person became destitute, the party helped him or her find a place to sleep and food to eat. Yet, Bernard Goss recalled, "None of the Negro artists I knew, however, joined the party. They were pro-communist, but never became members. . . . Negro artists in the union were usually not party members even though it seemed as if the party fought the most for the Negro artist."[34]

Black artists worked within the scope of social realism and social protest. "The Chicago Negro artist didn't go in for pure abstract art; it was too empty for him. The Negro artist painted Negro subject matter: street scenes; big-eyed, hungry children; or a bowl of fruit. Whatever the subject, the painting was full of social impact. There were a great number of Negro primitives, those who had no formal art education, but nonetheless they made a contribution to the Negro art movement."[35] In general, black artists sought to communicate their message by combining an ethnic viewpoint with technical skill. These artists improved their artistry and their stature as contributors to American culture.[36] Illinois boasted of a number of outstanding black artists, such as Eldzier Cortor, Archibald Motley, Charles Sebree, and Charles White, as a result of their working on the IAP and for the South Side Community Art Center (see plate 6).

In the fall of 1938, an attempt was made to establish an art center in East St. Louis, Illinois. But a number of organizational meetings failed to produce a working center. Had the East St. Louis "People's Art Center"[37] materialized, it would have been the first integrated CAC in the United States. While this initial effort failed, a craft center was developed later in 1939 in an abandoned East St. Louis school near the railroad-yard section along the riverfront. The work center incorporated such craftsmen as potters, weavers, and an iron forger from Granite City who made bicycle racks for school yards.

If there was a problem nationally with the CAC concept, it had to do with preparing communities to assume the economic responsibility for the centers once the FAP ended. The outbreak of World War II forced not only the IAP but also the communities to concentrate their energies on the war effort, and all but a few centers were closed. One of the exceptions was the Chicago South Side Art Center. With the closing of the Harlem Art Center in New York, the South Side Art Center remained the only black center operating into the 1960s much as it did during the depression. "It's a homing place for all those who were on the project."[38]

From the Japanese takeover of Manchuria in 1931 to the German invasion of Poland in September 1939, it was apparent to FDR's administration that the United States would eventually become involved in global conflict. Preparations for war included an extensive buildup of the nation's defenses and a gradual conversion of industry to production of military goods. But media coverage of international events suggested little need for action to the isolationists in the United States.[39]

After 15 January 1941, a series of exhibitions was held in public and recreation centers throughout the country to educate the nation concerning the threat of war and the country's preparations for it. The IACP, in close collaboration with the armed services, planned, organized, and circulated small exhibits consisting of eight and fifteen items (see plates 29 and 30). These materials included illustrations and pictorial records of the war effort and other exhibits in the field of plastic and graphic arts as they were requested by the armed forces (see plate 9).[40]

On 27–28 January 1941, Holger Cahill called a conference of state art supervisors in Washington, D.C., to coordinate defense requests. Florence Kerr organized the FAP's efforts into a coordinating unit to assemble all pertinent information for the files of the Washington office on available skills in each state project. The FAP maintained lists of projects equipped to undertake specific types of experimental work of standardized activities. "It [would] assemble files of information on local Defense orders accepted by the various states, in order that we may know those states best able to undertake specific types of work."[41]

In rapid order from early March through November 1941, numerous letters were sent from various military bases and recruiting

centers requesting materials and thanking the IAP for its assistance.[42] One letter, in particular, indicated that "the reproductions [of charts] are excellent and will serve a vital need in the training of our airplane mechanics, particularly in the new schools at Biloxi, Mississippi, and Wichita Falls, Texas, where there will be a shortage of equipment for some time to come."[43] Through this liaison, the IACP found demands for all phases of its design program.

In some cases, new technical problems were presented that required special design research and experimentation. For example, personnel from Savanna Ordnance Army Depot at Savanna, Illinois, needed the IACP's help in developing the "Training Program of the Renovation and Loading Department of the Depot." Also required were drawings of the "Fixed Rounds Plant and the Bomb Loading Plant," as well as charts to show the order of production, components of the ammunition itself, the process of loading ammunition and bombs, and necessary precautions.[44] Previously established project facilities were adequate in meeting the Defense program's more ordinary needs, such as decorating and furnishing Army recreation centers or in providing exhibitions.

In March 1941, Peter Pollack offered the South Side Art Center as the location of an exhibit of military life at Camp Custer.[45] In June 1941, he formulated a plan to provide for the continuance of the Art Center and submitted the proposal to Washington, D.C., in June 1942. The proposal emphasized "the part that art and its skills must play in military and civilian life."[46] The plan was reviewed favorably in Washington, and Florence Kerr wrote to George Field on 1 August 1942 that "Mr. Cahill, who has studied it, has requested this office to send it to the states as a model plan worked out in Illinois which other states might find valuable in redirecting their programs."[47]

On 25 March 1941, George Thorp called a conference of sixty-six IAP artists, IACP craftsmen, and state administrators for the purpose of unifying the IAP and IACP. In light of the defense efforts underway and the statewide redistricting of the IAP along new IACP boundaries, it was fiscally and programmatically essential that the two merge. Thorp stated in his opening remarks that

> with these two programs . . . there is a provision that you can write your art program or your craft program. It seems logical that they should become one program, and that is being done. We are only

waiting for an official project number to convert both projects into a state-wide program. You will have one program covering all of your activities. We should gain the strength of you people on the craft program and from a program which has always operated with a nation-wide plan, if we can work out here, in the next few days, many details of the operation that will be involved."[48]

A number of problems had to be solved for the Art Project to move from "doing only about five per cent National Defense work, [to] where it should be doing at least fifty per cent."[49] The IACP districts had to be converted to the full defense effort. In addition, Rockford District No. 1 was to be emphasized because, as William McMaster, its district manager, said, "We have quite a lot of National Defense activities within the geographical limits of the district. We begin on the north shore, above Chicago, in Lake County, with Camp Logan, move down to the North Chicago area, Great Lakes Naval Training Station, slip down to the highway area, and we are at Fort Sheridan. Then we move down to Rockford itself and there is Camp Grant. Other stations are in the vicinity of Savanna and Rock Island Arsenal, both permanent establishments of the army."[50]

In the private sector, McMaster indicated that a munition plant was being built in Will County, one which would employ twenty thousand workers "within the next four or five weeks. Operations in Will County . . . have had a more realistic effect on W.P.A. employment than any other county in the state of Illinois."[51] McMaster continued to emphasize that the craft shops needed to be organized from Chicago by means of coordinated requests for projects, with biweekly production reports, by the financial investment of at least three months' inventories of materials to support the increased 50 percent production, and by organization of a uniform method of correspondence among the districts and Thorp's office.[52] One unforeseen problem surfaced soon after the conference. Chicago personnel were not sufficiently trained in organizing the projects in design that were required by the military and national defense contracts. A twenty-four-page statement that detailed the scope of the new IACP soon followed, and nearly 20 percent of the document was geared toward remedying this problem.[53]

The IACP's Design Workshop provided a design for a field emergency medical cabinet that was particularly successful and that was

adopted for national use. The workshop produced a similar cabinet and toolbox for the Illinois Selective Service Board. The unit also became involved with room planning, including the furniture and furnishings for the dining room and lounge at Scott Air Force Base in Belleville, Illinois.[54]

It came as a surprise to the artists to discover that the military did not care how unconventional were the designs for the chairs and tables they used in temporary or mobile installations as long as they were functional. The designs that most impressed John Walley were a number of indirect-lighting fixtures conceived by Hin Bredendieck in the spirit of the Bauhaus's paper-cutting, -folding, and -twisting experiments.[55] Further, Walley thought that the diagrams of motor charts were an intriguing design problem. Ordnance and air force personnel found that by eliminating all lettering and undue detail they could actually increase students' comprehension. "We insisted that these large, beautiful diagrams would serve best by augmenting the officers' lectures. The other application that we developed was the projected overlay of titles that could be used as a flash technique, or sustained over a period of time and then removed completely for the open lecture technique."[56] When it was clearly proven that these methods had cut the training time by 20 to 50 percent, the Design Workshop was flooded with requests from all branches of the armed service. Admiral Harold R. Stark, commander of the Great Lakes Naval Training Center, was a great believer in visual models of all types. As a result of his requests, the Design Workshop produced large, cutaway models of mechanics, ammunition component parts, diagrammatic models of electrical and audio systems, and anatomical models for flight medicine.

The workshop produced "flow charts for Allison engines to be distributed to allied bases"[57] so that repairs could be made speedily and without complications. The designers produced "strip maps of Dakar and other World War II areas which would see fighting." In addition, they "worked on a paint cover for planes that reduced optical recognition."[58] Finally, one representative set of "Approved Orders" to be delivered between 7 January 1943 and 30 June 1943 included 120,000 booklets and handbooks as well as 6,969 other items (see appendix H). Therefore, demands for the Design Workshop remained heavy throughout its existence as the armed forces found ever-increasing need for its services.[59]

To meet the many requests for decorations and murals in army camps, recreation centers, training schools, and other locations, the Mural Division conducted a series of experiments testing the use of silk screen as a mural medium on panels or cloth. This method permitted the high-quality duplication of mural designs and their allocation to a large number of defense centers. The Mural Division undertook the design of the first official insignia of the Illinois Selective Service, which was later adopted on a national basis. The textile unit of the IACP made the first flag in silk appliqúe and embroidery for presentation to the Selective Service.[60]

The Sculpture Division also participated in the war effort. It produced two sculpture groups in cast stone for the front of the main hospital at Scott Air Force Base and made General Ulysses S. Grant the subject of a sculpture at the entrance gate of Camp Grant at Rockford, Illinois. Also, the Great Lakes Naval Training Station requested wood carvings for the base's auditorium.[61]

The Easel Division was not to be outdone. Over fifteen separate exhibitions of IAP art were organized by the IACP and sent out to defense centers across the country. Local boards of the Illinois Selective Service received exhibits to hang in their facilities. Easel artists were also called upon to use their talents in designing camouflage for everything from uniforms to tanks and aircraft. IAP artist Donald Vogel recalled,

> I was one of a small group to be placed on a project as a camouflager. The group's purpose was to camouflage the oil storage tanks along Chicago's south shoreline. It was entirely a futile effort, and a waste of time. We were assigned drafting desks near the bridge designers at Soldier's Field stadium. It was bitter cold and drafty, and there was no supervision. In the weeks that I was there, no one ever appeared to tell us what to do or where to submit what we did; however, we took the project in hand, discussed the ideas we invented, made drawings, which I believe all ended up in the waste basket.[62]

The Poster Division had a long history of accomplishment in the IAP. As the war effort increased, the Poster Division of the IACP came to the fore in serving national defense needs. As an IAP unit it had been successful because it fostered a common language between artist and public. It was seen by millions of people in streetcars, subways,

railroad stations, art museums, schools, libraries, settlement houses, community art centers, and neighborhoods by means of local merchants who donated window space for its display. The poster was a powerful mode of communication that, at the same time, provided an enjoyable visual experience.[63] "It was intended . . . to attract attention to a public message, and form is significant only in so far as it emphasized the message . . . the FAP, following in the tradition of Toulouse-Lautrec, realized that even the lowly poster, especially if used in a public cause, can achieve a quality of aesthetic expression that . . . rises above the pedestrian."[64]

George Melville Smith and, in 1937, Ralph Graham headed the Poster Division in Chicago. There, the division was divided into two sections: design and, after 1940, silk screen.[65] Smith's division developed slowly during the early stages of the IAP. Workers turned out handmade charts and posters, each person performing his or her assigned duty in assembly-line fashion. But the IAP Poster Division grew, eventually attaining a size larger than New York's.[66] The burgeoning of the IAP's Poster Division worried Holger Cahill. He wrote to Increase Robinson in 1936: "According to the projects which we have in this office, your poster project is nearly twice the size of any of your creative projects. This would seem to indicate that very little creative talent is available on the relief rolls in Illinois, or that your problem of reassignment is a very serious one."[67] Despite Cahill's concern, the Poster Division was not cut in size by any of the IAP directors.

By mid-1935, the Poster Division relied on use of the woodblock and the lithograph because these techniques were "traditionally associated with printing as an art."[68] Later in 1940, the silk screen department was set up so that poster designers could reproduce their work in quantity. The majority of posters in the United States and abroad were produced by offset lithography, which enabled the printing of subtle tones and blends of color, such as those made possible through the use of an airbrush.

Public institutions and agencies throughout Chicago and Illinois took advantage of the opportunity to purchase the IAP's well-designed, inexpensive posters. Sponsors included city, state, and federal health departments; the U.S. Postal Service as well as small-town post offices; the Chicago Park District; state parks; the Department of Conservation; the Department of Agriculture; the Chicago Zoologi-

cal Park; libraries; the Art Institute of Chicago; and various WPA agencies. These posters were disseminated to over sixty-two agencies in Illinois. In addition, the Poster Division produced book jackets, usually for guides to state historical record surveys that were written by members of the Federal Writers Project. In the four years from 1936 through 1939, the Poster Division "printed a total of 601,783 pieces, for an average of 611 finished posters per working day."[69]

Foremost among the various techniques used for the armed services was the silk-screen/decalcomania process, which was a distinct improvement over any other process previously employed and which was used to create identifying insignia for the 108th Quartermaster Division. The U.S. Air Corps Training School requested a series of eighteen thousand diagrammatic charts, each one using from six to eight colors. These charts involved three hundred different designs, with a new screen being cut after eighty copies.[70]

The success of the IACP also became its undoing. When the various armed services realized they had found a willing and competent agency capable of producing the type of materials required, they inundated the IACP with rush orders.[71] In response, Biesel made frequent trips to Rantoul and especially to the Savanna Ordnance where he oversaw the assembling of elaborate tactical dioramas. By January 1942, Frank J. Follmer, WPA District 4 supervisor, tried to stem the flow by appealing to Washington, "I am attempting in every way possible to keep intact that part of the Art and Craft Project personnel, which is essential to present war work. . . . If the Art and Craft Project continues to lose more of its key people, orders from Scott Field cannot be undertaken."[72] On 23 February 1942, Biesel sent a telegram also voicing his concern over the IACP's ability to meet the demands placed upon them. "No murals even if Army and Navy make requests. Want to transfer all personnel to research. We are moving to hundred percent for army and navy work and are now threatened with complete annihilation in Chicago. We have been at the point for several weeks of being very careful with commitments, beyond capacity to deliver."[73]

By March 1942, the entire project was geared to the war effort and was in conjunction with the instructional facilities on Army and Navy bases. The visual arts phase of the War Services Program (WSP), later known as the Graphics Services, in Illinois operated out of a four-story factory and warehouse on 1021–31 S. State Street. All remaining

project personnel received in-service training in the production of visual devices geared to the needs of these instructional facilities.

A conference was held on 22–24 September 1942 in the Department of Commerce Building in Washington to deal specifically with how the state projects could participate effectively in the training of officers for the Army and Navy. Holger Cahill chaired the conference. Walter M. Kiplinger, then director of the WSP, and state supervisors from California, Florida, Illinois, New York, Missouri, and Pennsylvania attended. Kiplinger's opening statements summed up the work and responsibility of the conference participants. "Our major task is to give employment to needy unemployed in useful public work, but right now the most useful public work we can give them is in services that will, first, help win the war, and second, provide training in skills useful to war industries."[74]

The keynote of the conference was to call for coordination of effort. By collaborating with officials in Washington, D.C., and officers of the Army and Navy training programs, most of the problems of production and quality were solved. What had once been an autonomous effort under the state direction of the Art and Craft programs was now an attempt at a unified effort. As a result of the war, state programs lost many outstanding designers and draftsmen, and it became imperative to make the best use of the designers still at work. The conference parceled out certain types of work to state projects that were better suited than others by virtue of their resources to complete projects. Illinois was singled out for its designing of training posters for the Air Corps, Ordnance, and the Great Lakes Naval Training Station.[75]

At the conference Biesel stressed that, while the Illinois program had been very successful to date with its visual aid program, there was one serious problem. By 1942, the Illinois program had lost most of its personnel, so Biesel appealed for permission to hire unskilled labor to fill orders from the Army and Navy programs. Biesel stated that he had forty to fifty skilled craftsmen on the Illinois project, with between 450 and 500 individuals on the project as a whole. The majority of these individuals were over draft age, and this work made them feel as though they were contributing to the war effort and gave them a skill that they might use in the private sector after the war.[76]

On the final day of the conference, specific recommendations were drawn up. Among these were that a set of written priorities be

established within the structure of the WSP; that this document emanate from Washington, D.C.; that an effort be made to emphasize the value in training unskilled and semiskilled personnel; that hiring quotas be liberalized permitting state units to meet the needs of the armed forces; and that an effort be made to establish uniform sponsor costs and methods of handling funds. Illinois was specifically designated to engage in jigsaw work, simple designs on Plexiglas, pattern making, polishing, plastering, cabinetmaking, sanding, wood finishing, spray-gun operating, tracing, and metal working. Illinois was also to build up its personnel levels to seven hundred, making it the largest WSP in the nation.[77] When Biesel returned to Chicago, he was buoyed by the conference and reinvigorated at the prospects for the Arts and Crafts Project.

But the remnants of the old IAP, by contrast, were nearly defunct. In seven months the whole FAP would be terminated. In preparation for its demise, Biesel had much unfinished business to address. Works of art had to be disposed of or delivered to sponsors. Funds had to be spent to clear remaining accounts. Boxes of records were in disarray and would have to be discarded, which troubled Biesel, who had a historical interest in preserving IAP documents. By leaving good administrative and financial records, one could gain an accurate picture of the efforts of the FAP in Illinois. Biesel told an assistant that "there is a lot of crud, but much must be retained."[78] Walley, who served as Biesel's assistant, recalled, "the destruction of a lot of the equipment and the destruction of the records, that was a sin! We were told to destroy these things, and to me this was a wasteful thing."[79]

If the destruction of records was indefensible, the handling of the artwork was even more so.[80] In April 1942, the national Central Allocations Unit, formerly the Central Exhibition Unit, was transferred from Washington, D.C., to Chicago. The unit had assembled thousands of paintings, sculptures, and prints from projects in every state and carried on an active national exhibition schedule. There were usually 250 exhibits on tour at any given time. In collaboration with the Washington office and under Biesel's direction, exhibits were recalled, and the responsibility of permanent allocation to museums, tax-supported institutions, military hospitals, and reservations was given to local authorities. There were too many artworks and too few people to conduct the liquidation in an organized fashion. "Occasionally some Washington personnel were given art for their offices.

The city of Chicago was given art for its offices, and they covered the hallways and everything. I guess a lot of that just simply in time, I think, went home with them. In other words, we didn't keep an inventory of the art."[81] Sponsors were given every opportunity to take as many pieces as they wished. Nicola Ziroli received his pink slip early in 1943, the same day he was in the process of crating a traveling IAP exhibit. When asked for his response, he said that he simply put down his hammer, put on his hat and coat, and walked out.[82]

Canvas liquidation was the most extreme step taken by the FAP. Those pieces not under sponsorship were ordered destroyed to prevent their being exploited. This group usually comprised less-developed examples, though competent works in storage were also destroyed.

> Somehow the people that were supposed to destroy [the paintings] didn't. A fellow showed up in New York, a dealer, and he had stacks of paintings, and some by leading people. He had some by Kuniyoshi and Bohrod and a couple of Weisenborns. It was a scandal, because this guy, a private citizen, was selling WPA work. I didn't think they ever really found out how that happened. Somebody, instead of destroying the work, sold it instead. A lot of sponsors, for any number of reasons, could and did give away an abandoned work which was given them by the project.[83]

There were also stories of artworks being saved for posterity. One such incident occurred over a large quantity of IAP sculpture being stored in a War Service warehouse in downtown Chicago. The warehouse and its contents, well over one hundred examples of plaster, clay, and wooden figures mostly in maquette stage, were scheduled for demolition. Louis Cheskin had been told that the sculpture would have to be bought in lot at a price of two hundred dollars. He scraped together the necessary funds and purchased the pieces. Much of the collection was subsequently donated to major museums across the country. Without this effort, a significant number of IAP sculptures would have been destroyed.[84]

The project was coming to a close. The IAP artists' enthusiasm and commitment that prevailed for so many years had faded as they left the project to join the service or to seek work in the private sector. Those issues that seemed so important to them earlier paled in the face of war. Many of those artists who enlisted were recommended for

full commissions and became officers. Others were ordered to go to the front in combat. George Biddle, in 1943, who was the chairman of the War Department's Art Advisory Board, said, "The U.S. must take the lead and find some way of getting our finest artists and writers the things they alone can give—a deeply, passionately felt, but profoundly reflective interpretation of the spirit and essence of War."[85] By the end of 1942, President Roosevelt knew that the nation could ill afford the WPA. He wrote to General Fleming, "I agree that you should direct the prompt liquidation of the affairs of the Work Projects Administration, thereby conserving a large amount of the funds appropriated to this organization. This will necessitate closing out all project operations in many states by February 1, 1943 and in other states as soon thereafter as feasible."[86] He went on to write, "I am proud of the Work Projects Administration. It has displayed courage and determination in the face of uninformed criticism."[87] On 15 May 1943, after preparing the IAP's incomplete records for microfilming, Fred Biesel wrote Evelyn S. Byron to submit his resignation.[88]

Some artists returned from the war ready to take up where they had left off with a federally sponsored art program. The country to which they returned, however, was not willing to repeat the efforts initiated during the depression years. Cahill, in a letter to Edgar Richardson in 1954, understood the dynamics of those years of the FAP, which gave artists the same sort of public work that laborers and white-collar workers enjoyed. He stated, "The mandate from Congress was not for creating works of art . . . but for the purpose of putting the unemployed to work."[89]

The project offered artists the opportunity to continue making art, to associate with professional artists who were their peers, to acquire disciplined working habits, to manage their production with some business sense, and most importantly, to work without interruption. The excitement of being on the project carried over to the end of each month, when artists submitted their works to the IAP office in Chicago, were subject to critiques, and saw what fellow artists had created. Afterward, they continued their discussions well into the night, at places like Thompson's Restaurant. Some artists got together weekly for all-night card games and potluck dinners.[90] All of these activities helped cement the bond among project artists. Despite the depression, they knew it was a good time in their lives, and at least some knew such a life would not last forever.

Many critics have argued that, from the standpoint of quality, the results of federal art patronage were negligible. But, as Cahill loved to say, "You had to have plateaus before you could develop the peaks."[91] In summary, "History has not been kind to the art of the Depression era . . . , but the artist could feel he was moving within the mainstream of American life, responding to the cataclysmic events of the time."[92] Ultimately, the FAP has remained an important part of our nation's cultural history. It broke down the age-old barriers between the artist community and the public at large, not only in sprawling urban areas but in small towns as well. The project established a concept of art in action. Murals were placed in post offices and in high schools across the country. Artists were put on display doing their work, thereby demystifying the act of painting.[93] The project also inaugurated mass production in art through the more than one hundred community art centers across the country that brought people together for the making and experiencing of art.

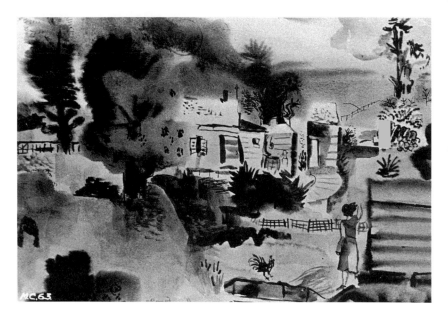

Plate 1. Rainey Bennett, Garden Entrance, *watercolor (The Chicago Public Library, Special Collections Division).*

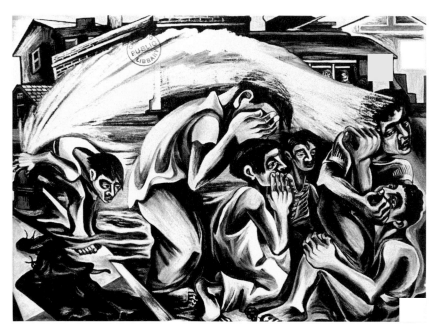

Plate 2. Bernice Berkman, Municipal Bathing, *oil (The Chicago Public Library, Special Collections Division).*

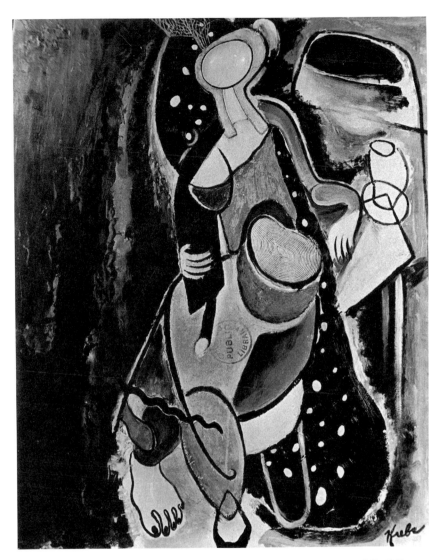

Plate 3. Kenneth Krebs, Madame Bovet, *oil (The Chicago Public Library, Special Collections Division).*

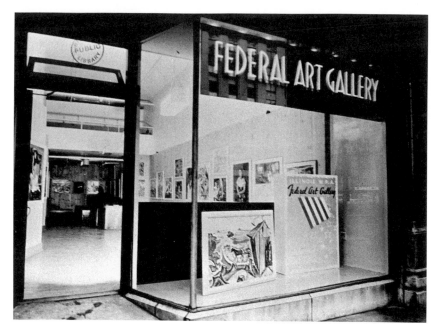

Plate 4. Entrance, Federal Art Gallery, Chicago (The Chicago Public Library, Special Collections Division).

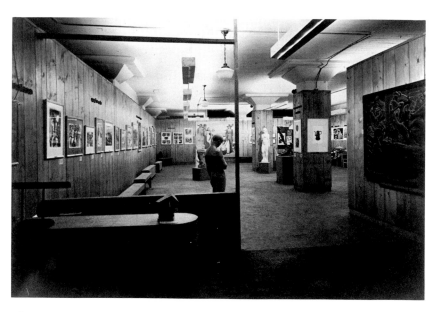

Plate 5. Interior, Federal Art Gallery, Chicago. (University of Illinois at Chicago. The University Library. University Archives. WPA Federal Art Project—Illinois. John Walley Papers.)

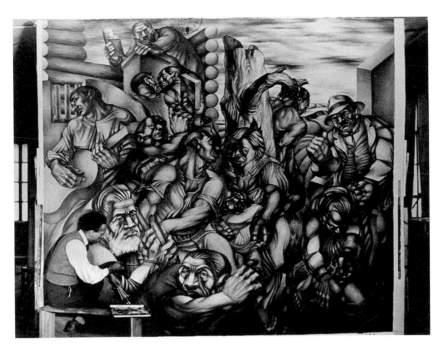

Plate 6. Charles W. White and mural (The Chicago Public Library, Special Collections Division).

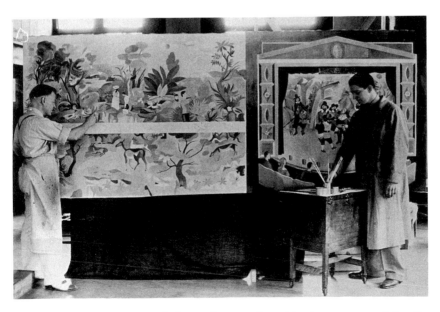

Plate 7. Rainey Bennett, left, and an assistant prepare a mural for the Crippled Boys' Ward of the University of Illinois Medical Center, Chicago (The Chicago Public Library, Special Collections Division).

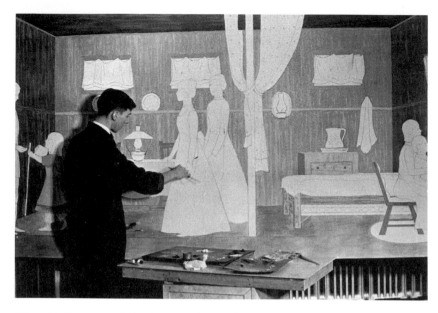

Plate 8. Emmanuel Jacobson and mural, Community Life of Oak Park, *Horace Mann School, Oak Park, Illinois (The Chicago Public Library, Special Collections Division).*

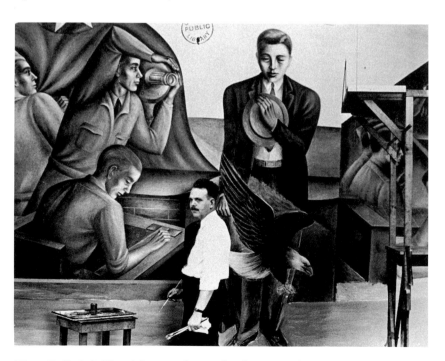

Plate 9. Ralph Henricksen and mural, The Recruit, *Scott Air Force Base, O'Fallon, Illinois (The Chicago Public Library, Special Collections Division).*

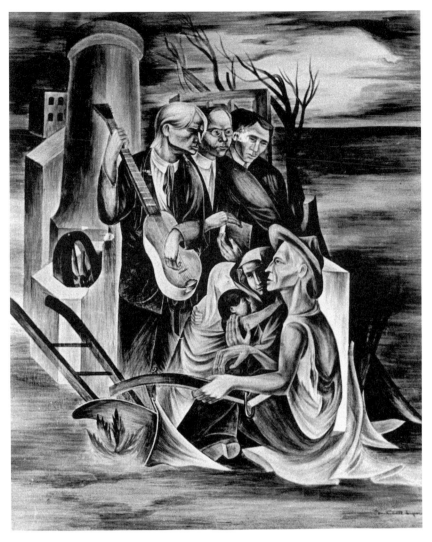

Plate 10. Mitchell Siporin, Prairie Poets, *medium unknown (The Chicago Public Library, Special Collections Division).*

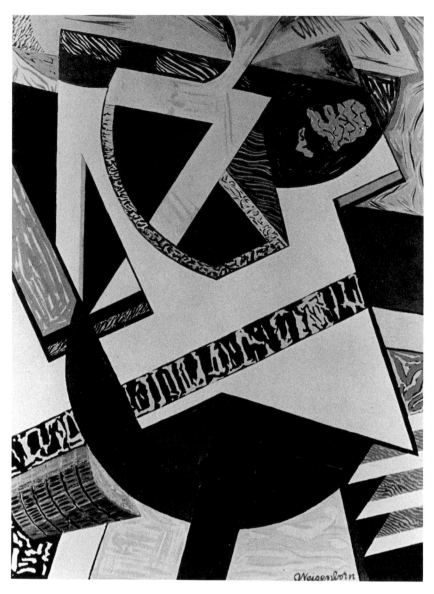

Plate 11. Rudolph Weisenborn, untitled, medium unknown (The Chicago Public Library, Special Collections Division).

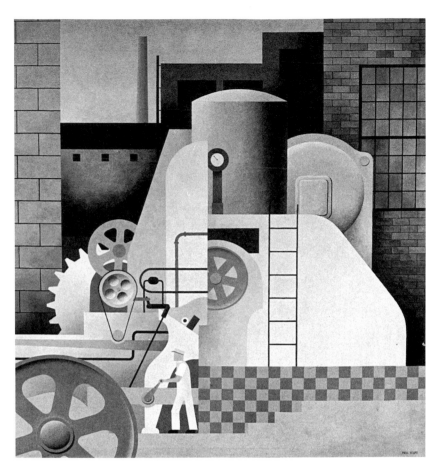

Plate 12. Paul Kelpe, Abstraction #5, *oil (Krannert Art Museum, University of Illinois at Urbana-Champaign).*

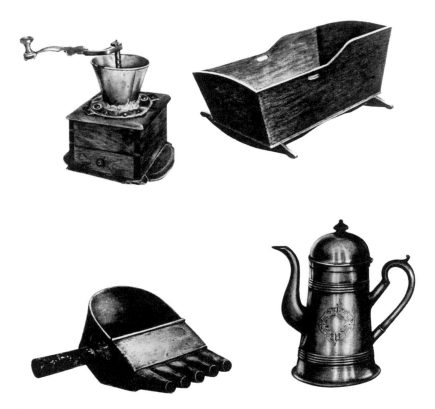

Plate 13. Index of American Design items; top row, left to right: *coffee grinder, cradle;* second row, left to right: *candle mold dipper, pewter coffeepot (National Gallery of Art, Washington, D.C.).*

Plate 14. Brookfield, Illinois, Zoo cafeteria table tops and water fountain relief screen. (University of Illinois at Chicago. The University Library. University Archives. WPA Federal Art Project—Illinois. John Walley Papers.)

Plate 15. Sidney Loeb, center, *working in the Sculpture Division Workshop, Chicago (The Chicago Public Library, Special Collections Division).*

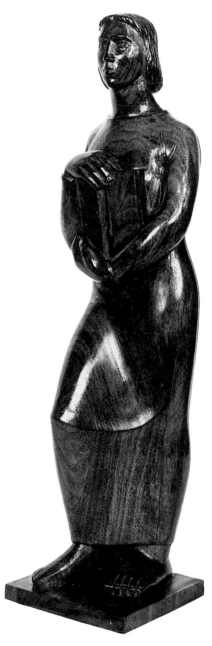

Plate 16. Mario C. Ubaldi, Female Figure with Book, *walnut (from the collection of the University Museum, Southern Illinois University, Carbondale, Illinois).*

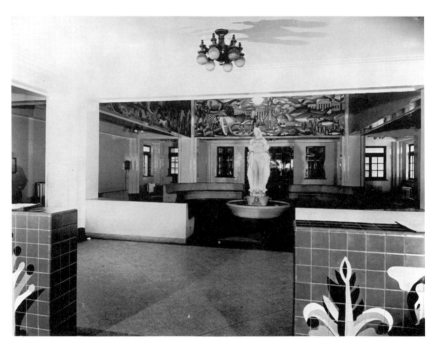

Plate 17. Cook County Hospital, Chicago, lobby; fountain, Protection, *by Charles Umlauf; murals by Edwin Boyd Johnson; ceramics by John Winters (George J. Mavigliano collection).*

Plate 18. Lane Technical High School, Chicago, landscape designed by Kurt Melzer (George J. Mavigliano and Richard A. Lawson collection).

Plate 19. Increase Robinson with sculpture Alice in Wonderland, *by Mary Anderson Clark (newspaper photograph, Fred Biesel Papers, Archives of American Art).*

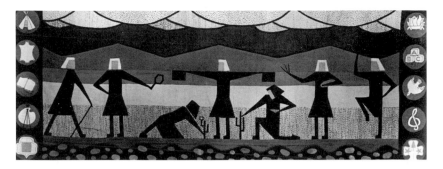

Plate 20. Cloth applique mural for Girl Scout House, Benton City Park, Benton, Illinois. (University of Illinois at Chicago. The University Library. University Archives. Illinois Craft Project—WPA. John Walley Papers.)

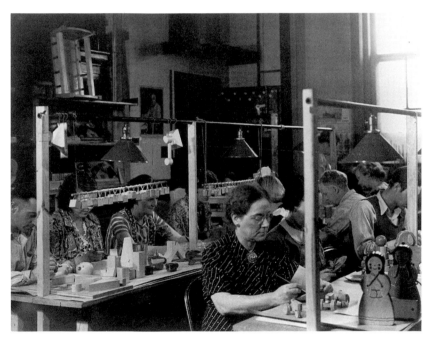

Plate 21. Decatur, Illinois, Toy Manufacturing Craft Shop. (University of Illinois at Chicago. The University Library. University Archives. WPA Federal Art Project—Illinois. John Walley Papers.)

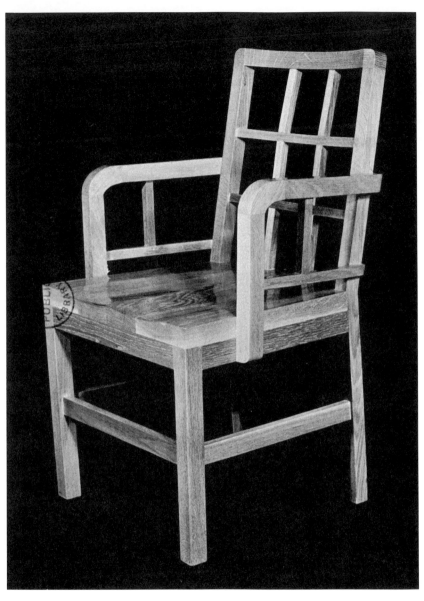

Plate 22. Don Vestal, wood armchair (The Chicago Public Library, Special Collections Division).

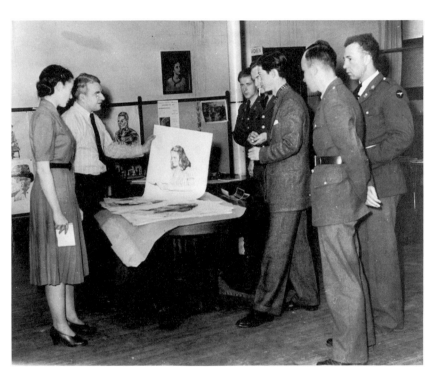

Plate 23. Second from left: *Fred Biesel with military personnel, 1942 (Fred Biesel Papers, Archives of American Art).*

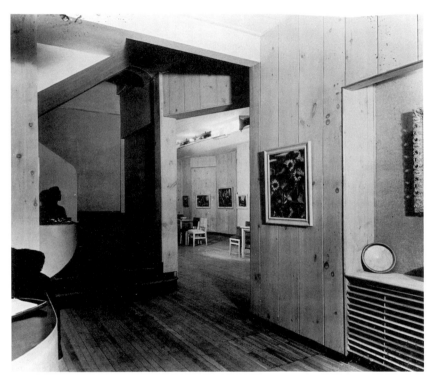

Plate 24. Interior, South Side Art Gallery, Chicago (George J. Mavigliano collection).

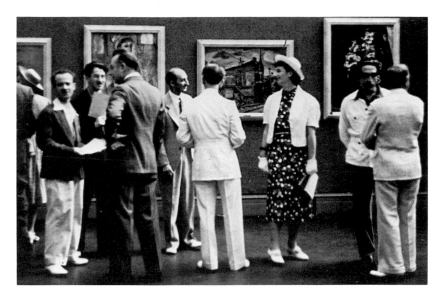

Plate 25. Illinois Art Project reception. First man on left, *Nicola Ziroli, artist;* woman, *Mrs. George Thorp;* second man from right, *Julio De Diego, artist (George J. Mavigliano collection).*

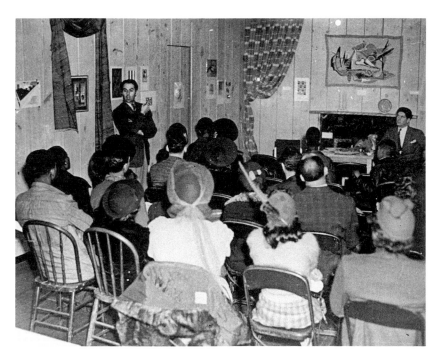

Plate 26. John Walley (standing) *lecturing at a South Side Art Center meeting. Peter Pollack is seated at the upper right (The Chicago Public Library, Special Collections Division).*

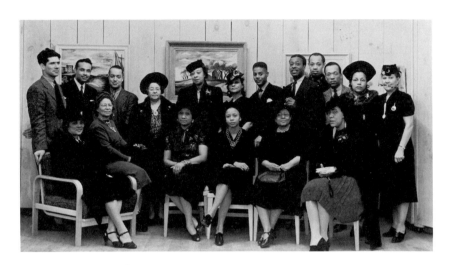

Plate 27. South Side Art Center, Chicago, personnel, c. 1940–1941. Standing, left to right: *Peter Pollack, first director; Vernon Winslow, assistant director; Joseph Kersey, sculptor and teacher; unidentified woman; unidentified woman; Pauline Kegh Reed, second director; Robert Davis (also known as Davis Roberts), poet, journalist, and actor; Henry Avery, artist; George Johnson, artist; Charles White, artist; unidentified woman; Julia Jackson Ferguson, educational and program director.* Seated, left to right: *unidentified woman; unidentified woman; Mrs. Gonzelle Motts, member of the board of directors; Dr. Margaret Goss Burroughs, secretary of the South Side Art Center Association, member of the board of directors, and artist; Pauline Jackson Lawrence, member of the board of directors; unidentified woman (George J. Mavigliano collection).*

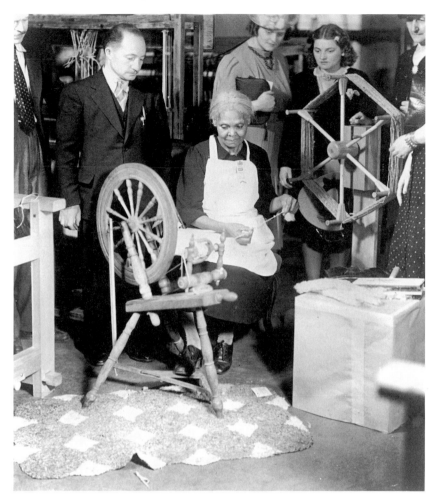

Plate 28. Spinning demonstration. (University of Illinois at Chicago. The University Library. University Archives. WPA Federal Art Project—Illinois. John Walley Papers.)

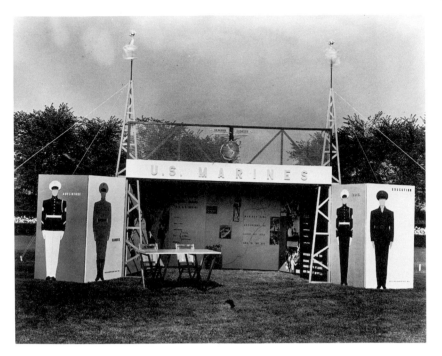

Plate 29. U.S. Marines recruitment booth (George J. Mavigliano collection).

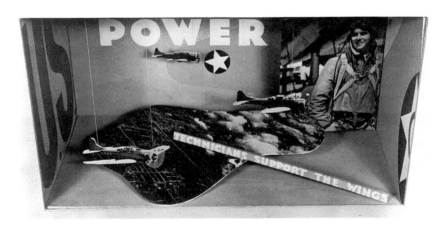

Plate 30. U.S. Air Force recruitment diorama. (University of Illinois at Chicago. The University Library. University Archives. WPA Federal Art Project—Illinois. John Walley papers.)

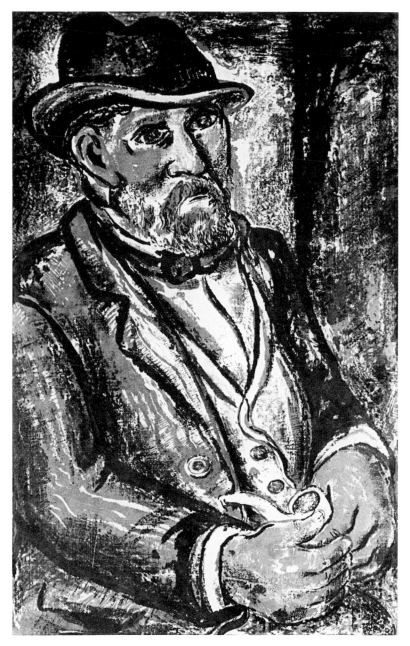

Plate 31. Roffe Beman, Old Man, *color lithograph (Krannert Art Museum, University of Illinois at Urbana-Champaign).*

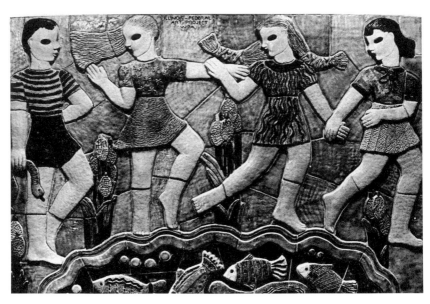

Plate 32. Louise Pain, Girls Chased by Boy with Snake, *decorative ceramic panel (The Chicago Public Library, Special Collections Division).*

11. *Appendixes*

List of Illinois Art Project Artists and Administrators

The following list of IAP artists and administrators has been com-
piled from newspaper articles, correspondence, exhibition catalogs, a
1983 brochure of the Illinois State Historical Society, The Chicago
Historical Society, the Chicago Public Library, PWAP lists, the *Federal
Art Project Production News, Government and the Arts in Thirties America,*
and lists of allocations of art recorded on microfilm in the National
Archives and in the Smithsonian Institution's Archives of American
Art.

To date, 60 percent of the artists appearing in this list have been
confirmed by the National Personnel Records Center. An additional
18 percent of the artists have come from exhibition lists. Many well-
known IAP artists have shown up on these lists but are not recorded in
the Records Center's files. Finally, 22 percent of the listed artists have
come from additional archival sources. Those artists whose identifica-
tion has come from marginal sources, even many of those who are
identified from the Records Center's files, worked for the IAP for very
brief periods, sometimes for even less than one month, for various
reasons: perhaps they were transferred to other WPA jobs, let go for
incompetence, or found employment in the private sector. Therefore,
no records of their employment were available or possibly even
processed or filed. One other group exists. Andrene Kauffman
indicated that a number of self-sufficient artists volunteered their
services to the IAP just to be involved in the program.[1]

Despite the incompleteness of IAP record keeping, the list more
than doubles the number of names appearing in other sources. We
are confident that it comes closest to approximating the total number
of artists enrolled in the IAP.

An article published in the *Chicago Daily News* in 1965 indicated the

scope of the IAP: "There were about 180 painters and 60 sculptors and other specialists. The state enrollment was 770 persons, 710 of them in Chicago."[2] This statement is the only one we have found that provides the totals of IAP personnel, their specialties, and the importance of Chicago as the focal point of the IAP. But it is only an approximation. We encountered difficulty authenticating the home locations of 221 of the artists, but we were able to find that 19 were from outside of Chicago. Those nineteen, plus forty-two others, who were loaned from Chicago or had commissions, could leave 703 in Chicago if all of the unidentified artists were in fact from Chicago only. Furthermore, the *Daily News'* figures for painters is low: we have identified 227 Easel Unit artists, and there are another 91 easel/mural or mural artists on the list as well. So, as the following summaries and the list itself will document, there were greater numbers of artists who moved into other specialties than the article indicated.

This list of artists reflects the wide range of people employed by the IAP. Although we have not identified them in detail, about 5 percent of the list is made up of black artists. In addition, 19 percent of the artists are female. Finally, our list contains several incomplete names and multiple spellings of some names owing to errors appearing on blurred or faint carbons or reproduced microfilms. We have used the National Personnel Records Center's spellings first: any variant spellings follow.

TABLE A-1
Identified Illinois Art Project Artists

	Number	*Percentage*
Exhibition lists	139	17.94
National Personnel Records Center	463	59.74
Other archival sources	173	22.32
Total	775	100.0
Out-of-state artists identified	19	2.4
Out-of-state and loaned Chicago artists or artists on commission	61	7.9

TABLE A-2

Number of Personnel, by Unit

Unit	Number
Administration	24
Design	15
Diorama	2
Easel	227
Easel/Design	1
Easel/Diorama	2
Easel/Graphics	34
Easel/IAD	6
Easel/Mural	49
Easel/Sculpture	8
Graphics	51
Graphics/IAD	1
Graphics/Poster	1
Index of American Design	47
Mural	42
Mural/Graphics	2
Mural/IAD	3
Mural/Sculpture	5
Photography	9
Poster	4
Sculpture	61
Sculpture/Diorama	1
Unknown Unit	180
Total	775

TABLE A-3
IAP List of Artists and Administrators

	Name	Department	Location[a]
*	Abercrombie, Gertrude	Easel	Chicago
*	Aberdeen, Harry G.	Mural/IAD	Chicago/W. Chicago/ Glen Ellyn/Elgin/ Rockford
‡	Abernathy, John R.	——	——
*	Abramson, Conrad	——	Chicago/Wrightwood
*	Adams, Jean Crawford (‖)	Easel	Chicago
*	Adams, Walter Burt	Easel	Chicago/Evanston
‡	Adler, Sam	——	——
*	Albert, Calvin	Easel/Graphics	Chicago
*	Albright, Ivan Le Lorraine	Easel	Chicago
*	Albright, Marvin Marr	Sculpture	Chicago/Marion
†	Algood, F.	——	——
*	Alizier, Andre (Andrew) G.	Easel	E. St. Louis/Chicago
*	Allworthy, Joseph	Easel	Chicago
*	Alt, Lenore	Graphics	Chicago
*	Amato, Guiseppe M.	Graphics	Chicago
*	Anderson, Ada M. C.	Graphics	Chicago
‡	Anderson, Andreas	——	——
*	Anderson, Anne	Graphics	Chicago
‡	Anderson, Axel	——	——
†	Anderson, L. A.	——	——
*	Anderson, Rose	Mural	Chicago
*	Antman, Jack	Easel	Chicago
*	Armin, Emil	Easel	Chicago
‡	Arnason, H. Howard	Administration	Chicago/Minnesota

*IAP status verified by National Personnel Records Center

†No personnel record available, but artist was identified by work(s) from exhibition lists

‡No personnel record available, but verification is by transfer of artist via letters, memoranda, newsletters, etc.

§ Responded to questionnaire

‖ Taped interview

Correspondence

[a]Artist listed by home base first, then by succeeding assignments.

TABLE A-3 — *(Continued)*

	Name	Department	Location[a]
‡	Arnold, Newell Hillis	——	——
*	Arquin, Florence	Easel/Administration	Chicago
*	August, Herbert J.	Easel	Chicago
*	Austen, Carl Frederick	Easel	Chicago
‡	Austin, Charles	——	——
*	Avery, Henry	Easel/Mural	Chicago
†	Avery, Samuel	——	——
*	Babcock, Fayweather B.	Mural	Chicago
*	Badger, Frances S. C.	Mural/Administration	Chicago/Joliet/Oak Park
*	Bagley, Frank	Photography	Chicago
†	Bailey, A.	Easel	——
†	Baldwin, Nixford	Graphics	——
‡	Ball, Charles	Mural	——
*	Balsham, Leah	Graphics	Chicago
†	Bannon, Laura	Easel	——
‡	Bara, Samuel	——	——
‡	Barloga, Viola H.	Easel	——
†	Barnes, Owen	Easel	Chicago
*	Barr, Frank	Design	Chicago
*	Barton, Macenna	Easel	Chicago
*	Bartsch, Fred H.	Mural	Chicago
†	Basil, C.	Easel	——
*	Bates, Dorthee (Dorothea) L.	IAD	Chicago
*	Bauer, Gustave	——	Chicago
‡	Bauf, Gus	——	——
*	Beauly, William J.	Easel	Chicago
‡	Behl, Charles	——	——
†	Beilin, A.	Easel/IAD	——
*	Bein, Lyda Barbara	Sculpture	Chicago
*	Bekker, David	Easel/Graphics	Chicago/Oak Park
*	Belasto, Jules	Sculpture	Chicago
†	Beldner, David	Easel	Chicago
*	Beman, Roffe (Roff)	Easel	Chicago

* IAP status verified by National Personnel Records Center

† No personnel record available, but artist was identified by work(s) from exhibition lists

‡ No personnel record available, but verification is by transfer of artist via letters, memoranda, newsletters, etc.

§ Responded to questionnaire

‖ Taped interview

Correspondence

TABLE A-3 — *(Continued)*

Name	Department	Location[a]
* Bender, Vere W.	Graphics	Chicago
† Beneduce, Antonio	——	Chicago
* Bennett, Rainey (#)	Easel/Mural/ Administration	Chicago/Rushville/ Naperville/U of I Medical Center
* Benson, Tressa (Trecca) Emerson	——	Chicago
* Berdick (Berdich), Vera	Graphics	Chicago
‡ Bergstrom, Charles	——	——
* Berkman, Bernice	Easel/Graphics	Chicago
† Bevier, Milton	IAD	Chicago
* Bianucci (Bienucci) (Soravia), Irene	Mural	Chicago/Mt. Carroll
* Biesel, Charles	Easel	Chicago
* Biesel, Fred	Easel/Administration	Chicago
‡ Biorman, Esther	Graphics	——
‡ Blaukmeyer, Ruth	Mural	——
* Blewett, Wellington	IAD	Chicago
* Bluhme, Oscar	IAD	Chicago
‡ Bock (Buck), Howard	Easel	——
* Bodine, John	IAD	Chicago
‡ Bodzowski, Ludwig	——	——
* Boghouse, Jacques der (Jacquesden)	——	Chicago
* Bohrod, Aaron (#)	Easel/Mural	Chicago/Vandalia Galesburg/Clinton
* Booth, Cameron	——	Chicago
* Bova, Joseph	——	Chicago
† Boyd, ——	——	——
† Bradley, M.	Easel	——
‡ Branobs, Sam	——	——
* Breinin, Raymond	Easel/Mural	Chicago/Garfield Park/Wilmette/ Elgin/Skokie/ Englewood

* IAP status verified by National Personnel Records Center
† No personnel record available, but artist was identified by work(s) from exhibition lists
‡ No personnel record available, but verification is by transfer of artist via letters, memoranda, newsletters, etc.
§ Responded to questionnaire
‖ Taped interview
Correspondence

TABLE A-3 — *(Continued)*

	Name	Department	Location[a]
‡	Bremer, Hester	——	——
*	Brenneman, Otto	——	Chicago
‡	Bringhurst, Walter S.	——	——
*	Britton, Edgar E.	Mural/Sculpture	Chicago/E. Moline/ Decatur/Chicago Heights/Bloom Township/Lane Tech/U of I Medical Center
*	Brod, Fritzi	Easel/Mural	Chicago
‡	Bromberg, George	——	Chicago
†	Brooks, Adele	IAD	Chicago
*	Brown, Clarence S.	Easel	Chicago
*	Brown, Herbert	——	Chicago
‡	Brown, H. Langden	IAD	Chicago
†	Brown, Howard	Graphics	Chicago
*	Brown, James	——	Chicago
†	Brown, J. Hamilton	Photography	Chicago
*	Brown, R. A.	——	Chicago
*	Brunow, William	Sculpture	Chicago
*	Buczak, John	Poster	Chicago/Lane Tech
*	Buechner (Bueckner), Edward	IAD	Chicago
*	Buehr, Mary G. Hess	Easel/Graphics	Chicago
‡	Bultman, Fritz	Design	Chicago/New York
*	Burke, Ralph	State Administrator	Chicago
*	Byron, Evelyn S.	Administration	Chicago
*	Cadell, John	Easel	Chicago
‡	Calkins, Kathleen	IAD Research	Chicago
*	Cameron, Edgar S.	Easel/Mural	Chicago
*	Carlson, Raymond B.	Administration	Chicago/Rockford
*	Carr, George (‖)	Easel	Harrisburg
†	Carson, ——	Easel	Chicago
*	Carter, Edward	Design	Chicago
*	Carter, William	Easel/Graphics	Chicago
‡	Casey, Charles	State Administrator	Chicago/Springfield

* IAP status verified by National Personnel Records Center

† No personnel record available, but artist was identified by work(s) from exhibition lists

‡ No personnel record available, but verification is by transfer of artist via letters, memoranda, newsletters, etc.

§ Responded to questionnaire

‖ Taped interview

Correspondence

TABLE A-3 — *(Continued)*

Name	Department	Location[a]
* Cent, Penny	Easel/Administration	Harrisburg/ Williamson County/Saline County
* Chaissaing, Edward	Sculpture/ Administration	Chicago/Brookfield Zoo/Field Museum/U of I Medical Center/ Evanston
* Chaissaing, Olga	——	Chicago
‡ Chapin, Francis	——	——
* Cheskin, David B.	Easel/Administration	Chicago
‡ Cheskin, Louis (#)	Administration	Chicago
† Chomyk, Michael	IAD	Chicago
* Chudom, Maurice	Design	Chicago
† Chumm, S. F.	Easel	——
‡ Cikovsky, Nicolai	Mural	Chicago/Washington, D.C.
* Claire, June	Easel	Chicago
* Clark, Mary Anderson (#)	Sculpture	Chicago
* Clark, Robert E.	IAD	Elgin/Chicago/Kane County
† Clarke, Ethel	IAD	Chicago
† Clay, H.	Easel	Chicago
* Clinton, John	Easel	Chicago
* Coan, Francis F.	Easel	Chicago
* Cocomise, Saine (Sam)	Easel	Chicago
* Coen, Eleanor (§) (Mrs. Max Kahn)	Easel/Graphics	Chicago
* Colwell, Elizabeth H.	Easel	Chicago
* Conzelmann, Henry	Sculpture	Chicago
* Copeland, Charles	Easel	Chicago
† Copeland, Leon	Easel	——
* Corazzo, Alex	Easel	Chicago
* Corson, Cliffa	Easel	Chicago

* IAP status verified by National Personnel Records Center

† No personnel record available, but artist was identified by work(s) from exhibition lists

‡ No personnel record available, but verification is by transfer of artist via letters, memoranda, newsletters, etc.

§ Responded to questionnaire

‖ Taped interview

Correspondence

TABLE A-3 — *(Continued)*

	Name	Department	Location[a]
*	Cortor, Eldzier	Easel	Chicago
*	Courtright, John	Easel/Mural	Chicago
*	Craig, Maude (Maudie)	Easel	Marion/Chicago/ Herrin
‡	Crawiec, Walter	——	——
*	Crissey, John C.	——/Administration	Chicago
*	Cross, Adelyen	Graphics/ Administration	Chicago
†	Curevio, V.	Easel	——
*	D'Agostino, Vincent	——	Chicago
‡	Dahlberg, ——	Photography	Chicago
*	Dalstrom, Gustafo	Mural/ Administration	Chicago/DeKalb/ Gillespie/Herrin/ Wilmette/Manteo/ Highland Park/ Green Bay Road School
‡	Dash, Joseph Eugene	——	——
*	Davis, Charles V.	Easel	Chicago
‡	Davis, Fay E.	——	——
†	Davis, J.	Easel	Chicago
‡	Davis, Lewis	——	——
*	Davis, Vachel	Easel	Eldorado/Saline County/Williamson County/Herrin
†	Davis, Wyatt	Photography	——
‡	Dawson, Charles C.	——	——
*	DeDiego, Julio	Easel	Chicago
*	Dejez, Aron	Easel	Chicago
*	Delson, Robert	Easel/Sculpture	Chicago
‡	De Rivera, Jose	Sculpture	Chicago/New York
‡	Deuker, Frederick	Sculpture	——
‡	Deutsch, Boris	——	——
‡	DeWolfe, Walter	——	——
*	Dillard, Perthany	Easel	Chicago
*	Donaldson, Elsie	Easel	Chicago
*	Doty, Anna (Ann) G.	Graphics	——

* IAP status verified by National Personnel Records Center

† No personnel record available, but artist was identified by work(s) from exhibition lists

‡ No personnel record available, but verification is by transfer of artist via letters, memoranda, newsletters, etc.

§ Responded to questionnaire

‖ Taped interview

Correspondence

TABLE A-3 — *(Continued)*

	Name	Department	Location[a]
†	Douglas, Aaron	Easel	——
†	Dovey, I.	Easel	——
*	Drennan, Stanford Hubert	Easel	Chicago/Springfield
*	Drews, Curt J. H.	Sculpture	Chicago/Carlyle/ Evanston
‡	Dunham, Robert	State Administrator	Chicago
*	Durzynski, Florian A.	Mural	Chicago
*	Dusek, Joseph	Graphics/ Administration	Chicago
*	Dyer, Briggs	Easel	Chicago/Rockford
*	Eberley, August	Mural/Sculpture	Elgin/Chicago
*	Eldred, Thomas	Administrative Foreman	Chicago
*	Ellison, Walter	Easel	Chicago
*	Elvis, Roberta	Mural/IAD	Chicago
*	Erickson, Sverd	Sculpture	Chicago
*	Erker, John	Sculpture	Chicago/Field Museum
‡	Eskridge, Robert Lee	Easel	——
‡	Evertsen (Eventsen), K.	Design	——
†	Ewing, Edgar	Easel	——
*	Fabian, John Sznalik (§)	Easel	Chicago
†	Fall, Thomas	Easel	——
*	Fantl (Fanth), Elmer	Sculpture/Diorama	Chicago
*	Faulkner, Paul W.	Mural	Chicago
*	Feder, Eudice	Easel	Chicago
*	Feibel, William	Easel	Chicago
*	Fellermeier, Rudolph	Graphics	Chicago
*	Fenelle, Stanford	——	Chicago
†	Fenyes, N.	——	——
*	Fernham, Grace	Photography	Chicago
‡	Fink, Lucille (Mrs. Frank Follmer)	Administration	East St. Louis

* IAP status verified by National Personnel Records Center

† No personnel record available, but artist was identified by work(s) from exhibition lists

‡ No personnel record available, but verification is by transfer of artist via letters, memoranda, newsletters, etc.

§ Responded to questionnaire

‖ Taped interview

Correspondence

TABLE A-3 — *(Continued)*

Name	Department	Location[a]
† Finley, William	IAD	Chicago
* Fisch (Fish), Pauline	Easel/IAD	Chicago
* Fogg, Adelaide	Easel	Chicago
‡ Follmer, Frank	Administration	East St. Louis
* Foreman, Frederick	Easel	Chicago
* Fossum, Sydney G.	——	Chicago
* Foster, Harter	——	Chicago
* Foster, Thomas	——	Chicago
* Foy, Frances (Mrs. Gustafo Dalstrom)	Easel/Mural	Chicago
† Frankenberg, B.	Easel	——
* Franz, Rudolph	Sculpture	Chicago
* Freeman, Charles S.	Mural	Chicago
* Freeman, Frank J.	Design/ Administration	Chicago
* Freund, Burton	Sculpture	Chicago/Brookfield Zoo
† Fromen, Agnes Wolborgo	Sculpture	Chicago
* Fry, Rowena	Easel	Chicago
‡ Fubel, William	——	——
‡ Funtel, Elmer	Sculpture	——
‡ Fursman, Lucille	——	——
* Futterknecht (Fullerknecht), John	——	Chicago
‡ Fyfe, William B.	Design	——
* Gabriel, Raymon C.	Easel	Chicago
* Galic, George	Graphics	Chicago
‡ Ganiere, George	Sculpture	——
* Garland, Leon	Easel	Chicago
* Garrison, Eve	Easel	Chicago
* Garrity, John A.	Easel	Chicago
‡ Gaspar, Miklos	Easel	——
* Gasslander, Karl	Easel	Chicago

* IAP status verified by National Personnel Records Center
† No personnel record available, but artist was identified by work(s) from exhibition lists
‡ No personnel record available, but verification is by transfer of artist via letters, memoranda, newsletters, etc.
§ Responded to questionnaire
‖ Taped interview
Correspondence

TABLE A-3 — *(Continued)*

	Name	Department	Location[a]
*	Gavencky (Gavecky), Frank	Easel	Chicago
*	Gelb, Lionel	Easel	Chicago
*	Geller, Todros	Mural/Graphics	Chicago
‡	Gibbs, Maurine Montgomery	——	——
‡	Gibson, Elizabeth	——	——
*	Gierman, Emily	IAD	Chicago
*	Gilbertson, Boris	Sculpture	Chicago
*	Gilbertson, Warren A.	Sculpture	Chicago
*	Gilcrest, Louis H.	——	Chicago
†	Ginno, Elizabeth	Graphics	——
*	Glaman, Eugenie	——	Chicago
‡	Goff, Suddeth	——	——
‡	Goldschlager, Belle	Easel/Mural	——
*	Goodrie, Mildred	——	Chicago
*	Goodspeed, Albert	Graphics	Chicago
*	Gordon, Irean (Irene) E.	Easel	Chicago
*	Gordon, Mary	——	Chicago
*	Gordon, Simon	Mural	Chicago
*	Goss, Bernard (‖)	Easel	Chicago
*	Graham, Ralph	Easel/Sculpture/ Poster/ Administration	Chicago/U of I Medical Center
*	Granger, Kathleen B.	Easel	Chicago
*	Gray, Fred G.	Graphics	Chicago
†	Green, A.	Easel	——
‡	Green, Denice	Easel	Chicago
*	Green, Russell D.	Easel/Graphics	Chicago
†	Greenberg, Samuel	Easel	Chicago
*	Gregg, Arlington	Graphics/IAD	Chicago
*	Griffen (Griffin), Davenport	Mural	Chicago
*	Grimmer, Vernon	Easel	Chicago
*	Grinbarg, Sophie	Easel/Photography	Chicago

* IAP status verified by National Personnel Records Center

† No personnel record available, but artist was identified by work(s) from exhibition lists

‡ No personnel record available, but verification is by transfer of artist via letters, memoranda, newsletters, etc.

§ Responded to questionnaire

‖ Taped interview

Correspondence

TABLE A-3 — *(Continued)*

	Name	Department	Location[a]
*	Grossen, Harry	IAD	Chicago
‡	Groth, John	——	——
*	Grover, Jeanne	Easel/Graphics	Chicago
*	Grumieaux, Emil J.	Easel	Chicago
*	Grumieaux, Louis P. H.	Easel	Chicago/U of I Medical Center
*	Gualtieri, Joseph	Easel/Graphics	Chicago
*	Guge, Roger J.	——	Elgin/Chicago
*	Gustafson, Julia	Easel	Chicago
*	Gutheim, Mary P. (Mrs.)	IAD/Administration	Chicago
*	Hackett, Malcolm E.	Easel/Mural	Chicago
†	Hackney, Malcolm	IAD	Chicago
‡	Haeberlin, Carolyn	Easel	Chicago
*	Haig, Charles F.	——	Chicago
*	Hake, Otto E.	Easel/Mural/IAD	Chicago/Champaign/ Evanston/Rock Island/Wheaton
†	Haley, John	Graphics	——
*	Hall, Lillian	Easel	Chicago
*	Hall, Thomas	Easel/Administration	Chicago
*	Hallsthammer, Carl	Mural/Sculpture	Chicago/U of I Medical Center
†	Halstrom, I.	——	Chicago
*	Hannell, V. M. S.	Easel/Sculpture	Chicago
*	Hansen, Askar J. W.	——	Chicago
*	Hanson, Oskar	——	Chicago
*	Harding, Laura	——	Chicago
*	Harrington, Nathaniel	——	Chicago
*	Hartrath, Lucie	Easel	Chicago
†	Hauge, Carl	Easel/Graphics	Chicago
*	Hauge, Mary Chambers	Easel	Chicago
*	Havens, Leonard	Graphics	Chicago
‡	Hawkinson, Frances Amie	——	——

*IAP status verified by National Personnel Records Center

†No personnel record available, but artist was identified by work(s) from exhibition lists

‡No personnel record available, but verification is by transfer of artist via letters, memoranda, newsletters, etc.

§Responded to questionnaire

‖Taped interview

#Correspondence

TABLE A-3 — *(Continued)*

	Name	Department	Location[a]
*	Hawthorne, Virgene	Mural	Chicago
‡	Haydon, Harold (‖)	——	——
*	Hazlett, Lawrence	——	Chicago
*	Hechter, Charles	Easel/Graphics	Chicago
†	Heidrick (Heldrick), Madeline	Easel/Mural	Chicago
*	Henricksen, Ralph (Rolf)	Easel/Mural	Chicago/Lake Forest/Scott Field/Staunton/ Oak Park
†	Hermant, Leon	Sculpture	——
†	Hibbard, Frederick Cleveland	Sculpture	Chicago/ Bloomington
†	Hiler (Hiller), Hilaire	Graphics	——
*	Himmel, Kalman	Easel	Chicago
*	Hoeckner, Carl	Graphics/ Administration	Chicago
†	Hoessne, Julius	Easel	——
†	Hoffman, A.	Mural	——
‡	Hoffman, Frank	Mural/Sculpture/ Design	——
*	Hohenberg, Margarite	Easel	Chicago
*	Holcomb, Dale	Easel	Chicago
*	Hollingsworth, Fred	Easel	Chicago
‡	Holloway (Halloway), Charles	——	——
†	Hoover, Mary	Easel	——
†	Hopkins, Willard A.	Graphics	——
‡	Horwitz, Vera	——	——
*	Houle, Elroy C.	Easel	Chicago
*	Hoyer, T. A. (E.) (Thorvald Arnst [Ernst])	Easel	Chicago
‡	Hubbard, Willis	——	——
†	Huber, K. (Y.)	Easel	——
*	Hunter, David	Sculpture	Chicago
†	Hunter, Lillian	IAD	Chicago

* IAP status verified by National Personnel Records Center

† No personnel record available, but artist was identified by work(s) from exhibition lists

‡ No personnel record available, but verification is by transfer of artist via letters, memoranda, newsletters, etc.

§ Responded to questionnaire

‖ Taped interview

Correspondence

TABLE A-3 — *(Continued)*

	Name	Department	Location[a]
*	Ibling, Miriam	——	Chicago
†	Irving, ——	Easel	——
†	Ivanoff, F.	Easel	——
*	Jackman, Reva	Easel/Mural/IAD	Chicago/Bushnell/ Attica
†	Jackson, Pat	Graphics	——
†	Jackson, Ruth	Easel	——
†	Jacob(s), Richard	Easel	——
*	Jacobs, William	Easel/Graphics	Chicago
†	Jacobson, B. Jacque	Photography	——
*	Jacobson, Emmanuel	Easel/Mural/IAD	Chicago/U of I School of Pharmacy/Elgin/ Oak Park
‡	Jacques, Loutfi	——	——
‡	Jahonda (Jahoda), Henry	——	——
*	Jelinek, Thomas	——	Chicago
*	Jewell, Austin K.	Mural	Chicago
*	Joansson, Ruth	Easel	Chicago
*	Johnson, Avery F. (#)	Easel	Chicago
*	Johnson, Edwin Boyd	Easel/Mural/ Administration	Chicago/Cook County Hospital/ Dickson, TN/East Aurora/Flossmore/ Melrose Park/ Sioux Falls, SD/ Tuscola/U of I Colleges of Fine Arts and Medicine/ Alaska
*	Johnson, George	Graphics	Chicago
*	Johnson, J. Theodore	Mural	Chicago/Morgan Park/Oak Park Garden City, NY

* IAP status verified by National Personnel Records Center
† No personnel record available, but artist was identified by work(s) from exhibition lists
‡ No personnel record available, but verification is by transfer of artist via letters, memoranda, newsletters, etc.
§ Responded to questionnaire
‖ Taped interview
Correspondence

TABLE A-3 — *(Continued)*

	Name	Department	Location[a]
*	Johnson, Lowell	Easel	Chicago
†	Johnson, Ruth	Easel	——
†	Johnson, Sargent	Graphics	——
*	Johnstone (Johnson), Ralph E.	Easel/Sculpture/ Administration	Chicago
‡	Jones, Basil	——	——
‡	Jones, Beauford	——	——
*	Jones, Robert	Mural	Peoria
†	Josimovich, George (§,#)	Easel/Graphics	——
*	Josset (Joset), Raoul	Sculpture	Chicago
*	Julius, Ivar	IAD	Chicago
*	Kaar, Virginia	Graphics	Chicago
*	Kadubec, George	——	Chicago
*	Kaganove, Joshua	Easel	Chicago
*	Kahler, Carl	Easel/Graphics	Chicago
†	Kahn, Harris	Easel	——
*	Kahn, Max (§)	Easel/Graphics	Chicago
*	Kaissaroff, Nicholas	Mural	Evanston
*	Kann, Cecil	Graphics	Chicago
*	Kann, Henry	Design	Chicago
*	Katz, Alexander (Sandor) Raymond	Easel/Mural/ Graphics/Design	Chicago
†	Katz, Hyman	Easel	——
*	Kauffman (Kaufman), Camille Andrene (§,#)	Easel/Mural	Chicago/Evanston/ Oak Park
*	Keeler, George	——	Chicago
*	Keeney, Anna	Sculpture	Chicago/Illinois State Hospital
‡	Kellman, Benjamin	Easel	Chicago
*	Kellner, Charles	——	Chicago
*	Kelpe, Karl	Mural	Chicago/Carthage/ Champaign/Oak Park/Carbondale
*	Kelpe, Paul (§)	Easel	Chicago

* IAP status verified by National Personnel Records Center

† No personnel record available, but artist was identified by work(s) from exhibition lists

‡ No personnel record available, but verification is by transfer of artist via letters, memoranda, newsletters, etc.

§ Responded to questionnaire

‖ Taped interview

Correspondence

TABLE A-3 — *(Continued)*

	Name	Department	Location[a]
*	Kempf (Kampf), F. P. Tud	Sculpture	Chicago
†	Kern, Cecil	Graphics	——
*	Kersey, Joseph A.	Easel	Chicago
*	Kibbee (Kibbie), Edward B.	Easel/Mural/IAD	Chicago/Oak Park
*	King, George	Easel/Mural	Chicago
*	Kirby, Oak Abner	Easel/IAD	Chicago
*	Kirchner (Kirschner), George	IAD	Chicago
‡	Kirkland, Wallace	——	——
*	Kirst, Richard	Sculpture	Chicago
‡	Klan, H. W.	——	——
*	Koch, Mary Williams	Sculpture	Chicago
*	Koehl, John	IAD	Chicago
*	Koehn, Alfred C.	IAD	Chicago
†	Kohn, Misch	Graphics	——
†	Kooning, M. (N.)	Easel	——
*	Koppe, Richard	Easel	Chicago
‡	Korbel, Mario J.	Sculpture	——
*	Kozman, Myron	Easel/Graphics	Chicago
*	Krafft, Carl R.	Easel	Chicago
*	Krause, William	——	Chicago
*	Krebs, Kenneth	Easel	Chicago
†	Krebs, L.	Easel	Chicago
*	Kreger (Kreyer), Paul R.	——	Chicago
†	Kroll, Alfred	IAD	Chicago
†	Kroll, Eleanor	IAD	Chicago
*	Kropp (Kroff), William A., Jr.	Mural/IAD/ Administration	Elgin/Chicago
*	Krueger, Joe	Easel	Chicago
*	Kufrin, Paul K.	Sculpture	Chicago
*	Kula, Elsa	Design	Chicago
‡	Kwiatt, ——	Photography	Chicago
*	Ladyard, Earl	Mural	Chicago/ Shawneetown

* IAP status verified by National Personnel Records Center

† No personnel record available, but artist was identified by work(s) from exhibition lists

‡ No personnel record available, but verification is by transfer of artist via letters, memoranda, newsletters, etc.

§ Responded to questionnaire

‖ Taped interview

Correspondence

TABLE A-3 — (Continued)

	Name	Department	Location[a]
*	Lambert, Gerald	Administration	Chicago
‡	LaMore, Chet	——	——
*	Lange, John	Mural	——
*	Larsen, Ernest	Easel	Chicago
*	Lasker, Aaron	——	Chicago
*	Lawson, Bert	——	——
‡	Lawson, Clarence	——	——
*	League, Thomas Jefferson	Easel/Mural	Chicago
‡	Lenin, George	Sculpture	——
‡	Lenore, A. L.	——	——
*	Lenzi, Alfred	Sculpture	Chicago/Evanston
*	Lerner, Nathan	Design	Chicago
*	Lesh, Lawrence	——	Chicago
*	Levy, Beatrice S.	Easel/Administration	Chicago
‡	Lewandowski, Edmund D.	Mural	Minnesota/ Wisconsin/Chicago
‡	Lewandowski, John	——	——
‡	Lewis, Roscoe	——	——
*	Lidov, Arthur	Easel	Chicago
†	Linck, Louis A.	Sculpture	——
*	Lindeman, Oliver	Sculpture	Chicago
‡	Lindin, Carl Olaf Erik	Easel	——
*	Loeb, Dorothy	Easel	Chicago
*	Loeb, Sidney	Sculpture	Chicago
‡	Long, Charles	Poster	Chicago
†	Long, Fannie Louella	Easel/IAD	Chicago
†	Lonnie, M.	Easel	——
†	Loper, Edward	Easel	——
‡	Lopez, Carlos	——	——
‡	Lozowick, Louis	——	——
†	Lrnip, Emil	Graphics	——
†	Ludwig, William	IAD	Chicago
‡	Luetgeus, Herman	Easel	Chicago
*	Lukosh, June	Easel	Chicago
‡	Lundquist, Einar	——	——

* IAP status verified by National Personnel Records Center

† No personnel record available, but artist was identified by work(s) from exhibition lists

‡ No personnel record available, but verification is by transfer of artist via letters, memoranda, newsletters, etc.

§ Responded to questionnaire

‖ Taped interview

Correspondence

TABLE A-3 — *(Continued)*

	Name	Department	Location[a]
*	Lush (Lusk), George	Easel	Chicago
*	Lyons, Earl	——	Chicago
‡	MacGowan, Clara	Easel	——
*	MacLeish, Norman	Easel/Mural	Chicago
*	Maguire, Marjorie	Easel/Mural	Chicago
‡	Majus, Stanley	——	——
‡	Malcher, Lucretia	——	——
†	Maller (Markovitz), Martin	Easel	——
*	Manoir, Irving Kraut	Easel	Chicago
*	Marchak, Willie	Mural	Chicago
*	Marcus, Nathan	Easel/Graphics	Chicago/U of I College of Medicine
*	Maresso, Joe	——	Chicago
‡	Martin, David	Mural/Administration	Elgin
‡	Martin, Joe	——	——
‡	Martin, Marvin	——	——
*	Marzolf, Les	Easel/Administration	Chicago
*	Masek, James	——	Chicago
‡	Massen, Don	Graphics	——
*	Masteller, John	Easel	Chicago
*	Matsuk, Paul	——	Chicago
†	Mattei, Tony	Easel	Chicago/Alaska
‡	Mazer, Sonia	——	——
*	Mazur, Stanley	IAD	Chicago
‡	McBirney, James	——	——
*	McClendon, Paulis	Easel	Harrisburg/Saline County
†	McClick, G.	Easel	——
*	McCombs (McComb), Orrie	IAD	Chicago
†	McCord, E.	Easel	——
*	McCosh, David John	Easel	Chicago
†	McEahn, S. (B.)	Graphics	——
†	McEntee, Frank	IAD	Chicago
‡	McGowan, Martha	Design	——

* IAP status verified by National Personnel Records Center
† No personnel record available, but artist was identified by work(s) from exhibition lists
‡ No personnel record available, but verification is by transfer of artist via letters, memoranda, newsletters, etc.
§ Responded to questionnaire
‖ Taped interview
Correspondence

TABLE A-3 — *(Continued)*

	Name	Department	Location[a]
*	McGrory (McGrony), William	Sculpture	Chicago
‡	McKeague, Robert I (∥,#)	Administration	Chicago
*	McKee, Richard	Mural	Chicago/U of I Medical Unit
‡	McKinnie, Miriam (Hofmeier)	Mural	Chicago
‡	Meiere, Hildreth	Sculpture	——
*	Melzer, Hildegarde Crosby (∥,#)	IAD/Administration	Chicago
*	Melzer, Kurt (∥)	IAD	Chicago
*	Messner, Fred	Mural	Chicago
*	Michalov, Anne	Easel/Mural/ Graphics	Chicago
†	Miller, Edgar	Sculpture	Chicago
*	Miller, Frederick	——	Chicago
*	Millman, Edward	Easel/Mural/ Administration	Chicago/Decatur/ Moline/St. Louis Post Office/Oak Park
‡	Miner, Charles	State Administrator	Chicago/Springfield
*	Mintz, Harry (§,#)	Easel	Chicago
*	Moir, Robert	Graphics	Chicago
*	Montgomery, William	——	Chicago
*	Moodie, Rossie	——	Chicago
‡	Moon, Mary Gillette	State Administrator	Chicago
*	Moore, Lonnie	Easel	Chicago
*	Morgan, Juliana	Sculpture	Chicago
*	Motley, Archibald John, Jr.	Easel/Mural	Chicago/Evansville/ Evanston/Wood River
‡	Mount, Cati	Easel/Mural	——
†	Mueller, Henry	Easel/Mural	——
*	Muenzenmier, Richard	Sculpture	Chicago

* IAP status verified by National Personnel Records Center

† No personnel record available, but artist was identified by work(s) from exhibition lists

‡ No personnel record available, but verification is by transfer of artist via letters, memoranda, newsletters, etc.

§ Responded to questionnaire

∥ Taped interview

Correspondence

TABLE A-3 — (*Continued*)

	Name	Department	Location[a]
*	Murray, Hester Miller	Easel/Mural/Poster	Chicago/Oak Park/ Cook County Hospital
‡	Myers, Joseph	Easel	Chicago
*	Navigato, Rocco Dante	IAD/Administration	Chicago
*	Neal, Frank	Easel	Chicago
‡	Neal, George E.	Easel	——
†	Nealffer, R.	Easel	——
*	Nederkorn, Lem	Art and Craft/ Administration	Chicago
*	Nesbitt, Robert	Photography	Chicago/ Murphysboro
‡	Nichols, Dale	Easel/Mural	Chicago/Mount Morris
*	Nichols, John Fountain	Easel	Chicago
*	Noecker, James	Easel	Chicago
*	Noel, Helen	——	Chicago
*	Noerdinger (Neardinger), John J.	Easel	Chicago
‡	Nordfeldt, Bror Julius Olsson	Easel/Mural/ Graphics	Chicago
*	Oatway, Margaret	Graphics	Chicago
*	O'Brien, Catherine	Mural	Chicago
†	Opstad, Adolph	IAD	Chicago
†	Orana, Russell	Easel	Chicago
*	Orloff, Gregory	Mural	Chicago
†	Osbold, John	IAD	Chicago
*	Osborn, Erel	Easel/Graphics	Chicago
‡	Osborne, Addis	Easel/Mural	——
*	Osver, Arthur (§,‖)	Easel	Chicago
*	Ott, Peterpaul	Sculpture/ Administration	Chicago/Lane Tech/ Plano/Oak Park
‡	Overholt, Claire	Graphics	——
†	Owen, Merry	IAD	Chicago

* IAP status verified by National Personnel Records Center
† No personnel record available, but artist was identified by work(s) from exhibition lists
‡ No personnel record available, but verification is by transfer of artist via letters, memoranda, newsletters, etc.
§ Responded to questionnaire
‖ Taped interview
Correspondence

TABLE A-3 — (Continued)

	Name	Department	Location[a]
*	Pain, Louise Carolyn	Sculpture/ Administration	Chicago/Evanston/ Carbondale
*	Palumbo, Othello Dan	Easel/Graphics	Chicago
*	Pearson, Albert R.	Easel	Chicago
‡	Pendergast (Prendergast), James	——	——
*	Perdikes (Perdikos), Nina	Easel	Chicago
‡	Perkins, Marion Marche	Sculpture	Chicago
*	Perri, Frank S.	Easel/Graphics	Chicago
*	Peterson, Mary C.	Easel	Chicago
†	Pettzman, Jacob	IAD	Chicago
‡	Pike, William	——	——
*	Pittman, Ralph	Diorama	——
‡	Pleshner, ——	Photography	Chicago
‡	Pollack, Peter	Administration	Chicago
*	Pollock, Merlin F. (§,#)	Mural/ Administration	Chicago/Manitowoc/ O'Fallon/Alaska/ Arkansas
*	Porth, Lawrence	IAD	Chicago
†	Posen, Tunis	Easel	——
*	Pougalis, Constantine	Easel	Chicago
*	Power, Ralph	Easel/Diorama/Art and Craft/ Administration	Chicago
*	Prashun, John G. (Svaton)	Sculpture	Chicago
†	Pratt, John	Easel	——
*	Press, Angela	Design/Poster	Chicago
‡	Pritkin, Samuel	——	——
*	Purser, Stewart R. (§)	Mural	Chicago
‡	Putnam (Putman), Louis	——	——
*	Putz, Joseph	——	Chicago

* IAP status verified by National Personnel Records Center

† No personnel record available, but artist was identified by work(s) from exhibition lists

‡ No personnel record available, but verification is by transfer of artist via letters, memoranda, newsletters, etc.

§ Responded to questionnaire

‖ Taped interview

Correspondence

TABLE A-3 — *(Continued)*

	Name	Department	Location[a]
†	Quinn, Vincent	Easel	——
†	Rabin, Sam	Easel	——
†	Rabino, Saul	Graphics	——
†	Radice, Canio, Jr.	Easel/Graphics	——
‡	Radville, Ann	——	——
‡	Ransom, Fletcher	——	——
‡	Ravlin, Grace	——	——
†	Redlick (Redlich), George	Easel/Graphics	——
*	Reesman, Howard	Easel/Mural	Chicago
*	Reichmann, Frank	Graphics	Chicago
†	Reichmann, Josephine L.	Easel	Chicago
†	Reiner, Louis	Easel/Graphics	Chicago
‡	Reitzel, Marques	——	——
†	Rekucki, Michael	Easel/IAD	Chicago
†	Remahl, Frederick	Easel	Chicago
‡	Reynolds, Art	Easel	——
‡	Riccardo, Richard	——	——
†	Richard, Jacob	Easel	——
†	Richardson, Judith	Easel	——
†	Rickenbaugh, ——	——	Chicago
*	Riddle, Henry	——	Chicago
‡	Rifka, Angel	Easel	Chicago
‡	Ritman, Maurice	——	——
†	Roberto (Roberti), Romolo	——	——
*	Robinson, Josephine P. or Increase	Administration	Chicago
‡	Robinson, Walter Paul	Easel	Chicago
*	Roche (Rocke), Gilbert	Easel	Chicago
†	Roecker, Leon	Easel	——
*	Rogalski, Anton	Easel	Chicago
‡	Rollo, Joseph	——	——
†	Rose, Iver	——	——

*IAP status verified by National Personnel Records Center

†No personnel record available, but artist was identified by work(s) from exhibition lists

‡No personnel record available, but verification is by transfer of artist via letters, memoranda, newsletters, etc.

§Responded to questionnaire

‖Taped interview

#Correspondence

TABLE A-3 — *(Continued)*

	Name	Department	Location[a]
†	Roseman, H.	Easel	——
†	Rosenberg, Ceil	Easel/Graphics	——
‡	Rosengren, Herbert	——	——
†	Rosenthal, Bernard	Sculpture	——
*	Rosenthal, Esther Zolott	Sculpture	Chicago
‡	Rosenthal, H. M. (Dr.)	Design	——
*	Ross, Charlotte Rothstein	Easel/Graphics	Chicago
‡	Ross, David	——	——
*	Ross, Louise	Sculpture	Chicago
‡	Roszak, Anton Theodore	Easel/Sculpture	Chicago
‡	Rouseff, Walter Vladimir	Mural	Chicago/Evanston/ Iron Mt., MI/ Kaukauna, WI/ Salem
*	Rovelstad, Trygve	Mural/Sculpture	Elgin
*	Rubin, Edith	Easel	Chicago
‡	Rubisoff, Ben	——	——
†	Rudin, Albert	IAD	Chicago
*	Ruhl, Theodore	Easel	Chicago
†	Rummel, Rudolph	Easel	——
*	Rupprecht, Edgar Arthur	Easel	Chicago
*	Russman, Felix	Easel	Chicago
*	Ruvolo, Felix (§)	Easel/Graphics	Chicago
†	Sako, Otto	Easel	——
*	Salla, Salvatore	Easel	Chicago
†	Sampson, Cornelius C.	Easel	Chicago
*	Sarner, Alfred (Albert)	Sculpture	Chicago
†	Satta, Bernard	Sculpture	West Frankfort
†	Scapicchi, Erminio A. (§)	Easel	Chicago

* IAP status verified by National Personnel Records Center

† No personnel record available, but artist was identified by work(s) from exhibition lists

‡ No personnel record available, but verification is by transfer of artist via letters, memoranda, newsletters, etc.

§ Responded to questionnaire

‖ Taped interview

Correspondence

TABLE A-3 — (*Continued*)

	Name	Department	Location[a]
‡	Scheps, Henry	——	——
‡	Schlaf, Theodore	——	——
*	Schlag, Felix Oscar	Sculpture	Chicago/U.S. Mint/ White Hall
‡	Schmid, R. V.	——	——
*	Schoembs, Emma R.	Administration	Chicago/Cairo
*	Schoolcraft, Freeman	Sculpture/ Administration	Chicago
†	Schucker, Charles L.	Easel/Graphics	Chicago
*	Schultz, George F.	Easel	Chicago
†	Schuster, C.	Easel	Chicago
†	Schwabe, Erwin	IAD	Chicago
*	Schwartz, Lester O.	Easel	Chicago
*	Schwartz, William Samuel	Easel/Mural	Chicago/Fairfield/ Eldorado/ Pittsfield/Cook County Nursing Home
*	Scott, Madelyn	Administration	Chicago
*	Scott, William Edouard	Easel/Mural	Chicago
*	Seaman, Ulrich	——	Chicago
*	Sebree, Charles	Easel	Chicago
*	Segedy, Georgina C.	Easel	Chicago
*	Segerberg, Olga	Graphics	Chicago
*	Senseney, George	Diorama/ Administration	Chicago
‡	Sepesky, Zoltan	Mural	Michigan/New York/ Chicago
*	Seymour, Louise	Easel	Chicago
*	Shannon, Leroy	Graphics/Poster	Chicago
*	Sharp, Bernadine Custer	Mural	Chicago
*	Sheffer, Glen C.	Easel	Chicago
*	Sherwood, Sherry	Easel/Mural	Chicago
*	Sigfusson, Sigfus	Easel	Chicago
‡	Sikuta, Helen	——	——

* IAP status verified by National Personnel Records Center

† No personnel record available, but artist was identified by work(s) from exhibition lists

‡ No personnel record available, but verification is by transfer of artist via letters, memoranda, newsletters, etc.

§ Responded to questionnaire

‖ Taped interview

Correspondence

TABLE A-3 — *(Continued)*

	Name	Department	Location[a]
*	Simon, Henry	Easel/Graphics	Chicago
*	Simone, Edgardo	Sculpture	Chicago
*	Simonetti, Angelo	——	Chicago
‡	Sindberg, Lawrence	——	——
*	Singer, William Earl	Easel	Chicago
*	Siporin, Mitchell	Easel/Mural	Chicago/Decatur/St. Louis Post Office/ Bloom Township/ Lane Tech
*	Skupas, Anthony (Cooper) (§)	Easel	Chicago
*	Slobe, Laura	Easel/Sculpture	Chicago
*	Smith, George Melville	Mural/ Administration	Chicago/Elmhurst/ Park Ridge
‡	Smith, Harriet	Administration	Chicago
*	Smith, Marshall D.	Easel	Chicago
‡	Smyth, Edmund	——	——
‡	Souer, August	——	——
*	Spears, Ethel	Easel/Mural/ Sculpture	Chicago/Evanston/ Hartford, WI/Oak Park
‡	Specketer, Carl C.	——	——
*	Spiecker, William	IAD	Chicago
*	Spongberg, Grace	Easel/ Photography	Chicago
‡	Steinberg, N. P.	——	——
*	Stenvall, John F.	Easel	Chicago
‡	Stenvall, Mitchell	——	——
*	Stephan, John	Easel	Chicago
†	Sterchi, Eda (Ada) Elisabeth	Easel	——
†	Sternberg, Henry	Mural	Chicago
*	Stewart, William	Easel	Chicago
*	Stierlin, Margaret	Sculpture/ Administration	Chicago
*	Stoddard, Paul (‖,#)	Graphics/ Administration	Chicago/East St. Louis

*IAP status verified by National Personnel Records Center

†No personnel record available, but artist was identified by work(s) from exhibition lists

‡No personnel record available, but verification is by transfer of artist via letters, memoranda, newsletters, etc.

§Responded to questionnaire

‖Taped interview

#Correspondence

TABLE A-3 — *(Continued)*

	Name	Department	Location[a]
*	Storrs, John Henry Bradley	——	Chicago
*	Strain, Frances (Mrs. Fred Biesel)	Easel	Chicago
‡	Sula, C. J.	——	——
*	Suto, Paul	——	Chicago
‡	Tarnowsky, Jacques	——	——
*	Taylor, Eloise	Easel	Chicago
*	Taylor, Helen	Easel/Mural	Chicago
*	Teitelbaum, Eva (Eve) D.	Graphics	Chicago
*	Teran (Toran), Peter	Easel	Chicago
†	Terari, ——	Easel	——
*	Terebesy, Louis	Sculpture	Chicago
*	Terrance, Ellsworth	——	Chicago
*	Terry, Lyle	——	Chicago
*	Teske, Edmond	——	Chicago
*	Thecla, Julia	Easel	Chicago
†	Thomas, D.	Easel	——
‡	Thomas, Leonore	——	——
*	Thompson, Archie	IAD	Chicago
*	Thompson, Frank W.	Mural	Chicago
*	Thorp, George Godfrey	Administration	Chicago
*	Thorsen, John	IAD	Chicago
‡	Tolpo, Carl	Sculpture	——
‡	Tomanek, Joseph	——	——
*	Topchevsky, Alex (Abraham)	Easel/Graphics	Chicago
*	Topchevsky, Morris	Easel/Graphics	Chicago/Oak Park
*	Torre-Bueno, Theodore	Design	Chicago
*	Troy, Adrian	Easel/Graphics	Chicago
*	Tufts, Robert Rider	Administration	Chicago
‡	Turtle, Arnold	——	——
*	Turzak, Charles	Mural/Graphics	Chicago/Lemont
*	Tuttle, Raymond E.	Sculpture	Chicago

* IAP status verified by National Personnel Records Center

† No personnel record available, but artist was identified by work(s) from exhibition lists

‡ No personnel record available, but verification is by transfer of artist via letters, memoranda, newsletters, etc.

§ Responded to questionnaire

‖ Taped interview

Correspondence

TABLE A-3 — *(Continued)*

	Name	Department	Location[a]
*	Tyler, Charles A.	Mural	Chicago
*	Tyler, Robert	——	Chicago
*	Tyler, William A.	Administration	Chicago
*	Ubaldi, Mario Camillo	Sculpture	Chicago
*	Umlauf, Charles	Sculpture	Chicago/Morton
†	Unger, Max	IAD	Chicago
‡	Upatel, Frank	——	——
*	Ursulescu, Michael M.	Easel	Chicago
*	Uyttebrouck, Oliver	Sculpture	Chicago
*	Vail, James, Jr.	Easel/Mural/IAD	Chicago
*	Valentino, Angeline F.	Graphics	Chicago
*	Van Buskirk, Cleo	Graphics	Chicago
‡	Van Court, Franklin	——	——
‡	Vandersluis, George	Easel/Mural	——
*	Vandre, Bessie	IAD	Chicago
‡	Van Pappelendam, Laura	——	——
*	Van Young, Oscar	Easel	Chicago
*	Vaughn, Harold W.	Easel	Chicago
†	Vaughn, J.	Easel	——
*	Vavak, Joseph	Easel/Mural	Chicago
‡	Vestal, Don	Design	Chicago
‡	Vice, Stoddard	——	——
‡	Vickery, Charles	——	——
*	Viviano, Emmanuel	Sculpture	Chicago
*	Vlasatry, Jim	Mural	Chicago
*	Vogel, Donald S. (§,#)	Easel	Chicago
*	Vogel, Elmer H.	——	Chicago
*	Vogel, John, Jr.	Easel/IAD	Chicago
*	Volk, Victor	Graphics	Chicago
†	Von Lutze, Benjamin	IAD	Chicago
*	Von Physter, George H.	Graphics	Chicago

*IAP status verified by National Personnel Records Center

† No personnel record available, but artist was identified by work(s) from exhibition lists

‡ No personnel record available, but verification is by transfer of artist via letters, memoranda, newsletters, etc.

§ Responded to questionnaire

‖ Taped interview

Correspondence

TABLE A-3 — *(Continued)*

	Name	Department	Location[a]
*	Von Schroetter, Hans	——	Chicago
‡	Waeltz, Russel	Easel	Chicago
‡	Wagner, Karl	——	——
†	Waldo, Miller	Poster	——
*	Walker, Dickman	——	Chicago
*	Walker, Earl	Easel	Chicago
†	Walker, H.	Easel	——
†	Wallace, John	Sculpture	Chicago/Brookfield Zoo
*	Wallace, Oren J.	——	Chicago
*	Walley, John Edwin (‖,#)	Easel/Mural/Design/ Administration	Chicago/Lane Tech/ Alaska
†	Walsh, Hardin	IAD	Chicago
†	Walsh, Louise	Graphics	——
*	Waltrip, Mildred	Easel/Mural/Poster	Chicago/Cook County Hospital/ Highland Park/Oak Park
*	Ward, John	——	Chicago
*	Ward, Lucille	Easel/Mural	Chicago
‡	Watson, Dudley Crafts	Easel	——
†	Watt, Parker H.	Easel	Chicago
‡	Wayne, June	Graphics	Chicago/New York/ California
‡	Weiner, A. S.	——	——
*	Weiner, Harry (Henry) A.	Easel/Graphics	Chicago
*	Weiner, Isadore	Easel/Graphics	Chicago
*	Weiner, Louis	——	Chicago
‡	Weinstein, Charles	——	——
*	Weisberg, Shari	——	Chicago
*	Weisenborn, Rudolph	Easel	Chicago
*	Weisheit, Fred	——	Chicago
‡	Weismueller, Anton	Stonecutter	Chicago
†	Weissbuch, Oscar	Graphics	——

* IAP status verified by National Personnel Records Center

† No personnel record available, but artist was identified by work(s) from exhibition lists

‡ No personnel record available, but verification is by transfer of artist via letters, memoranda, newsletters, etc.

§ Responded to questionnaire

‖ Taped interview

Correspondence

TABLE A-3 — *(Continued)*

	Name	Department	Location[a]
†	Wellington, Reynolds J.	Easel	——
‡	Welsh, William P.	Easel/Mural	——
‡	Welshans, L.	Easel/Mural	——
†	Wenger, M.	IAD	Chicago
†	West, Hebilly	IAD	Chicago
*	West, Theodore (Ted)	——	Chicago
*	Whitcup, Ivan	Easel	Chicago
*	White, Charles W.	Easel/Mural	Chicago
*	White, Francis Robert	Easel/Design/ Administration	Chicago
†	White, Wayne	IAD	Chicago
*	Whitley, Kenneth	Poster	Chicago
*	Whittle, Charles Robert	Easel	Chicago
‡	Wiley, Lucia	Mural	——
*	Williams, Walter R.	Easel/Diorama	Chicago
*	Williams, Warren	——	Peoria/Chicago
*	Wilson, Douglas	Easel	Chicago
†	Wilson, Ellis	Graphics	——
*	Wilson, Gladys	——	Chicago
*	Wilson, LaVerne A.	Easel/Graphics	Chicago
†	Wilson, Lawrence	Graphics	——
‡	Wilson, William	——	——
*	Winn, Oscaretta	Easel	Chicago
*	Winslow, Vernon	Administration	Chicago
*	Winters, John Richard	Easel/Mural/IAD/ Administration	Chicago/Cook County Hospital/ Oak Park/ Petersburg
*	Wittenber, Jan	Easel	Chicago
‡	Wittich, Wolfgang	——	——
*	Woelffer, Emerson S. (§)	Easel	Chicago
†	Woelffer, M.	Easel	——
*	Woeltz, Russell	Easel/Administration	Chicago/Urbana
*	Wold, Enok Harry	——	Chicago
‡	Wolf, Viola	Graphics	——

* IAP status verified by National Personnel Records Center

† No personnel record available, but artist was identified by work(s) from exhibition lists

‡ No personnel record available, but verification is by transfer of artist via letters, memoranda, newsletters, etc.

§ Responded to questionnaire

‖ Taped interview

Correspondence

TABLE A-3 — *(Continued)*

	Name	*Department*	*Location*[a]
*	Wolff, Robert Jay	Easel/Sculpture/ Administration	Chicago
‡	Woodruff, Claude W.	——	——
*	Wright, Leon	Easel	Chicago
†	Wynn, E.	Easel	——
*	Yampolsky, Oscar	Easel	Elgin
‡	Yarack, Joseph	——	——
*	Yochim, Maurice	——	Chicago
*	Young, Ellsworth	Easel	Chicago
‡	Zabel, Max	Sculpture	——
‡	Ziegler, Frank	——	——
*	Zimmer, Eli	Easel	Chicago
*	Ziroli, Nicola Victor (‖)	Easel/Sculpture/ Administration	Chicago
‡	Zischeck, Martin	——	——
*	Zolkiewicz, Michael	——	Chicago
‡	Zubbrick, John	——	——
*	Zussin, Harold	Easel	Chicago

* IAP status verified by National Personnel Records Center
† No personnel record available, but artist was identified by work(s) from exhibition lists
‡ No personnel record available, but verification is by transfer of artist via letters, memoranda, newsletters, etc.
§ Responded to questionnaire
‖ Taped interview
Correspondence

List of Murals

The present list of murals was assembled from three major sources: Merline Pollock, IAP muralist and supervisor of the mural unit; Barbara Bernstein who, with Pollock's list, did yeoman's work in verifying the whereabouts of these murals and added substantially to the list; and finally, our work at the National Archives. Additional information was discovered in a booklet entitled *Guide to Chicago Murals: Yesterday and Today,* edited by V. A. Sorell and published by the Chicago Council On Fine Arts, 1979. To date, 233 murals have been identified by the authors.

Institution and Address	Title	Muralist	Program	Size	Medium	Completion date	Status of work
EDUCATIONAL INSTITUTIONS							
Abraham Lincoln School 641 S. Lake West Aurora, IL	Educational Topics	Unknown	WPA FAP	3 panels (1) 10' x 27' 2" (2) 4' 6" x 16'	Oil on canvas	1937	Extant (in storage)
Abraham Lincoln School 641 S. Lake West Aurora, IL	*History of Aurora*	Morris Topchevsky	WPA FAP	(1) 33' 2" x 6' 4½"	Oil on canvas	1940	Extant
Barton School	Unknown	I. Bianucci	FAP	Unknown	Unknown	1940	Unknown

Institution and Address	Title	Muralist	Program	Size	Medium	Completion date	Status of work
Bateman School 4220 N. Richmond Chicago, IL (stage wall)	Decorative Landscape	Florian Durzynski	WPA FAP	(1) 12' x 30'	Oil on muslin Glued to wall	1940	Extant
Bateman School 4220 N. Richmond Chicago, IL	Characters From Children's Literature	Unknown	WPA FAP	(1) 7' 11" x 11' 6"	Oil on canvas	1937	Extant
Belding School 4257 N. Tripp Chicago, IL	Children's Activities	Roberta Elvis	WPA FAP	(3) 5' 4½" x 14' 8½"	Oil on canvas	1938	Extant
Bennett Elementary School 10115 Prairie Ave. Chicago, IL (classroom)	History of Books	Gustaf Dalstrom	WPA FAP	3 (1) 24' x 4' 6" (1) 30' x 4' 6" (1) 23' x 4' 6"	Oil on canvas	1937	Extant
Bennett Elementary School 10115 Prairie Ave. Chicago, IL (assembly hall)	Children's Subjects	Grace Spongberg	WPA FAP	4 panels	Oil	1940	Unknown
Bloom Township High School 10th & Dixie Hwy. Chicago Heights, IL	Occupational Studies and Their Application	Edgar E. Britton	WPA FAP	(6) 4' 6" x 9' (approx.)	Fresco	1936	Extant

Institution and Address	Title	Muralist	Program	Size	Medium	Completion date	Status of work
Bloom Township High School 10th & Dixie Hwy. Chicago Heights, IL	*Steel Worker*	Edgar E. Britton	WPA FAP	3 panels	Egg tempera	1936	Extant
Brady School 600 Columbia East Aurora, IL	*Small Children at Play*	Edwin Boyd Johnson	WPA FAP	(1) 6′ 7″ x 7′ 7½″	Oil on canvas	1936	Extant
Burbank School 2035 N. Mobile Ave. Chicago, IL (auditorium)	*Circus*	Andrene Kauffman	WPA FAP	(2) 10′ x 10′	Oil on canvas	1938	Extant
Burbank School 2035 N. Mobile Ave. Chicago, IL (classroom)	*Incidents in Life of Luther Burbank*	Andrene Kauffman	WPA FAP	(2) 20′ x 4′	Oil on canvas	1937	Extant
Byford School 5600 W. Iowa Chicago, IL	*Children on Beach*	Unknown	WPA FAP	(1) 8′ x 6′	Oil on canvas	1938	Unknown
Champaign Jr. High School Champaign, IL	*Historical Incidents of Champaign, Illinois*	Karl Kelpe	WPA FAP	3 (1) 10′ x 4′ (2) 17′ x 4′	Oil on canvas	1939	Extant

Institution and Address	Title	Muralist	Program	Size	Medium	Completion date	Status of work
Champaign Jr. High School Champaign, IL	*Early History of Champaign*	Karl Kelpe	WPA FAP	(1) 21' 10" x 4' 8"	Oil on canvas	1939	Extant
Chicago State University (former name) 6800 S. Stewart Chicago, IL	*Unknown*	M. Waltrip A. Lidov	WPA FAP	2 panels	Oil on canvas	1940	Extant
Chopin School Rice & Grand Sts. Chicago, IL (auditorium)	*Chopin and Steven Foster*	Florian Durzynski	WPA FAP	(2) 86' x 5'	Oil on canvas	No date	Extant
Christopher School for Crippled Children 51st & Artesian Ave. Chicago, IL (assembly hall)	*Characters from Children's Literature*	Unknown	WPA FAP	(2) semicircular 3' 2" radius	Tempera on presswood	1940	Extant
Clissold School 2350 W. 110 Place Chicago, IL (auditorium)	*Historical Periods*	Jefferson League	WPA FAP	(4) 6' 2" x 11' 1"	Oil on canvas	1939	Extant
Columbus School 2120 Augusta Blvd. Chicago, IL	*Landscape*	Unknown	WPA FAP	(1) 6' x 14'	Stage Background	1940	Unknown

Institution and Address	Title	Muralist	Program	Size	Medium	Completion date	Status of work
Cook School	Unknown	Thomas League	WPA FAP	Unknown	Unknown	1940–41	Unknown
Crane Technical High School 2245 Jackson Blvd. Chicago, IL	*Boilermakers, Pipe fitters, Architects*	Rudolph Weisenborn	WPA FAP	(3) 5′ x 8′	Oil on canvas	1937	Unknown
Deerfield Grammar School Deerfield, IL	*Landscape*	Unknown	WPA FAP	(1) 24′ x 4′ 6″	Mosaic	1937	Unknown
Des Plaines Township High School Des Plains, IL	Two principal industries of Des Plaines *Green Houses* and *Making of Glass Lampshades*	Paul Stoddard	WPA FAP	(2) 10′ x 14′	Oil on canvas	1937	Extant (in storage)
Dixon School 8310 St. Lawrence Chicago, IL (auditorium)	*Winter and Summer*	Mary Chambers Hague	WPA FAP	(2) 9′ x 10′	Oil on canvas	1937	Extant
Doolittle School 535 E. 35th St. Chicago, IL	*Recreation*	Stuart Purser	WPA FAP	(1) 9′ x 3′ 6″	Oil on canvas	1940	Unknown

Institution and Address	Title	Muralist	Program	Size	Medium	Completion date	Status of work
Englewood High School 6201 S. Stewart Ave. Chicago, IL (main stairway)	*School Activity*	Francis Coan	WPA FAP	(1) 25' x 6'	Oil on canvas	1937	Extant
Falconer School 3000 N. Lamon Chicago, IL (entrance lobby)	*Landscape with Children*	Florian Durzynski	WPA FAP	(1) 11' 5" x 11' 2"	Oil on canvas	1940	Extant
Flower Technical High School 3545 W. Fulton Blvd. Chicago, IL	*Outstanding American Women*	Unknown	WPA FAP	6 (2) 7' 9" x 9' (2) 4' 5½" x 9' (2) 9' 2" x 9'	Fresco	1940	Unknown
Franklin Jr. High School 14 Blackhawk St. Aurora, IL	*History of Alphabet* or *History of Education*	Unknown	WPA FAP	2 (1) 43' 6" x 6' 10" (1) 46' 9" x 6' 8"	Oil on canvas	1938	Extant
Freeman School West Aurora 153 S. Randall West Aurora, IL	Unknown	Emmanuel Jacobson	Unknown	Unknown	Unknown	No date	Unknown
Freeman School 153 S. Randall West Aurora, IL	*Landing of the Pilgrims*	Anne Michalov	WPA FAP	(1) 16' x 9'	Oil on canvas	1937	Extant

Institution and Address	Title	Muralist	Program	Size	Medium	Completion date	Status of work
Gompers School 12302 S. State St. Chicago, IL	*Indians Crafts*	Unknown	WPA FAP	6 (1) 14′ x 2′ 6″ (2) 13′ x 2′ 6″ (3) 2′ x 5′	Oil on canvas	1938	Unknown
Gorton Elementary School Lake Forest, IL	*Air-Water-Earth-Fire*	Ralph Henricksen	WPA FAP	(4) 9′ 8″ x 5′ 8½″	Oil on canvas	1936	Destroyed
Green Bay Road School 1936 Greenbay Road Highland Park, IL	*Flora and Fauna*	Gustaf Dalstrom	WPA FAP	(2) 10′ x 10′	Oil on canvas	1938	Unknown
Greenman School 729 W. Galena West Aurora, IL	*Westward Movement*	Florian Durzynski	WPA FAP	(2) 4′ x 22′ 8″	Oil on canvas	1936	Extant
Harper School Dartmouth and Greenwood Wilmette, IL	*Gardening and Farming*	Gustaf Dalstrom	WPA FAP	(2) 26′ x 9′	Oil on canvas	1938	Unknown
Harrison Technical High School 2850 W. 24th Chicago, IL	*Life and Times of Carter Harrison, Senior*	Lucille Ward	WPA FAP	8 (2) 6′ 2½″ x 7′ 1½″ (2) 5′ 11½″ x 3′ 2″ (4) 5′ 11½″ x 10′ 2″	Oil on canvas	1938	Extant (in storage)

Institution and Address	Title	Muralist	Program	Size	Medium	Completion date	Status of work
Harvard School 7525 Harvard Ave. Chicago, IL (assembly hall)	Harvesting of Grain Spring and Fall	Florian Durzynski	WPA FAP	(2) 9' x 12' 6"	Oil on canvas	1939	Extant
Hatch School 1000 N. Ridgeland Oak Park, IL (entrance hall)	Historical and Industrial Maps	Mildred Waltrip	WPA FAP	(2) 13' 1½" x 7'	Oil on canvas	1938	Extant
Hatch School 1000 N. Ridgeland Oak Park, IL	Map of the World and Map of the Solar System	Mildred Waltrip	WPA FAP	2 (1) 7' 6" x 7' 6" (1) 6' 6" x 7' 6"	Oil on canvas	1937	Extant
Hatch School 1000 N. Ridgeland Oak Park, IL	American Characters	Mildred Waltrip	WPA FAP	(2) 13' x 7'	Oil on canvas	1938	Extant
Hawthorne School Cuyler & Washington Oak Park, IL (entrance hall)	Early Farmers and Pioneers	Karl Kelpe	WPA FAP	2 panels 16' 11" (overall)	Oil on canvas	1936	Extant
Hawthorne School Libertyville, IL	Children's Stories	Unknown	WPA FAP	(1) 3' 6" x 10' 10"	Oil on canvas	1937	Unknown

Institution and Address	Title	Muralist	Program	Size	Medium	Completion date	Status of work
Hayt School 1518 Granville Ave. Chicago, IL (assembly hall)	Circus	Unknown	WPA FAP	3 (1) 11' x 6' 3½" (2) 2' x 6' 3½"	Oil on canvas	1937	Extant
Herzl Jr. High School 1401 S. Hamlin Chicago, IL	Unknown	Emmanuel Jacobson	WPA FAP	Unknown	Unknown	1940–41	Unknown
Highland Park High School 433 Vine Highland Park, IL	Scenes of Industry	Edgar Britton	WPA FAP	9 panels	Oil on canvas	No date	Extant (in storage)
Hirsch High School 7740 Ingleside Ave. Chicago, IL	Circus	Andrene Kauffman	WPA FAP	(1) 9' x 22'	Oil on canvas	1936	Covered over
Hirsch High School 7740 Ingleside Ave. Chicago, IL	Rodeo	Andrene Kauffman	WPA FAP	(1) 23' 3" x 9'	Oil on canvas	1938	Covered over
Hirsch High School 7740 Ingleside Ave. Chicago, IL	Stock Show and Amusement Park	Andrene Kauffman	WPA FAP	(2) 9' x 12'	Oil on canvas	1940	Covered over
Holmes School Chicago & Woodbine Oak Park, IL	North American Children Working	Morris Topchevsky	WPA FAP	(4) 55' x 6'	Oil on canvas	1936	Unknown

Institution and Address	Title	Muralist	Program	Size	Medium	Completion date	Status of work
Hookway School 8101 S. LaSalle Chicago, IL (assembly hall)	History of the New World: Discovery of America, Arrival of Pilgrims, Early Settlers, and Modern Life	Ralph Henricksen	WPA FAP	(4) 10' 10" x 6' 2"	Oil on canvas	1940	Extant
Hookway School 8101 S. LaSalle Chicago, IL	Fort Dearborn, Father Marquette, Kenzie Cabin, Water Tower at Chicago Ave., 1871 Fire, State St. in 1880, and The Fair of 1893	Unknown	WPA FAP	(1) 6' 2½" x 8' (8) 22" x 46"	Oil on canvas	1940	Extant
Horace Mann School 921 N. Kenilworth Oak Park, IL	Community Life of Oak Park in the Nineteenth Century	Emmanuel Jacobson, Rolf Henricksen	WPA FAP	(1) 7' x 75'	Oil on canvas	1936	Extant

Institution and Address	Title	Muralist	Program	Size	Medium	Completion date	Status of work
Howe School 720 N. Lorel Chicago, IL (back of stage)	*Landscape*	Unknown	WPA FAP	(1) 20' x 10'	Oil on canvas	1938	Extant
Hugh Manley High School 2935 W. Polk St. Chicago, IL	*Winter-Summer-Fall*	Gustaf Dalstrom	WPA FAP	(3) 9' 8" x 12' 7"	Oil on canvas	1936	Unknown
Hugh Manley High School 2935 W. Polk St. Chicago, IL	*Rural Scenes*	Unknown	WPA FAP	(2) 19' 10" x 4' 7"	Oil on canvas	1937	Unknown
Irving School Howard & Ridgeland Oak Park, IL	*World of Children*	Hester M. Murray	WPA FAP	3 (1) 16' 11" x 6' 11" (2) 5' 3" x 4' 3"	Oil on canvas	1936	Unknown
J. Mills Elementary School 2824 N. 76th Ave. Elmwood Park, IL	*Evolution of the School*	Gregory Orloff	WPA FAP	(2) 8' x 5'	Oil on canvas	1937	Extant
Kelvin Park High School	*Applications of Study*	Emmanuel Jacobson	Unknown	Unknown	Unknown	No date	Unknown

Institution and Address	Title	Muralist	Program	Size	Medium	Completion date	Status of work
Kohn School 10414 S. State St. Chicago, IL (stairwells)	*Covered Wagon and Indians*	Unknown	WPA FAP	2 (1) 7' 8" x 28' (1) 7' 10" x 28'	Oil on canvas	1939	Extant
Kozminaki School 936 E. 54th St. Chicago, IL	*Episodes from Literature*	Unknown	WPA FAP	(1) 3' 6" x 28'	Oil on canvas	1937	Unknown
Lakeview High School 4015 N. Ashland Ave. Chicago, IL	*Old and Modern School Systems*	Gregory Orloff	WPA FAP	2 (1) 21' 10" x 6' 4" (1) 23' 5" x 6' 4"	Oil on canvas	1936	Unknown
Lane Technical High School 2501 W. Addison Chicago, IL (cafeteria)	*Epochs in the History of Man*	Edgar E. Britton	WPA FAP	7 (1) 12' 1" x 6' (6) 12' 1" x 14' 4"	Fresco	1937	Extant
Lane Technical High School 2501 W. Addison Chicago, IL (assembly hall curtain)	*Indian Motif*	John Walley	WPA FAP	1 curtain 20' x 43'	Oil on steel curtain	1936	Extant
Lane Technical High School 2501 W. Addison Chicago, IL (library)	*Indian Scene, Medieval Scene*	Thomas League	WPA FAP	(2) 15' x 8'	Oil on canvas	1937	Extant

Institution and Address	Title	Muralist	Program	Size	Medium	Completion date	Status of work
Lane Technical High School 2501 W. Addison Chicago, IL (assembly hall entrance)	*The Teaching of Art*	Mitchell Siporin	WPA FAP	(4) 3′ 6″ x 15′	Fresco	1938	Extant
Laurel School Wilmette, IL	*Animals and Flowers*	Gustaf Dalstrom	WPA FAP	(1) 9′ 9″ x 23′	Oil on canvas	1936	Unknown
Lawson School 1256 S. Homan Ave. Chicago, IL (third floor)	*History of Ships*	Unknown	WPA FAP	(1) 20′ x 3′ 6″	Oil on canvas	1936	Unknown
Lawson School 1256 S. Homan Ave. Chicago, IL (second floor)	*History of Transportation*	Unknown	WPA FPA	(1) 4′ 8″ x 31′	Oil on canvas	1937	Extant
Lincoln Elementary School Evanston, IL	*Lincoln-Mania*	Otto E. Hake	WPA FAP	5 (1) 8′ 1″ x 7′ 1″ (1) 8′ 1″ x 7′ 2″ (1) 8′ 1″ x 2′ 8″ (1) 8′ 1″ x 3′ 8″ (1) 8′ 1″ x 9′ 4″	Oil on canvas	1936	Unknown
Lincoln School Highland Park, IL	*Small Children's Activities*	Unknown	WPA FAP	(1) 12′ x 4′ 6″	Oil on canvas	1937	Unknown

Institution and Address	Title	Muralist	Program	Size	Medium	Completion date	Status of work
Lincoln School Howard & Kenilworth Oak Park, IL	Pre-Glacial Period of America or Episodes— American Scene	Malcolm E. Hackett	WPA FAP	5 (1) 24' x 10' (1) 20' x 5' (1) 16' x 3' (2) 23' x 10'	Oil on canvas	1936	Unknown
Lowell School Homer and N. Blvd. Oak Park, IL	Child and Sports	Ethel Spears	WPA FAP	(2) 16' 10" x 6' 2"	Oil on canvas	1937	Unknown
Mann School 8050 S. Chappel Ave. Chicago, IL (assembly hall)	Life of Horace Mann	Ralph Henricksen	WPA FAP	3 (1) 10' x 8' 7" (2) 13' 6" x 8' 7"	Oil on canvas	1937	Extant
Mason Upper Grade Center 1830 S. Keeler Chicago, IL	Spring and Fall	Grace Spongberg	WPA FAP	6 (2) 14' x 4' (4) 1' 6" x 1' 6"	Oil on canvas	1939	Extant
May School 512 S. Lavergne Chicago, IL (main corridor)	Children at Play	Roberta Elvis	WPA FAP	(1) 26' x 4' 6"	Oil on canvas	1939	Extant
Marshall High School	Unknown	William Krepp	WPA FAP	Unknown	Unknown	1940–41	Unknown
Mary Todd School Aurora, IL	Unknown	Anne Michalov	WPA FAP	Unknown	Unknown	1940–41	Unknown

Institution and Address	Title	Muralist	Program	Size	Medium	Completion date	Status of work
McCormick School 2700 S. Sawyer Chicago, IL	Various Decorative Work	Unknown	WPA FAP	(4) 3' x 20'	Oil on wall	1940	Unknown
McKay School 6901 S. Fairfield Chicago, IL (assembly hall)	*Decorative Landscape*	Unknown	WPA FAP	(2) 6' x 8' three-fold screens	Oil on presswood	1938	Extant
Melrose Park Public School Melrose Park, IL	*Stage Settings*	Unknown	WPA FAP	(8) 5' 9" x 10' (14) 46¼" x 10'	Oil on canvas	1937	Unknown
Miller School Dempster & Hinman Evanston, IL	*Early History of Evanston*	Unknown	WPA FAP	(1) 15' 7" x 5' 6"	Oil on canvas	1938	Unknown
Mills Elementary School 2824 W. 76th Ave. Chicago, IL	*Evolution of the School*	Gregory Orloff	WPA FAP	(2) 8' x 5'	Oil on canvas	1937	Extant
Morrill School 6011 S. Rockwell Chicago, IL (kindergarten room)	*Child Activities*	Unknown	WPA FAP	(2) 30' x 2' 6"	Oil on canvas	1938	Extant

Institution and Address	Title	Muralist	Program	Size	Medium	Completion date	Status of work
Mozart School 2200 N. Hamlin Chicago, IL (old library room)	*Characters from Children's Literature*	Charles Freeman	WPA FAP	(2) 20' x 6'	Oil on canvas	1937	Extant
Mozart School 2200 N. Hamlin Chicago, IL (assembly hall)	*Mozart at the Court of Maria Theresa— 1769* and *Michelangelo in the Medici Gardens— 1490*	Elizabeth F. Gibson	WPA FAP	(2) 15' x 10'	Oil on canvas	1937	Extant
Nancy Hill School West Aurora, IL	*Educational Matter*	Unknown	WPA FAP	6 (2) 11' 7" x 2' 6" (2) 24¼" x 2' 6" (2) 23¼" x 13' 6½"	Oil on canvas	1937	Unknown
Nettlehorst School 3252 N. Broadway Chicago, IL (library)	*Horses from Literature*	Ethel Spears	WPA FAP	Frieze around library 86' 6⅝" x 3' 2" overall	Oil on canvas	1940	Extant

Institution and Address	Title	Muralist	Program	Size	Medium	Completion date	Status of work
Nettlehorst School 3252 N. Broadway Chicago, IL (main corridor)	*Contemporary Chicago*	Rudolph Weisenborn	WPA FAP	(1) 7' x 23'	Oil on canvas	1939	Extant
New Trier High School Winnetka, IL	*Music*	Unknown	WPA FAP	(1) 8' x 8' 6"	Oil on canvas	1937	Extant
Nichols Elementary School Evanston, IL	*Negro Children*	Archibald Motley, Jr.	WPA FAP	(1) 9' 5" x 2' 4"	Oil on canvas	1936	Unknown
North Eastern Il. U. Center for Inner City Studies 700 Oakwood Blvd. Chicago, IL (Formerly: Abraham Lincoln Center)	*Development of Man*	Morris Topchevsky	WPA FAP	(6) 4' x 5'	Casein on panel (glass murals)	1940	Extant
Oak Park Board of Education 960 North Blvd. Oak Park, IL	*Making of Chinese Kite*	Unknown	WPA FAP	(2) 3' x 6'	Oil on canvas	No date	Unknown
Oakton School 436 Ridge Evanston, IL	*Knights and Damsels*	Unknown	WPA FAP	2 panels	Oil on canvas	No date	Extant

Institution and Address	Title	Muralist	Program	Size	Medium	Completion date	Status of work
O'Toole School 6550 S. Seeley Chicago, IL	Characters from Children's Literature	Unknown	WPA FAP	(2) 16' x 4'	Fresco	1940	Extant
Parental School 3600 W. Foster Chicago, IL (cafeteria)	Boy's Activities	Otto E. Hake	WPA FAP	(1) 25' x 5'	Oil on canvas	1940	Extant
Park Manor School 7049 S. Rhodes Ave. Chicago, IL	Decorated Panels	Unknown	WPA FAP	(6) 4' x 6'	Casein	1940	Unknown
Parker School 6800 S. Stewart Chicago, IL (first floor stairs)	The Children's World	Unknown	WPA FAP	Unknown	Oil on canvas	No date	Unknown
Pasteur School 5825 S. Kostner Chicago, IL (kindergarten room)	A,B,C's	Lucille Ward	WPA FAP	(2) 4' x 15'	Oil on canvas	1937	Extant
Penn School 1616 S. Avers Chicago, IL (assembly hall)	Meeting of Pilgrims, City of the Future, and two others	Unknown	WPA FAP	(4) 6' 6" x 4' 6"	Oil on canvas	1940	Extant

Institution and Address	Title	Muralist	Program	Size	Medium	Completion date	Status of work
Perry School	*Unknown*	Mary Chambers Hauge	WPA FAP	Unknown	Unknown	1940–41	Unknown
Ravinia School 763 Dean Highland Park, IL	*Robin Hood*	Unknown	WPA FAP	(2) 5′ 4″ x 7′ 1″	Oil on canvas	1940	Extant
Ryerson School 646 N. Lawndale Chicago, IL (auditorium)	*Discovery of America*	Irene Bianucci	WPA FAP	(2) 6′ x 8′	Oil on canvas	1940	Unknown
Sawyer School 5248 S. Sawyer Chicago, IL (assembly hall)	*History of Chicago*	Lucille Ward	WPA FAP	5 (2) 6′ x 10′ (3) 9′ x 10′	Oil on canvas	1940	Extant
Schubert School 2727 N. Long Ave. Chicago, IL (assembly hall)	*Life of Franz Schubert* and *The Hurricane*	George Melville Smith	WPA FAP	(2) 9′ x 9′	Oil on canvas	1938	Extant
Skokie School 520 Glendale Ave. Skokie, IL	*Farms, Machinery, Industry, and Children*	Raymond Breinin	PWAP	3 panels 40′ x 10′	Fresco	1934	Covered over

Institution and Address	Title	Muralist	Program	Size	Medium	Completion date	Status of work
Southern Illinois University Carbondale, IL	*Typical Products of Southern Illinois*	Karl Kelpe	WPA FAP	(3) 8' x 106' overall	Oil on canvas	1937	Extant (in storage)
Southern Illinois University Carbondale, IL	*Lincoln-Douglas Debate*	Karl Kelpe	WPA FAP	(1) 8' x 8' 2"	Oil on canvas	1940	Extant (in Faner Hall)
Spalding School Corridors	Unknown	Frank Perri, Michael Ursuleseu, William Jacobs, Scapicchi, John Stenvall	Unknown	Unknown	Unknown	No date	Unknown
Steinmetz High School 3030 N. Mobile Chicago, IL	*Life of Steinmetz*	Unknown	WPA FAP	18' x 30'	Oil on steel curtain	1939	Unknown
Sullivan High School 6631 Bosworth Chicago, IL	*Tree of Knowledge*	Unknown	WPA FAP	20' x 40'	Oil on canvas	1939	Unknown
Tilden Technical High School 4747 Union Ave. Chicago, IL	*Steel Mill*	Merlin Pollock	WPA FAP	(1) 10' x 26'	Fresco	1937	Unknown

Institution and Address	Title	Muralist	Program	Size	Medium	Completion date	Status of work
Tilden Technical High School 4747 Union Ave. Chicago, IL	*Sylvan Dell*	Unknown	WPA FAP	1 stage backdrop 49' 6" x 23'	Oil	1937	Unknown
University of Illinois Medical Center 1737 W. Polk St. Chicago, IL	*Map of Champaign Campus, and Apple Harvest and Farm Animals*	Rainey Bennett	WPA FAP	8' x 12'	Oil	1938	Extant
University of Illinois Medical Center 1737 W. Polk St. Chicago, IL (basement)	*Women and Child Among Ruins*	Edgar Britton	WPA FAP	2' 11" x 3' 11"	Fresco	1938	Extant
University of Illinois Medical Center 1737 W. Polk St. Chicago, IL	*Painted Windows*	Ralph Graham, Rainey Bennett	WPA FAP	Ten windows of 8' x 10" panes	Painted glass	1938	Extant
University of Illinois Medical Center 1737 W. Polk St. Chicago, IL (library)	*Great Men of Medicine*	Edwin Boyd Johnson	WPA FAP	(9) 1' 8" x 2' 6"	Fresco	1938	Extant

Institution and Address	Title	Muralist	Program	Size	Medium	Completion date	Status of work
Waters School 2519 Wilson Ave. Chicago, IL	*Alice in Wonderland*	Malcolm E. Hackett	WPA FAP	(1) 5' 8" x 1' 8"	Oil on canvas	1936	Unknown
Wentworth School 6950 S. Sangamon Chicago, IL (fourth floor)	*American Youth*	Florian Durzynski	WPA FAP	3 (1) 7' 10" x 8' 3" (1) 7' 9" x 8' 3½" (1) 10' x 5' 9"	Oil on canvas	1937	Extant
West Pullman School 11941 S. Parnell Ave. Chicago, IL (assembly hall)	*Americanization of Immigrants*	Ralph Henricksen	WPA FAP	(2) 9' 2" x 5' 6"	Oil on canvas	1940	Extant
Wilbur Wright College Chicago, IL	Unknown	Merlin Pollock	WPA FAP	Unknown	Unknown	1940–41	Unknown

PUBLIC LIBRARIES

Institution and Address	Title	Muralist	Program	Size	Medium	Completion date	Status of work
Chicago Public Library Austin Branch 5615 Race St. Chicago, IL	*Animals at Play* and *Cultural Steps to American Progress*	Francis F. Coan	WPA FAP	4 (1) 37' x 8' 9" (1) 37' x 9' 11" (1) 50' x 8' 9" (1) 50' x 9' 11"	Oil on canvas	1938	Unknown
Chicago Public Library Hall Branch	Unknown	Charles Davis	WPA FAP	Unknown	Unknown	1940–41	Unknown

Institution and Address	Title	Muralist	Program	Size	Medium	Completion date	Status of work
Chicago Public Library Hild Branch 4536 N. Lincoln Ave. Chicago, IL or (4544 N. Lincoln)	*The Children's World* or *Children— The World We Live In*	Francis F. Coan	WPA FAP	(2) 9' x 34'	Oil on canvas	1937	Extant
Chicago Public Library (branch unknown)	Unknown	Charles White	WPA FAP	Unknown	Unknown	1940–41	Unknown
Flagg Township Library or Rochelle Branch Library Rochelle, IL	*Merry Go Round*	Ethel Spears	WPA FAP	(1) 6' 8" x 3' 6"	Oil on canvas	1939	Extant

HISTORICAL SOCIETY

| DuPage Historical Society 102 E. Wesley Wheaton, IL | *Indians of the Region and Pueblo and Navajo Indians* | Otto Hake | WPA FAP | 2 panels | Oil | No date | Extant |

POST OFICES

| Berwyn Post Office 6625 Cermak Berwyn, IL | *The Picnic* | Richard Haines[b] | T.S.[a] | (1) 5' x 17' | Oil | 1942 | Extant |

[a]Treasury Section
[b]Non-IAP muralist

Institution and Address	Title	Muralist	Program	Size	Medium	Completion date	Status of work
Bushnell Post Office Bushnell, IL	*Pioneer Home in Bushnell*	Reva Jackman	T.S.	(1) 10' x 3' 10"	Oil on canvas	1939	Extant
Carmi Post Office Carmi, IL	*Service to the Farmer*	Davenport Griffin	T.S.	Unknown	Oil on canvas	1939	Unknown
Carthage Post Office Carthage, IL	*Pioneers Tilling the Soil and Building Log Cabin*	Karl Kelpe	T.S.	Unknown	Mural	1938	Unknown
Chester Post Office Chester, IL	*Loading the Packet*	Fay E. Davis	T.S.	(1) 13' 6" x 5' 9"	Egg tempera on plaster mural	1940	Extant
Chestnut Street Post Office 830 N. Clark Chicago, IL (north wall)	*Great Indian Council, Chicago— 1833*	Gustaf Dalstrom	T.S.	(1) 15' x 5'	Oil on canvas	1938	Extant
Chestnut Street Post Office 830 N. Clark Chicago, IL (south wall)	*Advent of the Pioneers, 1851*	Frances Foy	T.S.	(1) 15' x 5'	Oil on canvas	1938	Extant (moved to Loop Station on S. Clark Street)
Chicago Post Office Canal & Van Buren St. Chicago, IL	Unknown	Charles Turzak	T.S.	(15) 8' 6" x 5' 6"	Oil	1937	Unknown

Institution and Address	Title	Muralist	Program	Size	Medium	Completion date	Status of work
Chicago Uptown Post Office 4850 N. Broadway Chicago, IL	*Carl Sandburg and Louis Sullivan*	Henry Valnum Poor[b]	T.S.	(2) 10' 6" x 7' 6"	Ceramic tile mural	1943	Extant
Chillicothe Post Office Chillicothe, IL	*Railroading*	Arthur Lidov	T.S.	Unknown	Tempera on board	1942	Extant
Clinton Post Office Clinton, IL	*Clinton in Winter*	Aaron Bohrod	T.S.	(1) 12' 7" x 5' 8"	Oil	1939	Extant
Decatur Post Office Decatur, IL	*Early Pioneers, Social Consciousness, and Growth of Democracy in Illinois*	Edward Millman	T.S.	10 (4) 5' x 4' (6) 20' x 4'	Fresco	1938	Extant
Decatur Post Office Decatur, IL	*Nat. Resources of Illinois, and Development of Illinois*	Edgar Britton	T.S.	Unknown	Fresco	1938	Extant
Decatur Post Office Decatur, IL	*Fusion of Agriculture and Industry in Illinois*	Mitchell Siporin	T.S.	(1) 12' 10" x 7'	Fresco	1938	Extant

[b]Non-IAP muralist

Institution and Address	Title	Muralist	Program	Size	Medium	Completion date	Status of work
Downers Grove Post Office 920 Curtis Downers Grove, IL	*Chicago— Railroad Center of the Nation*	Elizabeth Tracy[b]	T.S.	(1) 12' 10" x 6'	Oil on canvas	1940	Extant
Dwight Post Office Dwight, IL	*Stage at Dawn*	Carlos Lopez[b]	T.S.	(1) 14' x 7'	Fresco	1937	Extant
East Alton Post Office East Alton, IL	*The Letter*	Frances Foy	T.S.	(1) 4' x 4' 6"	Oil on canvas	1936	Extant
East Moline Post Office East Moline, IL	*Early Settlers of Moline along the Mississippi*	Edgar Britton	T.S.	(1) 8' x 8' 6"	Fresco	1936	Extant
Eldorado Post Office Eldorado, IL	*Mining in Illinois*	William Schwartz	T.S.	(1) 10' x 5' 6"	Oil on canvas	1937	Extant
Elmhurst Post Office 154 Park Elmhurst, IL	*There Was Vision*	George Melville Smith	T.S.	(1) 14' x 7'	Oil on canvas	1938	Extant
Fairfield Post Office Fairfield, IL	*Old Settlers*	William Schwartz	T.S.	(1) 3' x 4'	Oil on canvas	1936	Extant
Flora Post Office Flora, IL	*Good News and Bad*	Davenport Griffin	T.S.	(1) 12' x 5'	Oil on canvas	1937	Extant

[b]Non-IAP muralist

Institution and Address	Title	Muralist	Program	Size	Medium	Completion date	Status of work
Forest Park Post Office Forest Park, IL	*The White Fawn*	Miriam McKinnie (Hofmeier)	T.S.	(1) 14′ x 6′	Mural	1940	Extant
Galesburg Post Office Galesburg, IL	*Breaking the Prairie—Log City 1887*	Aaron Bohrod	T.S.	(1) 25′ x 5′ 9″	Oil on canvas	1938	Extant
Geneva Post Office Geneva, IL	*Fish Fry in the Park*	Manuel Bromberg[b]	T.S.	(1) 14′ x 9′	Tempera	1940	Extant
Gibson City Post Office Gibson City, IL	*Hiawatha Returns with Minehaha*	Frances Foy	T.S.	(1) 13′ x 5′	Oil on canvas	1940	Extant
Gillespie Post Office Gillespie, IL	*Illinois Farm*	Gustaf Dalstrom	T.S.	(1) 5′ x 4′	Oil on canvas	1936	Extant
Glen Ellyn Post Office Glen Ellyn, IL	*Settlers Building*	Daniel Rhodes[b]	T.S.	Unknown	Oil on canvas	1937	Unknown
Hamilton Post Office Hamilton, IL	*Threshing Grain*	Edmund D. Lewandowski	T.S.	(1) 12′ x 5′	Mural	1942	Extant
Herrin Post Office Herrin, IL	*George Rogers Clark with Indians near Herrin*	Gustaf Dalstrom	T.S.	Unknown	Mural	1940	Painted over

[b]Non-IAP muralist

Institution and Address	Title	Muralist	Program	Size	Medium	Completion date	Status of work
Lakeview Post Office 1343 W. Irving Park Chicago, IL	Chicago—Epoch of a Great City	Henry Sternberg	T.S.	(1) 24' 2" x 7' 7"	Oil on canvas	1938	Extant
Lemont Post Office Lemont, IL	Canal Boats	Charles Turzak	T.S.	(1) 13' 2" x 5' 2"	Oil on canvas	1938	Extant
Lewiston Post Office Lewiston, IL	Lewiston Milestones	Ida Abelman[b]	T.S.	(1) 14' x 4' 3"	Tempera	1941	Extant
Madison Post Office Madison, IL	Assimilation of the Immigrant into Industrial Life of Madison	A. Raymond Katz	T.S.	(1) 12' 6" x 4' 6"	Oil and tempera on canvas	1940	Extant
Marseilles Post Office Marseilles, IL	Industrial Marseilles	Avery F. Johnson	T.S.	(1) 12' x 5'	Oil on canvas	1938	Extant
Marshall Post Office Marshall, IL	Harvest	Miriam McKinnie (Hofmeier)	T.S.	(1) 12' x 4' 6"	Oil on canvas	1938	Extant
McLeansboro Post Office McLeansboro, IL	First Official Air Mail Flight	Dorothy Mierisch[b]	T.S.	(1) 13' 11" x 4' 10"	Oil	1941	Extant
Melrose Park Post Office Melrose, IL	Air Mail	Edwin Boyd Johnson	T.S.	Unknown	Fresco	1937	Destroyed

[b]Non-IAP muralist

Institution and Address	Title	Muralist	Program	Size	Medium	Completion date	Status of work
Moline Post Office Moline, IL	*Manufacture of Plowshares in Moline*	Edward Millman	T.S.	(1) 7' x 8' 6"	Egg tempera on gesso	1936	Extant
Morgan Park Post Office 1805 W. Monterrey Chicago, IL	*Father Jacques Marquette— 1674*	J. Theodore Johnson	T.S.	(1) 14' x 8' 6"	Oil	1937	Extant
Mount Carroll Post Office Mount Carroll, IL	*Rural Scene— Wakarusa Valley*	Irene Bianucci	T.S.	(1) 11' 2" x 3' 1"	Oil	1941	Extant
Mount Morris Post Office Mount Morris, IL	*Growth of Mt. Morris*	Dale Nichols	T.S.	(1) 12' x 5'	Oil on canvas	1939	Extant
Mount Sterling Post Office Mount Sterling, IL	*The Covered Bridge*	Henry Bernstein	T.S.	(1) 12' x 4' 6"	Tempera on composition panel	1941	Extant
Naperville Post Office Naperville, IL	*George Martin's Home Overlooking Old Naper Hill*	Rainey Bennett	T.S.	(1) 10' x 4'	Oil on canvas	1941	Extant
Nashville Post Office Nashville, IL	*Barn Yard*	Zoltan Sepesky	T.S.	(1) 15' 8" x 3' 6"	Tempera on masonite	1942	Extant

Institution and Address	Title	Muralist	Program	Size	Medium	Completion date	Status of work
Normal Post Office Normal, IL	*Development of the State Normal School*	Albert Pels[b]	T.S.	(1) 11' x 4'	Oil on canvas	1938	Extant
Oak Park Post Office 901 Lake Street Oak Park, IL	*LaSalle's Search for Tonti, Founding of Ft. Crevecoeur, The Pioneer— 1943,* and *The Osceola*	J. Theodore Johnson	T.S.	4 (2) 9' x 4' (2) 11' x 4'	Oil	1939	Extant
O'Fallon Post Office O'Fallon, IL	*John Mason Peck, First Postmaster, Handing Out Mail*	Merlin Pollock	T.S.	(1) 12' x 4' 8"	Oil on canvas	1939	Extant
Oglesby Post Office Oglesby, IL	*Illini and Pottawatomies Struggle at Starved Rock*	Fay E. Davis	T.S.	(1) 12' 5" x 6' 9"	Oil on canvas	1942	Extant
Oregon Post Office Oregon, IL	*The Pioneer and Democracy*	David B. Cheskin	T.S.	(1) 14' x 5' 6"	Tempera on plaster	1940	Extant
Park Ridge Post Office Park Ridge, IL	*Indians Cede the Land*	George Melville Smith	Unknown	(1) 17' 10" x 6'	Unknown	1940	Extant (in storage)

[b]Non-IAP muralist

Institution and Address	Title	Muralist	Program	Size	Medium	Completion date	Status of work
Peoria Post Office Peoria, IL	Unknown	Madeleine J. Heldrick	T.S.	Unknown	Unknown	No date	Unknown
Petersburg Post Office Petersburg, IL	*Lincoln at New Salem*	John Winters	T.S.	(1) 14' 10" x 6' 9"	Oil on canvas	1938	Extant
Pittsfield Post Office Pittsfield, IL	*River Boat and Bridge*	William Schwartz	T.S.	(1) 11' 6" x 5'	Oil on canvas	1938	Extant
Rushville Post Office Rushville, IL	*Hart Fellows: Builder of Rushville*	Rainey Bennett	T.S.	(1) 12' x 4'	Oil on canvas	1939	Extant
Salem Post Office Salem, IL	*Lincoln as Postmaster in New Salem*	Vladimir Rouseff	T.S.	(1) 12' x 4' 6"	Oil on canvas	1938	Extant
Shelbyville Post Office Shelbyville, IL	*Shelby County Fair 1900*	Lucia Wiley[b]	T.S.	(1) 14' x 4' 6"	Fresco	1941	Extant
Staunton Post Office Staunton, IL	*Going to Work*	Ralph Henricksen	T.S.	(1) 10' x 4'	Oil on canvas	1941	Extant
Tuscola Post Office Tuscola, AL	*The Old Days*	Edwin Boyd Johnson	T.S.	(1) 10' x ?	Oil on canvas	1941	Extant
Vandalia Post Office Vandalia, IL	*Old State Capitol*	Aaron Bohrod	T.S.	(1) 10' 4" x 4'	Oil on canvas	1936	Extant

[b]Non-IAP muralist

Institution and Address	Title	Muralist	Program	Size	Medium	Completion date	Status of work
Virden Post Office Virden, IL	*Illinois Pastoral*	James Daugherty[b]	T.S.	(1) 12' x 5'	Tempera and oil	1939	Extant
Wilmette Post Office 1241 Central Wilmette, IL	*In the Soil Is Our Wealth*	Raymond Breinin	T.S.	(1) 13' 5" x 5' 2"	Oil	1938	Extant
Wood River Post Office Wood River, IL	*Stagecoach and Mail*	Archibald Motley, Jr.	T.S.	(1) 3' x 4' 3"	Oil	1937	Extant

GOVERNMENT BUILDINGS

Bureau of Water City Hall LaSalle & Randolph Chicago, IL	*Blessings of Water*	Edward Millman	WPA FAP	(1) 10' x 42'	Fresco	1937	Painted over
Division of Parks and Memorials 120 State Capitol Building Springfield, IL	*Landing of Father Marquette*	Unknown	WPA FAP	(1) 7' x 5'	Oil on canvas	1940	Unknown
5th Army Headquarters Chicago, IL	*Abstract Symbols of Army*	Charles Turzak	Unknown	Unknown	Unknown	No date	Unknown
Fort Sheridan Illinois Officer's Mess	Unknown	Julio DeDiego	T.S.	Unknown	Unknown	No date	Unknown

[b]Non-IAP muralist

Institution and Address	Title	Muralist	Program	Size	Medium	Completion date	Status of work
Great Lakes Naval Base, Building 1–A Waukegan, IL	*Drawing Base*	Ralph Henricksen	WPA FAP	10' x 5' (overall)	Oil on canvas	1936	Destroyed
Illinois National Guard, 132d Infantry Armory 2653 W. Madison St. Chicago, IL	*Special Government Design Instruction Map* or *Study Maps— U.S. Army Design*	Unknown	WPA FAP	(1) 37' 6" x 10"	Oil on canvas	1936	Unknown
New Shawneetown Courthouse New Shawneetown, IL	Unknown	Unknown	Unknown	3 panels	Unknown	No date	Extant
124th Field Artillery	Unknown	Ed Kibbee, Walter Robinson	WPA FAP	Unknown	Unknown	No date	Unknown
Scott Air Force Base O'Fallon, IL	*The Recruit*	Ralph Henricksen	WPA FAP	3 panels	Oil on canvas	1942	Destroyed

CARE FACILITIES

Institution and Address	Title	Muralist	Program	Size	Medium	Completion date	Status of work
Chicago Home for Jewish Orphans 62d and S. Drexel Chicago, IL	*Youth's Work and Recreation*	Catherine O'Brien	WPA FAP	(1) 31' x 7'	Oil on canvas	1936	Unknown

Institution and Address	Title	Muralist	Program	Size	Medium	Completion date	Status of work
Chicago Home for Jewish Orphans 62d and S. Drexel Chicago, IL	Boy and Girl Sports	Unknown	WPA FAP	(1) 15' x 4'	Oil on presswood	1937	Unknown
Cook County Hospital 1835 W. Harrison Chicago, IL	Children Playing	Rose Anderson	WPA FAP	(4) 36" x 50"	Oil on masonite	1940	Unknown
Cook County Hospital 1835 W. Harrison Chicago, IL	Farm Scene	Roberta Elvis	WPA FAP	(1) 12' x 5'	Oil on canvas	1937	Unknown
Cook County Hospital 1835 W. Harrison Chicago, IL	Animals	Lillian Hall Designed by Francis Badger	WPA FAP	13 panels 4' 2" x 55' 9½" overall	Oil on canvas	In progress as of February 1941	Unknown
Cook County Hospital 1835 W. Harrison Chicago, IL	Zoo and Beach Scenes	Ethel Spears	WPA FAP	12 panels 6' 9" x 46' 9½" overall	Oil on canvas	In progress as of February 1941	Unknown
Cook County Hospital 1835 W. Harrison Chicago, IL	Park Scenes	Ethel Spears	WPA FAP	21 panels 63' x 6' 6" overall	Oil on canvas	1941	Unknown

Institution and Address	Title	Muralist	Program	Size	Medium	Completion date	Status of work
Cook County Hospital 1835 W. Harrison Chicago, IL	*Mountain Landscape with Flora and Fauna*	Ethel Spears	WPA FAP	6 panels 5′ 7″ x 25′ 6″ overall	Oil on canvas	In progress as of February 1941	Unknown
Cook County Hospital 1835 W. Harrison Chicago, IL	*Cook County Scenes*	Mildred Waltrip	WPA FAP	4 (2) 4′ x 40′ (2) 4′ x 30′ and 30′ x 40′ ceiling	Oil on canvas decoration	1940	Unknown
Cook County Hospital 1835 W. Harrison Chicago, IL	*Children at Play in the Park*	Lucille Ward	WPA FAP	8 (1) 9′ x 1′ 6″ (2) 3′ x 10′ (2) 15′ x 10′ (3) 7′ x 10′	Oil on canvas	In progress as of February 1941	Unknown
Cook County Hospital 1835 W. Harrison Chicago, IL	*Zoo, Fort Dearborn, Museums, and Stock Yards and Industry*	Edwin B. Johnson	WPA FAP	4 (2) 24′ x 6′ (2) 26′ x 6′	Oil on canvas	1940	Unknown
Cook County Hospital 1835 W. Harrison Chicago, IL	*Circus and 2 murals*	Andrene Kauffman	WPA FAP	(1) 310 sq. feet (2) 1 7′ 6″ x 7′ 1 7′ 6″ x 15′	Oil on canvas	1941	Unknown

Institution and Address	Title	Muralist	Program	Size	Medium	Completion date	Status of work
Cook County Hospital 1835 W. Harrison Chicago, IL	*Children's Friends*	Rose Anderson & Mildred Waltrip Designed by Hester M. Murray	WPA FAP	213 sq. ft.	Oil on canvas	1940	Unknown
Cook County Hospital 1835 W. Harrison Chicago, IL	*Farm*	Othello Palumbo	WPA FAP	2 (1) 15' x 4' (1) 15' x 5'	Oil on canvas	1940	Unknown
Cook County Hospital 1835 W. Harrison Chicago, IL	*Fruit Pickers*	Henry Simon	WPA FAP	(2) 4' x 14'	Egg tempera on gesso panels	1940	Unknown
Cook County Juvenile Detention Home Ogden and Roosevelt Chicago, IL (girls' dining room)	*Outdoor Landscape with Figures*	Frances Badger	WPA FAP	(2) 22' 6½" x 6' 10" or 22½' x 10½'	Oil on canvas	1937	Extant
Cook County Juvenile Detention Home Ogden and Roosevelt Chicago, IL (girls' living room)	*Recreation*	Frances Badger	WPA FAP	(1) 52' 7" x 5' 1"	Oil on canvas	1937	Extant

Institution and Address	Title	Muralist	Program	Size	Medium	Completion date	Status of work
Elgin State Hospital 750 S. State St. Elgin, IL	*Jungle Scene* and *Domestic Animals*	David Martin, Frank W. Thompson	Unknown	Unknown	Unknown	Unknown	Unknown
Fort Sheridan Army Hospital	*Fruits of Nature*	Julio DeDiego	Unknown	Unknown	Unknown	No date	Unknown
Manteno State Hospital Manteno, IL	*Indian Camp* and *Canoe Making*	Gustaf Dalstrom	WPA FAP	(2) 9' 6" x 2' 9"	Oil on canvas	1936	Unknown
Manteno State Hospital Manteno, IL	*Indian Dance* and *Early Settlers*	Gustaf Dalstrom	WPA FAP	(2) 2' 9" x 9' 8"	Oil on canvas	1937	Extant
Manteno State Hospital Manteno, IL	*Pastoral Scene #1*, and *Pastoral Scene #2*	Gustaf Dalstrom	WPA FAP	(2) 7' 5" x 6'	Oil on canvas	1939	Extant
Manteno State Hospital Manteno, IL	*Indians of the Region*	Unknown	WPA FAP	2 (1) 2' 9" x 10' (1) 2' 9" x 36'	Oil on canvas	1938	Unknown

Institution and Address	Title	Muralist	Program	Size	Medium	Completion date	Status of work
RECREATIONAL FACILITIES							
Black Hawk State Park Rock Island, IL	*Chief Blackhawk— Winter Round House* and *Sauk and Fox Indians— Summer Long House*	Unknown	WPA FAP	2 (1) 18' x 8' 6" or 18' x 18' (winter house) (1) 15' x 8' 6" or 15' x 18' 6" (summer house)	Oil on canvas	1937 or 1939	Extant
Brookfield Zoological Gardens Giraffe Building Brookfield, IL	*Giraffes*	Unknown	WPA FAP	Unknown	Paint on wall	1938	Extant
Brookfield Zoological Gardens Brookfield, IL	*Background Decorations on Stalls*	Unknown	WPA FAP	(6) 12' x 16'	Unknown	1936	Unknown
Chicago Park District Grant Park 900 S. Columbus Administrative Building Chicago, IL	*Park Scenes*	Mildred Waltrip	WPA FAP	(1) 16' x 9'	Oil on canvas	1939	Unknown

Institution and Address	Title	Muralist	Program	Size	Medium	Completion date	Status of work
Federal Theater Project, WPA Great Northern Theater Chicago, IL	Satirical Musical Comedy	Rudolph Weisenborn	WPA FAP	2 (1) 8' 4½" x 6' 11" (1) 4' 10" x 11' 3"	Oil on canvas	1937	Unknown
Hans Christian Anderson Playground 3748 Prairie Ave. Chicago, IL	Snow Queen	Ethel Spears	WPA FAP	(1) 2' 6" x 17'	Oil on canvas	1938	Unknown
James Barrie Playground Oak Park, IL	Peter Pan	Unknown	WPA FAP	(2) 2' 6" x 2' 2"	Oil on canvas	1938	Extant
Louis Carroll Playground Oak Park, IL	Alice in Wonderland	Unknown	WPA FAP	4 (2) 3' 1" x 14' 6" (2) 3' 1" x 10' 3"	Oil on canvas	1937	Unknown
Robert Louis Stevenson Playground Lake & Lombard Ave. Oak Park, IL	Treasure Island	Unknown	WPA FAP	4 panels 147' overall	Oil	1937	Unknown

List of Public Sculpture

The following list of public sculpture may be incomplete. Records for sculpture commissions are not as well organized as they are for murals, reflecting a possible lack of interest in such art. More to the point, for lack of sponsors fewer sculptures were commissioned, so it may very well be that this list is more complete than was at first thought.

Sculptor	Title	Material	Program	Completion date	Location
Anonymous	*Drinking Fountain: Fishes and Water Birds*	Ceramic	IAP	No date	Bateman School 4220 N. Richmond Chicago, IL (3d floor corridor)
Anonymous	*Physical Education*	Ceramic relief	IAP	No date	O'Toole School 6550 S. Seely Chicago, IL
Anonymous	*Lambs' and Horses' Heads*	Plaster relief	IAP	No date	O'Toole School 6550 S. Seely Chicago, IL
Anonymous	*Pilots and Plane Mechanics*	Wooden relief panels	IAP	No date	Scott Air Force Base Belleville, IL
Anonymous	*Eagles*	Precast concrete	IAP	No date	Armories Throughout Illinois
Newell, H. Arnold	*Post Rider*	Terra-cotta relief	Treasury Section	1941	Abingdon Post Office Abingdon, IL

Sculptor	Title	Material	Program	Completion date	Location
Edward Chassaing	Signs of the zodiac	Mosaic tiles (14) 8′ x 15′ each	IAP	No date	Archway School 1819 W. Polk Chicago, IL
Edward Chassaing	*Aesculapius and Hygeia*	Stone, life-size	IAP	No date	University of Illinois College of Medicine Chicago, IL
Edward Chassaing	*Farming*	Wood	Treasury Section	1943	Kankakee Post Office Kankakee, IL
Edward Chassaing	*Means of Mail Transportation*	Plaster	Treasury Section	1937	Brookfield Post Office Brookfield, IL
Edward Chassaing	Assyrian frieze	Unknown	IAP(?)	No date	Field Museum Chicago, IL
Olga Chassaing	Statue of woman with child	Stone	IAP	No date	University of Illinois Medical Center Chicago, IL (orthopedic building)
Mary Anderson Clark	*Alice in Wonderland* and *Tom Sawyer*	Cast stone	IAP	No date	Mary Todd School Aurora, IL
Mary Anderson Clark	*Peace* and *Harvest*	Indiana limestone 8′ each	IAP	1939	Tuberculosis Sanitarium Peoria, IL (moved to the Court House Plaza, 1975)
Mary Anderson Clark	*Harvest*	Ceramic	IAP	No date	Board of Education Offices Oak Park, IL
Mary Anderson Clark	*Three Children*	Limestone	IAP	No date	Evanston, IL
Robert Delson	*Ape* directional sign	Fir wood	IAP	No date	Brookfield Zoo Brookfield, IL

Sculptor	Title	Material	Program	Completion date	Location
Curt Drewes	Fish Hatchery, Farm, and Dairy Farming	Cast Stone	Treasury Section	1939	Carlyle Post Office Carlyle, IL
Curt Drewes	Farming by Hand and The Manufacture of Farm Implements	Plaster reliefs	Treasury Section	1939	Rock Falls Post Office Rock Falls, IL
Marshall M. Fredericks[a]	The Family	Terra-cotta relief	Treasury Section	1941	Sandwich Post Office Sandwich, IL
Burton Freund	America Working	Wood 4' x 15'	IAP(?)	No date	Bateman School 4220 N. Richmond Chicago, IL
Burton Freund	Tailor	Plaster model	IAP	No date	Unknown
Burton Freund	Directional Markers	Painted wood	IAP	No date	Brookfield Zoo Brookfield, IL
Maurine Montgomery Gibbs	The Letter	Wood relief	Treasury Section	1942	Homewood Post Office Homewood, IL
Warren Gilbertson	Buffalo Hunt	Ceramic tiles	IAP	No date	Unknown
Carl Hallsthamer	Hippocrates and Democritus, The Royal Touch, Charles II, and The Destruction of the Alexandrian Library	Mahogany wood 24" x 30" each bas-relief panels	IAP(?)	No date	University of Illinois Medical Center Chicago, IL (rare book library)
Anna Keeney	Boy and Boar	Plaster sketch for cast stone	IAP	No date	Unknown
Anna Keeney	Fountain	Unknown	IAP	No date	Stone School
Alfred Lenzi	Animals	Pine wood relief	IAP	No date	Oakton School Evanston, IL

[a]Non-IAP artist

Sculptor	Title	Material	Program	Completion date	Location
Alfred Lenzi	*Muse*	Plaster model	IAP	No date	Unknown
Louis Linck	*Ball Player*	Walnut wood	IAP	No date	Thornton Fractional High School Calumet City, IL (athletic trophy)
Hildreth Meiere	*The Post*	Bronze 5′ x 9′	Treasury Section	No date	Logan Square Post Office 2339 N. California Chicago, IL
Edgar Miller	*Animal Court* (6) animals	Limestone	TRAP	No date	Jane Addams House 1324 S. Loomis Chicago, IL
Peterpaul Ott	*Mercury*	Aluminum	Treasury Section	1938	Chicago Post Office 3750 N. Kedzie Avenue Chicago, IL
Peterpaul Ott	*Harvest*	Wood relief	Treasury Section	1941	Plano Post Office Plano, IL
Peterpaul Ott	No title	Wood carving	IAP	No date	Gage Park School Gage Park, IL
Peterpaul Ott	No title	Wood carving	IAP	No date	Haven School Evanston, IL
Peterpaul Ott	No title	(3) Wood panels	IAP	No date	Lincoln School Evanston, IL
Peterpaul Ott	No title	(7) Wood panels	IAP	No date	Washington School Evanston, IL

Sculptor	Title	Material	Program	Comple-tion date	Location
Peterpaul Ott	No title	Mixed media dioramas	IAP	No date	Nicholas School Evanston, IL
Peterpaul Ott	*Evolution of the Book* (6 panels), *Control of the Elements* (5 panels)	Mahogany wood	IAP	No date	Lane Technical High School 2501 W. Addison Chicago, IL (library)
Peterpaul Ott	*No title*	Wood (?)	IAP	No date	Plano Post Office Plano, IL
Louise Carolyn Paine	*Sundial*	Ceramic	IAP	No date	Oakton School Evanston, IL
Louise Carolyn Paine	*Girls Chased by Boy with Snake*	Ceramic relief	IAP	No date	Oak Park School Aurora, IL
Louise Carolyn Paine	*Elephant*	Glazed ceramic	IAP	No date	Board of Education Offices Oak Park, IL
Bernard Rosenthal	No title	(10) Walnut reliefs	IAP	No date	Museum of Science and Industry Chicago, IL
Robert I. Russin[a]	*Throwing the Mail*, and *Mail Handler*	Cast aluminum surface with gold foil	Treasury Section	1941	Evanston Post Office Evanston, IL
Armin A. Scheler[a]	*The Message*, and *The Answer*	Carved limestone reliefs	Treasury Section	1940	Evanston Post Office Evanston, IL
Felix Schlag	*Potter and His Burro*	Plaster relief	Treasury Section	1939	Whitehall Post Office Whitehall, IL
Felix Schlag	*Runner*	Mahogany	IAP	No date	Athletic Trophy Lawson School Chicago, IL

[a]Non-IAP artist

Sculptor	Title	Material	Program	Completion date	Location
Freeman Schoolcraft	*Postal Service, Native Indian, Agriculture,* and *Industry*	Limestone	IAP(?)	1939	Peoria Post Office Peoria, IL
Freeman Schoolcraft	*War Dead*	Wood panel	IAP	No date	University of Illinois Medical Center Chicago, IL
Freeman Schoolcraft	*Emblem*	Bronze	IAP	No date	Kiwanis International
Freeman Schoolcraft	*Decorative Panels*	Unknown	IAP	No date	Highland Park Shopping Center
Freeman Schoolcraft	*Portraits*	Unknown	IAP	No date	Michael Reese Hospital Chicago, IL
Freeman Schoolcraft	*Unknown*	Bronze and black granite bas-reliefs	IAP	No date	St. Xavier College Evergreen Park, IL
Freeman Schoolcraft	*The Young Lincoln*	Unknown	IAP	No date	Lincoln Elementary School Dixon, IL
Charles Umlauf	*Spirit of Communication*	Cast-stone relief 3′ x 5′	Treasury Section	1939	Morton Post Office Morton, IL
Charles Umlauf	*Paulding Industries*	Mahogany relief 4′ x 12′	Treasury Section	1940	Paulding Post Office Paulding, OH
Charles Umlauf	*Boys with Sea Forms*	Cast stone (2) 14′ high	IAP	1941	Lane Technical High School Chicago, IL (botanical garden)
Charles Umlauf	*Protection, and Mosaic Pool*	Cast stone 8′ high, mosaic tiles	IAP	1940	Lobby, Cook County Hospital, Chicago, IL

Sculptor	Title	Material	Program	Completion date	Location
Emmanuel Viviano	*Statue of a Girl*	Stone	IAP	No date	University of Illinois Medical Center Chicago, IL
Emmanuel Viviano	*Girl with Fish*	Gray limestone	IAP	No date	University of Illinois Medical Center Chicago, IL
Emmanuel Viviano	No title	Unknown	IAP	No date	Brookfield Zoo Brookfield, IL
Emmanuel Viviano	*Deer Alone, Deer and Fawn, Sheep,* and *Wart Hog*	Ceramic tile lunettes	IAP	No date	Nancy Hill School Aurora, IL
Emmanuel Viviano	*Animal Court*	Unknown	IAP	No date	Jane Adams House Chicago, IL
Emmanuel Viviano	Music, drama, education	Plaster models for niches	IAP	No date	Lane Technical High School Chicago, IL
John Wallace	(2) Drinking fountains	Cast stone	IAP	No date	Brookfield Zoo Brookfield, IL
John Winters	Animals, birds and plants	Glazed ceramic tiles 5½' x 12'	IAP	1940	Lobby, Cook County Hospital Chicago, IL
John Winters	*Animals*	Glazed ceramic tiles	IAP	No date	Hatch School Oak Park, IL

List of Index of American Design Completed Renderings

This list is compiled from *The Consolidated Catalog to the Index of American Design,* ed. Sandra Sheffen Tinkham (Cambridge: Chadwyck-Healey, Ltd., 1980); Kurt and Hildegarde Crosby Melzer, Scrapbook of Index of American Design news releases, and interview with the authors; and *John Walley, Selected Papers: John E. Walley, 1910–1974* (University of Illinois at Chicago).

ABERDEEN, HARRY G.
 Auger (walnut, wrought iron)
 Candlestick (iron)
 Gold Watch and Frame
 Gold Watch and Frame
 Gold Watch and Frame
 Gold Watchcase and Plate
 Gold Watch Dial and Frame
 Gold Watch Frame and Case
 Key-Wind Chronometer and Plate
 Locket for Perfume
 Silver Watch Dial Case and Frame
 Split-Second Sporting Watch
 Steam Fire Engine (iron, copper)
 Stove (iron)
 Tricycle
 Watch Case
 Whale Oil Lamp (pewter)

BATES, DOROTHEA
 Appliqué Quilt
 Fishnet Mender
 Toy Bank: *Punch and Judy*

BEILIN, A.
 Carved Bird and Nest (wood, paint)

BEVIER, MILTON
Betty Lamp (tin)
Blotter (lignum wood)
Candlestick
Coffee Mill (wood, metal)
Deer Figurine (painted chalk ware)
Resist Fabric (linen)
Toy Bank: *William Tell*
Trivet
Virgin and Child (wood, crown of gilded tin)

BLEWETT, WELLINGTON
Bed (birch)
Bed (natural walnut)
Bell — from Swedish Church
Bootjack
Boot Iron
Bowl (white birch)
Box for Nails and Pins
Buttermold (acorn and oak leaf, maple)
Buttermolds (maple wood)
Chair (rosewood)
Cradle (black walnut)
Cupboard (walnut)
Decorative Designs: *Upper Berths*
Decoy (pine)
Fireplace (mahogany)
Flask
Knife and Fork Holder (mahogany)
Mangle
Mannequin Shoe (cast iron)
Mirror (chippendale style, walnut)
Mirror (mahogany)
Panel (carved mahogany)
Panels and Designs
Panels from Upper Berths (Pullman coach)
Pitcher
Plate (flint glass)
Plate (wood)
Resist Pattern (pine, tin)
Resist Pattern (pine, tin strips)
Rush Holder (wrought iron)
Saltshaker
Seal (alloy)
Settee Chest (walnut)
Scissors (nickel-plated steel)

Sofa (rosewood, stained brown)
Table (mahogany)
Table (walnut)
Trammel (wrought iron)
Trivet
Two-Drawer Chest (walnut)
Vase (opaque glass)
Washing Flail
Woolen Parrot

BLUHME, OSCAR
Betty Lamp (brass)
Betty Lamp (tin)
Bit Brace (mahogany, brass, copper)
Currier's Shaving Knife
Dado Plane (maple)
Dagger and Sheath (gold, silver, steel)
Decoy (pine)
Hot Coal Carrier
Lantern (preformed tin)
Miner's Lamp (tin)
Mirror
Pinker and Wood
Popcorn Popper or Coffee Roaster
Pump Reamer
Scrimshaw: *Landing of Columbus* (walrus tusk)
Scrimshaw: *Swordfish Bill*
Scrimshaw (walrus tusk)
Scrimshaw (walrus tusk)
Spinning Wheel (oak)
Spiral Horse-Hay Fork
Teapot (Japanned tin)
Twin Sewing Bird

BODINE, JOHN
Spice Box
Tailor's Stove (cast iron, sheet iron)

BROOKS, ADELE
Salt Box (carved wood)

BROWN, H. LANGDEN
Accounting Desk (walnut)
Apple Peeler (wood, iron, steel)
Augur (unfinished oak)
Bandwagon
Betty Lamp (wrought iron)
Canteen (tin)
Ceiling Decoration (rough sand plaster)

Chalk Ware
Church Pew (walnut, maple)
Conestoga Wagon
Cross (hand-wrought iron)
Deer Figurine (painted)
Doorstop (cast iron)
Eyeshade (wood, fiber)
Fire Engine
Horse Comb (pine wood)
Mangle (pine)
Needle Case (cotton)
Rush Holder with Candle Socket (wrought iron)
Shoes
Spectacles (gold)
Stockings
Textile (centennial, cotton muslin)
Thread Cutter (maple, iron)
Ticket Pouch
Ticket Punch (nickel plated)
Toleware Inkwell (tin)
Weathervane (brass)
Woman's Dress
Wood Pin on Dowel Cutter
Wood-Turning Lathe

BUECHNER, EDWARD W.
Crock (white stoneware)
Nubian Card Tray (cast iron)
Paperweight (cast iron)
Toy Bank: *Jumping Dog*
Trick Bank: *Chinese Card Player*
Wallpaper Box

CHOMYK, MICHAEL
Augur (wood, iron)

CLARK, ROBERT
Carved Ivory Cane Head (ivory)
Flask
Hand Compass
Pipe (cherry)
Sewing Bird (brass)
Sleigh Bells
Tombstone
Toy Bank: *Eagle Feeding Her Young*
Toy Bank: *Negro Mammy*
Toy Train (cast iron)
Trivet

Watch Key
Watch Key (gold)

CLARKE, ETHEL
Bridal Box

ELVIS, ROBERTA
Bowl
Bowl (pressed glass)
Candlestick
Candlestick
Covered Dish (cut glass)
Cradle (black walnut)
Cruet (pressed glass)
Cup Plate
Earring
Flax Apron
Grain Cradle (ash, iron)
Home Collar for Burro
Jug (steamboat bar glass)
Mirror
Posset Pot (clay)
Scissors (steel)
Table (walnut)
Weathervane (iron)
Wooden Spoon (ash or maple)

FINLEY, WILLIAM
Copper Skillet (copper, iron legs)

FISH, PAULINE
Bottle

GIERMAN, EMILY
Embroidery Detail

GREGG, ARLINGTON
Iron

GROSSEN, HARRY
Bell
Boots (leather, metal toes)
Camphene Lamp (glass, brass alloy)
Clogs
Coffeepot (painted tin)
Doll (papier-mâché)
Hickory-Nut Doll
Lantern (tin, glass)
Panslider (tin slate, oak handle)
Petticoat Lamp (tin)
Scales
Shirtwaist

Stove (iron)
Thin-Cake Iron
Toy Boy and Goat (papier-mâché)
Toy Fire Engine
Toy Fire Engine (cast iron)
Trivet
Watch Key
Watch Key (gold, black enamel)

HACKNEY, MALCOLM

HAKE, OTTO E.
Base and Stand (walnut)
Bed (mahogany, oak)
Cigar-Store Indian (pine)

HUNTER, LILLIAN
Memorial Ring
Toy Rooster

JACKMAN, REVA
Pincushion

JACOBSON, EMANUEL
Pigeon Bank (chalk ware)

JULIUS, IVAR
Chalice
Clock Hand
Corn Jobber (birch)
Eggbeater (steel, oak)
Election Torch (tin)
Flambeaux (wrought iron)
Grospoint
Textile Pattern (cotton)

KIBBEE, EDWARD
Bedspread
Textile Coverlet

KIRBY, OAK ABNER
Embroidery
Hair Brooch

KIRSCHNER, GEORGE
Chair (Sheraton influence, cherry wood)
Chair (walnut)

KOEHL, JOHN
Bell Jar (wedding cake)
Bridal Chest (painted, carved with iron hinges)
Clock
Coffeepot (unpainted tin, punched design)
Document (paper)

Fractur (paper)
Picture Frame (walnut)
Powder Horn
Powder Horn (steer horn)
Sausage Grinder
Still Life and Frame (tin foil)
Whiskey Canteen (wood, leather)

KOEHN, ALFRED
Bed (walnut, natural finish)
Bible Box (pine wood, handmade nails)
Bicycle (wooded spoke wheels)
Chair (walnut)
Clock (stained mahogany)
Desk (walnut)
Doors (wood, rope)
Police Rattle (wood)
Printing Measure (iron)
Sconce (glass, metal)
Trivet

KROLL, ALFRED

KROLL, ELEANOR
Hitching Post (cast iron)

KROPP, WILLIAM A.
Inlaid Wood Panel

LONG, LOUELLA
Wallet (linen, flannel, cotton tape)

LUDWIG, WILLIAM
Bowl (china)
Candy Vessel (copper, iron handles)
Cape Cod Lighter
Cup and Saucer (china)
Knife, Fork, Spoon
Ladle (copper)
Pitcher
Pitcher (clay)
Spoon (tarnished silver dollar)
Trench Knife and Sheath (steel, wood, leather)

MAZUR, STANLEY
Bas-relief Plaque (sandstone)
Brooch and Earring
Bullet Mold
Cabinet
Candy Vessel (copper, iron handles)
Carriage Lamp (brass, tin, glass)
Cigar-Store Indian

Conductor [conduit] Head (tin)
Detail Sketch: *Memorial Picture of Hair*
Doll [Greiner Patented Head]
Doll: *Mabel Ellis* (china and cloth)
Figure (ash wood)
Figure: *Little Fanny*
Flintlock (iron, brass)
Grape Pomice Tongs (unfinished oak)
Grille from a Balcony in New Orleans (cast iron)
Hitching Post (cast iron)
Horseshoe (iron)
Hunting Horn (cow horn)
Indian (wood)
Jug (clay, salt glazed)
Knife and Fork (bone, steel)
Match Safe (iron)
Powder Flask (copper)
Powder Horn
Rabbit Figurine (painted chalk ware)
Religious Embroidery
St. Joseph (walnut)
Shoe
Shoeshine Footrest (cast iron)
Slave Handcuffs (iron)
Squaw (painted wood)
Squaw (wood)
Starch Strainer (brass)
Table (walnut)
Trivet
Virgin Mary (yellow poplar)
Wooden Plaque (walnut)

MCCOMBS, ORRIE
Saltshaker (pewter)
Saltshaker (pewter)
Trivet
Truck (calfskin)

MCENTEE, FRANK
Candy Ladle (copper)
Chicken (chalk ware)
Coffee Grinder (maple, cherry, iron)
Coffeepot (pewter)
Drinking Vessel (Loving cup) (oak)
Fly Catcher
Kettle Ring (cast iron)
Nutcracker (wrought iron)

Pannier Pockets
Pieboard (walnut)
Sewing Bird (brass, iron stalk)
Shoes
Squeak-toy kitten
Tailor's Shop Figure (wood)
Toaster
Toaster on Broiler
Toy Rooster
Woman's Corset

MELZER, KURT
Baby Carriage
Billethead (oak)
Brooch (diamonds, pearls. Spires bolted onto enamel)
Brooch (gold mesh, seed pearls)
Brooch (onyx, malachite, gold)
Bureau (walnut)
Cabinet
Chair
Chair (Louis XV style, mahogany)
Chair (poplar wood)
Chest (stained walnut)
Desk (walnut)
Dressing Case (walnut)
Grape Crusher (oak)
Key, Escutchen, Drawer Pulls from Wardrobe
Mirror Frame
Plate
Powder Flask (brass)
Ring
Sperm Oil Street Lamp (tin, glass)
Table (walnut)
Toy Bank: *Uncle Sam*
Walking Sticks

NAVIGATO, ROCCO
Decoy (pine)
Iron Sole
Kettle (iron)
Letter Box (wood, leather, brass)
Trivet

OPSTAD, ADOLPH
Appliqué Coverlet (detail)
Coverlet
Coverlet
Coverlet (detail)

Coverlet (detail) (blanket)
Coverlet (detail) (nun's veiling)
Coverlet (detail) (nun's veiling)
Cuspidor (iron, tin)
Frame (walnut)
Gatepost Finial (cast iron)
Memorial Picture (colored threads)
Potpourri Jar
Powder Flask (brass)
Sampler
Weathervane (cast iron, tin)

OSBOLD, JOHN
Painting on Velvet
Quilt Swatches

OWEN, MERRY
Butter Mold (six-pointed star)
Butter Molds (conventional leaf)

PETTZMAN, JACOB

PORTH, LAWRENCE
Candlestick
Table (oak)

REKUCKI, MICHAEL
Dagger and Sheath (steel, bone, leather)
Embroidered Picture
Teakettle (brass, wood)

RUDIN, ALBERT
Betty Lamp (brass)
Bootjack
Camp Lamp (iron and brass)
Corn-Husk Doll
Gros Point (wool threads, glass and metal beads on scrim)
Hand Saw and Wood Case
Knife and Sheath (steel, bone, leather)
Naval Clapper
Pistol
Roller Skates
Rolling Pin (beach wood)
Sausage Stuffer and Funnel
Ship Carving: *Gang Board* (walnut bound in brass)
Shoes
Trivet

SCHWABE, ERWIN
Teapot

SPIECKER, WILLIAM
 Barometer
 Building Bricks (clay)
 Butter Box
 Cravat and Box
 Flatiron (wrought iron)
 Jug (glazed clay)
 Jug (clay)
 Pot (clay)
 Pottery Jug (clay, brown glaze)
 Rocking Chair
 Sewing Bird
 Stereopticon
 Strawberry Basket (fir wood)
 Toy Bank: *Policeman*

THOMPSON, ARCHIE
 Bishop Hall Hotel Lantern (sheet iron, glaze)
 Broad Axe (iron, hickory)
 Broad Axe (iron, hickory)
 Butter Stamp (pinewood)
 Chair (stained walnut)
 Chair (walnut)
 Cherry Pitter (cast iron)
 Coffee Mill (pine, poplar)
 Compass
 Compass (black walnut)
 Composition Doll
 Dress Material (wool)
 Flail (oak, rawhide, leather)
 Hot-water Goose (iron)
 Jug (clay)
 Large Spoon (five silver dollars)
 Loving Cup (glazed, earthenware)
 Mirror
 Mittens
 Newel Post (walnut)
 Painting (oil)
 Paul Revere Print: *Boston Massacre*
 Plate (clay)
 Powder Flask (copper, brass)
 Primitive Doll (muslin body)
 Scissors (steel)
 Scissors (steel)
 Sewing Bird (wrought iron)
 Shoes

Stock (plaid stain, linen, cotton)
Textile (chintz)
Wooden Pitcher (birch or maple)

V A N D R E , B E S S I E
Bucket Yoke
Still Life (watercolor)

V O G E L , J O H N
Honey Dish

V O N L U T Z E , B E N J A M I N
Coverlet
Powder Flask (copper, brass)

W A L S H , H A R D I N
Coffeepot (copper)
Fire Extinguisher (wood)

W E N G E R , M .
Cowbell

W E S T , H E B I L L Y
Bottle
Table (cherry wood)
Wallpaper (smooth oatmeal texture paper)

W H I T E , W A Y N E
Apache Gun
Book with U.S. Seal (leather, paper, brass)
Cherry Pitter
Coffee Grinder (maple, cherry, iron)
Coffeepot (Japanned tin)
Door Knocker (brass)
Drum (Civil War, 9th Regiment, Vermont)
Fort Dearborn Doll (wooden)
Land Lamp (tinned iron)
Painted Panel from Pullman Car Interior
Sled
Straw Rake (oak)

W I N T E R S , J O H N
Plush-toy Dog
Pottery Pig: *Bottoms Up Drinking Vessel* (glazed clay)

U N K N O W N A R T I S T
Gilt Eagle (tin)
Toy Carriage

Weekly Federal Hiring Quotas for Illinois Employment

Date	IAP Employed	Federal Quota	Date	IAP Employed	Federal Quota
11/1/35	70		5/2/36	319	
11/27/35	133		5/5/36		334
12/4/35	143		5/15/36	323	334
12/11/35	145		7/10/36	325	340
12/18/35	161		7/14/36	328	
12/23/35	185		7/17/36	329	
12/25/35	175		7/19/36	325–30	
1/1/36	185		7/31/36	328	
1/8/36	189		8/3/36	321	
1/29/36	205		8/7/36	320	340
1/30/36	205		8/14/36	320	340
2/5/36	216		8/21/36	324	340
2/12/36	225		8/28/36	324	340
2/19/36	244		9/4/36	327	340
2/26/36	255		9/11/36	325	340
3/4/36	264		9/18/36	325	340
3/6/36	264		9/25/36	328	340
3/7/36	336		10/2/36	329	340
3/11/36	262		10/8/36	328	
3/18/36	334		10/16/36	328	340
3/20/36	334		10/23/36	329	
3/25/36	278		10/30/36	330	340
4/1/36	305		11/6/36	327	340
4/8/36	321		11/13/36	330	340
4/10/36	321		11/20/36	333	340
5/1/36	319		11/27/36	332	340

Source: Microfilm DC72 and DC73, Archives of American Art, and Folder 651.3, National Archives.
Note: Blank spaces indicate data not available.

Date	IAP Employed	Federal Quota	Date	IAP Employed	Federal Quota
12/4/36	335	340	10/13/37	224	
12/11/36	297	340	10/20/37	226	
12/18/36	298	300	10/27/37	226	
12/24/36	298		11/3/37	225	
12/31/36	296	300	11/10/37	224	
1/8/37	297	300	11/17/37	222	225
1/15/37	296	300	11/24/37	223	
1/22/37	296		12/1/37	223	228
1/29/37	295		12/8/37	224	228
2/5/37	295	300	12/15/37	227	
2/12/37	296		12/22/37	223	
2/19/37	297		12/29/37	223	228
2/26/37	298		1/5/38	223	
3/5/37	294	300	1/12/38	223	
3/12/37	289	300	1/19/38	225	228
3/19/37	289	310	1/26/38	225	
3/26/37	289	310	2/2/38	225	
4/2/37	290		2/9/38	225	
4/7/37	291	310	2/16/38	226	
4/14/37	292		2/23/38	226	231
4/21/37	289		2/25/38	226	
4/28/37	290	310	3/2/38	227	
5/5/37	294	310	3/16/38	230	232
5/12/37	300	310	3/23/38	232	
5/19/37	298	305	3/30/38	233	
5/26/37	293	305	4/6/38	230	
6/2/37	293		4/13/38	231	
6/9/37	293		4/20/38	238	232
6/16/37	295		4/27/38	241	232
6/23/37	289		5/4/38	241	
6/30/37	291		5/11/38	217	232
7/7/37	276		5/18/38	223	232
7/9/37	225		5/25/38	223	
7/14/37	234	305	6/1/38	226	
8/25/37	231	225	6/8/38	227	
9/1/37	227		6/15/38	230	232
9/8/37	226		6/22/38	231	
9/15/37	226		6/23/38	231	232
9/22/37	224	225	6/29/38	233	232
9/29/37	224		7/6/38	283	
10/6/37	224		7/13/38	282	332

Note: Blank spaces indicate data not available.

Date	IAP Employed	Federal Quota	Date	IAP Employed	Federal Quota
7/20/38	282		3/1/39	366	
7/27/38	297	332	3/22/39	352	370
8/3/38	307		4/5/39	362	
8/10/38	312	357	4/12/39	364	
8/17/38	316		4/19/39	367	
8/31/38	331		4/26/39	364	370
9/7/38	336	357	5/3/39	368	370
9/14/38	343	357	5/10/39	371	
9/21/38	346		5/17/39	373	370
9/28/38	349	357	5/24/39	375	
10/5/38	350	357	5/31/39	375	
10/12/38	352	357	6/7/39	370	370
10/15/38		375	6/14/39	369	
10/18/38		375	6/21/39	369	
10/19/38	348	375	6/28/39	366	
10/26/38	349		7/5/39	352	370
11/2/38	359	375	7/12/39	348	
11/9/38	366		7/19/39	348	
11/16/38	380	375	7/26/39	343	
11/26/38	397		8/2/39	389	370
12/28/38	419	375	8/9/39	401	370
1/15/39		370	8/16/39	403	
1/25/39	387		8/23/39	399	
2/15/39	370	370	8/31/39	280	370

Note: Blank spaces indicate data not available.

Federal Art Project Job Classifications and Salaries for Artists

The following information is a summary of artists' and administrators' job and salary classifications derived from individual records supplied by the National Personnel Records Center. This summary represents 60.5 percent of the records of those artists and administrators listed in appendix A.

As the IAP and the federal bureaucracy developed, job classifications and their attendant salary scales became more profuse. The predominant example of this followed the 1 September 1939 reallocations. On 2–4 January 1940, most artists were shifted to two expanded classifications, artist grade 1 and artist grade 2, which added four additional wage scales and made room for more artists on the rolls. These expanded classifications were operative until the end of the IAP.

Many artists entered the IAP after having been hired by the WPA in laborer or common laborer classifications. As the IAP grew, many artists moved into other art-related classifications such as draftsman (tracer and map maker), mold maker, commercial artist, art instructor, and handicraft worker. Later, many were transferred to other WPA positions such as recreation leader, seamstress, or vocational trainee. The high point for these other classifications (draftsman, trainee, and vocational trainee) occurred between late 1939 and 1943, as they specialized in the war effort.

Administrative salaries in the middle management supervisor and superintendent classifications differed radically according to no discernible pattern. In subsequent moves to a higher classification, some

administrators took cuts in pay before again securing higher salaries. One could also move up in salary in a shift from a higher- to a lower-level job. Although we do not have records for four key administrators, we do have sufficient information to offer a reasonable view of the wages in administrative positions. Finally, we should note that the positions of supervisor of art and superintendent of art, and their variants, ran during the early part of the IAP from 1935 to early 1941. The project technician and unit supervisor positions, and their variants, began in late 1939 and expired with the project in May 1943.

Although several wage scales existed within each job classification, most of the salaries for professional and technical artists ranged from $87.60 to $94.90 monthly, with $94.00 being the predominant wage; skilled artists earned $85.00 per month. On 9 July 1935, a 10 percent adjusted increase raised the salaries to a maximum of $103.40 for professional and technical artists and $93.50 for skilled artists. Thus, hourly salaried artists' wages were based, until 1939 when the hourly prevailing wage (union influence) was abandoned, on a maximum of eight hours per day and forty hours per week. By March 1936, artists were expected to work a minimum of 120 hours per month, not the earlier 96. Artists could not exceed 140 hours per month or the maximum salary as established by the ERA Act of 1936.[1]

Working hours were reduced in order to make the prevailing hourly rate conform to the monthly security rate [WPA base pay from the 1936 ERA Act]. Thus within a given project division, workers in different categories worked a different number of hours a month; even workers in the same category (e.g., professional and technical) did not work the same hours per month if the prevailing hourly rates for each group were not the same. This made it difficult, and at times impossible, to synchronize hours of work of workers on a given project division. Thus both quality and continuity of supervision suffered. . . . Furthermore, the morale that comes from regularity of hours within a working group was lacking, and workers with higher hourly wages and correspondingly shorter hours not infrequently accepted private employment in their leisure time—a practice that aroused the jealousy both of fellow project workers and of those in private employ, who saw in the practice a threat to their own security.[2]

TABLE F-1

Summary of Artists' Wage Scales

	Hourly	Weekly	Monthly	Yearly
CWA				
Artist, Class A	$38.25			
Artist, Class B	$23.85			
ILLINOIS ART PROJECT				
	$1.00	$30.00	$94.00	$1,128.00
	.91	27.30	94.00	1,128.00
		to 28.41	to 103.40	to 1,240.80
	.79	23.73	94.90	1,138.80
	.78	23.50	94.00	1,128.00
	.77	23.10	92.40	1,108.80[a]
	.76	22.80	91.20	1,094.40
	.75	22.43	89.70	1,076.40
	.74	22.30	89.20	1,070.40
	.73	21.90	87.60	1,051.20
	.713	21.40	85.60	1,027.20[a]
	.71	21.25	85.00	1,020.00
	.70	21.13	84.50	1,014.00[a]
	.691	20.72	82.86	994.32[a]
	.69	20.70	82.80	993.60
	.66	19.80	79.20	950.40[a]
	.64	19.25	77.00	924.00[a]
	.639	19.18	76.70	920.40[a]
	.63	18.95	75.80	909.60[a]
	.59	17.70	70.80	849.60[a]
	.58	17.50	70.00	840.00[a]
	.57	17.10	68.70	820.80[a]
	.54	16.20	64.80	777.60[a]
	.53	15.90	63.60	763.20[a]
	.50	15.00	60.00	720.00[a]
	.46	13.75	55.00	660.00[a]

[a]Infrequently used salaries

TABLE F-2

Job Classifications and Salaries for Artists

Classifications and Salaries	Range of Dates of Employment
1. Professional and Technical Artist(s)	
$77.oo/mo*	12/5/35 to 4/2/36
94.oo/mo	10/31/35 to 12/28/36
2. Professional and Technical Artist(s) Wage Class P (Professional and Technical)	
94.oo/mo	10/31/35 to 7/17/36
3. Senior Artist	
.73/hr (87.6o/mo)	3/19/38 to 5/16/41
1.oo/hr	11/18/36 to 6/3/40
82.8o/mo	11/7/38 to 7/1/39
84.5o/mo	12/8/39 to 1/3/40
85.oo/mo	11/13/39 to 5/22/42
94.oo/mo	10/26/35 to 12/26/42
94.9o/mo	12/5/36 to 11/8/39‡
4. Senior Artist, Wage Class S (Skilled)	
.73/hr (87.6o/mo)	10/26/36 to 7/25/39
94.oo/mo	10/26/36 to 7/25/39
5. Senior Artist, Wage Class P (Professional and Technical)	
.5o/hr* (6o.oo/mo)	to †
.53/hr* (63.6o/mo)	to †
.54/hr* (64.8o/mo)	to †
.59/hr* (7o.8o/mo)	to †
.73/hr (87.6o/mo)	10/26/36 to 12/31/39
1.oo/hr	6/27/37 to 12/16/39
85.oo/mo	to †
87.6o/mo	to †
94.oo/mo	10/31/35 to 2/26/42
94.9o/mo	11/2/35 to 1/3/40
6. Artist Senior	
.73/hr (87.6o/mo)	9/2/36 to †
1.oo/hr	5/10/38 to 3/3/39
94.oo/mo	7/25/38 to 11/19/39‡

* Wages most frequently assigned to artists outside of Chicago

† Dates were unavailable although a salary had been given.

‡ Artists, while still remaining in the same job classification, were moved from one wage scale to another without notation in the records.

Note: Salaries listed by the Records Center as hourly rather than monthly have their monthly equivalent computed following the hourly rate in the summary of artists' wage scales. These figures are based on thirty-hour work weeks.

Classifications and Salaries	Range of Dates of Employment
7. Artist Senior, Wage Class P (Professional and Technical)	
.73/hr (87.60/mo)	5/10/38 to 11/17/39
1.00/hr	4/13/38 to 1/3/40
91.20/mo	4/7/42 to 3/2/43
94.00/mo	4/6/36 to 9/18/39
8. Artist Senior, Applied Art	
94.00/mo	to †
9. Artist	
.69/hr (82.80/mo)	11/9/38 to 5/9/40
.73/hr (87.60/mo)	3/30/39 to 5/5/39
.77/hr (92.40/mo)	4/13/36 to 6/2/36
.91/hr	9/19/38 to 5/9/40‡
1.00/hr	1/24/39 to 10/25/39
77.00/mo*	3/16/36 to 9/2/36
82.80/mo	8/27/40 to 7/8/41
87.60/mo	5/2/39 to 5/16/41
89.70/mo	10/25/39 to 4/15/41
90.00/mo	12/16/35 to 11/21/39
94.00/mo	11/1/35 to 3/28/41
94.90/mo	12/3/39 to 3/18/40
96.36/mo	1/4/40 to 5/3/40
10. Artist, Wage Class P (Professional and Technical)	
.91/hr	to †
87.60/mo	1/4/40 to 11/20/41
94.00/mo	10/27/35 to 7/20/36
94.90/mo	1/4/40 to 11/20/41
11. Artist, Wage Class S	
.66/hr (79.20/mo)	4/7/39 to †
.69/hr (82.80/mo)	10/25/39 to 11/16/39
.73/hr (87.60/mo)	9/19/38 to 1/3/40
.79/hr (94.90/mo)	10/13/39 to 1/3/40
.91/hr	9/19/38 to 12/18/39
70.00/mo*	1/27/36 to 4/3/36
89.70/mo	11/17/39 to 12/31/39
91.20/mo	11/21/41 to 2/8/43

* Wages most frequently assigned to artists outside of Chicago

† Dates were unavailable although a salary had been given.

‡ Artists, while still remaining in the same job classification, were moved from one wage scale to another without notation in the records.

Note: Salaries listed by the Records Center as hourly rather than monthly have their monthly equivalent computed following the hourly rate in the summary of artists' wage scales. These figures are based on thirty-hour work weeks.

Classifications and Salaries	Range of Dates of Employment
94.90/mo	3/29/39 to 7/19/39‡
12. Artist, Applied Art(s)	
94.00/mo	to †
13. Artist, Applied Art(s), Wage Class P (Professional and Technical)	
94.00/mo	to †
14. Artist, Class 1	
87.60/mo	7/17/40 to 5/9/41
91.20/mo	3/27/41 to 3/4/43
94.90/mo	7/17/40 to 5/19/41
15. Artist, Class 1, Grade P (Professional and Technical)	
87.60/mo	6/9/40 to 12/13/40
16. Artist, Grade 1	
.91/hr	2/23/39 to 12/7/39
1.00/hr	8/11/38 to 4/14/41
55.00/mo*	3/11/40 to 7/15/41
70.80/mo*	to †
75.80/mo*	to †
76.70/mo*	to †
82.86/mo	10/7/40 to 3/ /41
87.60/mo	11/16/38 to 4/7/43
91.20/mo	8/7/39 to 3/4/43
94.00/mo	10/31/39 to 6/5/42
94.90/mo	12/7/39 to 7/16/41
17. Artist, Grade 1, Wage Class P (Professional and Technical)	
87.60/mo	11/19/39 to 3/4/43
91.20/mo	4/22/41 to 3/4/43
94.00/mo	1/3/40 to 3/28/41
94.90/mo	11/4/39 to 11/28/41
18. Artist, Grade 2	
.64/hr (77.00/mo)	1/2/40 to 1/17/40
.66/hr* (79.20/mo)	to 1/17/40†
.69/hr* (82.80/mo)	4/15/41 to 7/7/41
77.00/mo	12/27/39 to 2/17/40
79.20/mo	1/17/41 to †

* Wages most frequently assigned to artists outside of Chicago

† Dates were unavailable although a salary had been given.

‡ Artists, while still remaining in the same job classification, were moved from one wage scale to another without notation in the records.

Note: Salaries listed by the Records Center as hourly rather than monthly have their monthly equivalent computed following the hourly rate in the summary of artists' wage scales. These figures are based on thirty-hour work weeks.

Classifications and Salaries	*Range of Dates of Employment*
82.80/mo	11/18/38 to 8/21/41
87.60/mo	1/2/40 to 4/30/43
89.20/mo	to †
89.70/mo	1/2/40 to 7/15/41
91.20/mo	11/4/39 to 7/16/41
19. Artist, Grade 2, Wage Class S (Skilled)	
82.80/mo	1/3/41 to 8/17/42
87.60/mo	to †
91.20/mo	1/4/40 to 2/3/40
20. Junior Artist	
.66/hr (79.20/mo)	to 11/24/36†
.91/hr	7/10/37 to 8/31/39
85.00/mo	10/10/36 to 7/4/38
85.60/mo	7/18/38 to 9/25/38
94.00/mo	6/30/38 to 7/18/38
21. Junior Artist, Wage Class S (Skilled)	
.91/hr	8/16/37 to 9/18/38
85.00/mo	11/4/36 to 9/1/37
22. Artist Junior	
.91/hr	7/25/38 to 9/18/38
89.70/mo	9/19/38 to 8/17/39
23. Artist Junior, Wage Class S (Skilled)	
.91/hr	to †
85.00/mo	10/27/36 to 7/11/37
24. Skilled Artist	
70.00/mo	1/27/36 to 4/3/36
85.00/mo	1/29/36 to 8/27/36
25. Skilled Artist, Wage Class S (Skilled)	
85.00/mo	to †
95.00/mo	to †
26. Skilled Artist, Applied Art	
85.00/mo	to †
27. Assistant to Artist(s)	
85.00/mo	11/21/35 to 8/31/39

* Wages most frequently assigned to artists outside of Chicago
† Dates were unavailable although a salary had been given.
‡ Artists, while still remaining in the same job classification, were moved from one wage scale to another without notation in the records.

Note: Salaries listed by the Records Center as hourly rather than monthly have their monthly equivalent computed following the hourly rate in the summary of artists' wage scales. These figures are based on thirty-hour work weeks.

Classifications and Salaries	*Range of Dates of Employment*
28. Assistant to Artist(s), Wage Class S (Skilled)	
85.oo/mo	5/18/36 to 8/31/39
29. Assistant to Artist(s), Applied Art	
85.oo/mo	to †
30. Assistant Artist(s)	
70.oo/mo*	4/3/36 to 9/3/36
85.oo/mo	10/31/35 to 7/11/37
95.oo/mo	to †
31. Assistant Artist(s), Wage Class S (Skilled)	
85.oo/mo	9/2/36 to 11/3/36
32. Assistant Artist(s), Applied Arts, Wage Class S (Skilled)	
85.oo/mo	6/22/36 to 10/26/36
33. Skilled Assistant Artist	
85.oo/mo	11/12/35 to 11/24/36
34. Skilled Assistant to Artist(s)	
70.oo/mo	to †
85.oo/mo	11/21/35 to 7/17/36
35. Assistant Skilled Artist, Wage Class S (Skilled)	
85.oo/mo	3/9/36 to †
36. Artists Helper	
55.oo/mo	7/26/39 to 8/17/39
37. Senior Art Critic	
1.oo/hr	5/9/38 to 4/21/39
38. Senior Art Critic, Wage Class P (Professional and Technical)	
1.oo/hr	5/10/38 to 7/10/38
39. Art Critic Senior	
1.oo/hr	5/9/38 to †
40. Art Critic Senior, Wage Class P (Professional and Technical)	
1.oo/hr	to †
94.oo/mo	to †
41. Art Critic, Wage Class P (Professional and Technical)	
94.oo/mo	to †
42. Art (Artist) Critic, Grade 1, Wage Class P (Professional and Technical)	
1.oo/hr	1/4/40 to 1/15/40

* Wages most frequently assigned to artists outside of Chicago

† Dates were unavailable although a salary had been given.

‡ Artists, while still remaining in the same job classification, were moved from one wage scale to another without notation in the records.

Note: Salaries listed by the Records Center as hourly rather than monthly have their monthly equivalent computed following the hourly rate in the summary of artists' wage scales. These figures are based on thirty-hour work weeks.

Classifications and Salaries	Range of Dates of Employment
87.60/mo	2/28/40 to 7/1/41
91.20/mo	8/18/41 to 3/4/43
43. Junior Art Critic	
.91/hr	to †
44. Art Critic, Junior	
.91/hr	to †
45. Commerical Artist	
94.00/mo	12/4/35 to 12/9/35
46. Commercial Artist, Wage Class P (Professional and Technical)	
94.00/mo	11/26/35 to 3/31/36

* Wages most frequently assigned to artists outside of Chicago
† Dates were unavailable although a salary had been given.
‡ Artists, while still remaining in the same job classification, were moved from one wage scale to another without notation in the records.

Note: Salaries listed by the Records Center as hourly rather than monthly have their monthly equivalent computed following the hourly rate in the summary of artists' wage scales. These figures are based on thirty-hour work weeks.

TABLE F-3
Job Classifications and Salaries for Administrators

	Month	Year
1. State Deputy Administrator	$500.00 to $680.00	$6,000.00 to $8,160.00[a]
2. Senior Administrative Officer		
Grade 14	400.00	4,800.00
3. Junior Administrative Officer		
Grade 12	320.00	3,840.00
4. State Supervisor P&S		
Grade 12, Travel Included	175.00 to 325.00	2,100.00 to 3,900.00
5. State Director	250.00 to 300.00	3,000.00 to 3,600.00[a]
6. Assistant State Director	200.00 to 225.00	2,400.00 to 2,700.00
7. Supervisor of Operations	200.00	2,400.00
8. State Supervisor	280.00 to 300.00	3,360.00 to 3,600.00
9. Assistant State Supervisor		
Wage Class 4[a]	237.00	2,844.00
Wage Class 4, Grade 6	210.00	2,520.00
Wage Class 4, Grades 7–7B	237.00 to 276.36	2,844.00 to 3,316.32
10. District Supervisor		
Grade 12	175.00 to 280.00	2,100.00 to 3,360.00
11. Assistant District Supervisor		
Grade 8	175.00	2,100.00
12. Field Consultant	175.00	2,100.00
13. Project Technician		
Wage Class 4	120.00	1,440.00
Wage Class 6	191.67 to 300.00	2,300.04 to 3,600.00
14. Assistant Project Technician	162.40	1,948.80
Wage Class 3, Grade 6	.00	.00[a]

[a] Limited or no information available.
[b] For three days only.

	Month	Year
Wage Class 4, Grade 1	145.60	1,747.20
Wage Class 4, Grade 5	201.00	2,412.00
Wage Class 4, Grade 6	187.60 to 210.00	2,251.20 to 2,520.00
Wage Class 4, Grades 6D–6E	205.60 to 210.60	2,467.20 to 2,527.20
Wage Class 4, Grade 6 SU	219.60 to 245.28	2,635.20 to 2,943.36
15. Unit Supervisor	120.00 to 243.04	1,800.00 2,916.48
Wage Class SU	120.00	1,440.00
Wage Class 2	150.00 to 152.40	1,800.00 to 1,828.80
Wage Class 2	200.00	2,400.00[b]
Wage Class 3, Grade 5	120.40	1,444.80
Wage Class 4, Grade 4	152.40	1,828.80
Wage Class 4, Grade 5	128.80	1,545.60
Wage Class 4, Grades 7–7D	145.60 to 240.80	1,747.20 to 2,889.60
16. Assistant Unit Supervisor		
Wage Class 4, Grade 7	189.28	2,271.36
Wage Class SU, Grade 6	170.00 to 170.80	2,040.00 to 2,049.60
Wage Class SU, Grade 7	189.28	2,271.36
17. Supervisor of Art	120.00 to 175.00	1,440.00 to 2,100.00
Wage Class 1	150.00	1,800.00
Wage Class 2	175.00 to 200.00	2,100.00 to 2,400.00
Wage Class 3	200.00	2,400.00
Wage Class 4, Grade 5	128.80	1,545.60
Wage Class 4, Grade 7C	159.60 to 171.00	1,915.20 to 2,052.00
18. Assistant Supervisor of Art	125.00 to 150.00	1,500.00 to 1,800.00

[a] Limited or no information available.
[b] For three days only.

	Month		Year	
Wage Class 1	125.00 to	150.00	1,500.00 to	1,800.00
Wage Class 2	125.00 to	150.00	1,500.00 to	1,800.00
19. Project Supervisor		201.00		2,412.00
Wage Class 4, Grade 6C		216.00		2,592.00
20. Area Supervisor		156.00		1,872.00
21. Area Project Supervisor	145.60 to	156.00	1,747.20 to	1,872.00
22. Architectural Supervisor		125.00		1,500.00
23. Assistant Director, Poster Division		85.00		1,020.00
24. Superintendent of Art		175.00		2,100.00
Wage Class 1	125.00 to	150.00	1,500.00 to	1,800.00
Wage Class 2	125.00 to	200.00	1,500.00 to	2,400.00
Wage Class 3	150.00 to	200.00	1,800.00 to	2,400.00
25. Assistant Superintendent of Art		125.00		1,500.00
Wage Class 1		125.00		1,500.00
Wage Class 2 + 5.00 to 10.00 for travel	125.00 to	135.00	1,500.00 to	1,620.00
Wage Class 3 + 10.00 to 15.00 for travel	160.00 to	165.00	1,920.00 to	1,980.00
26. Skilled Foreman		120.00		1,440.00
Wage Class 2		108.00		1,296.00

Summary of Completed IAP Art Production through 31 January 1940

The following information, taken from George Thorp's WPA twelve-month "Project Proposal" for 1940–41, Fred Biesel Papers, Archives of American Art, totals what and how much the IAP produced through 31 January 1940.

Since the totals indicated here do not match those in the appendixes dealing with murals, sculpture, and the IAD (see appendixes B through D), some clarification is needed. First, we have listed in appendix B those murals that were begun and those not completed for a total of 233 murals completed. Appendix C lists only those sculptures commissioned by the Treasury Section or by the IAP. In appendix D, we list 493 completed plates in the IAD.

Works Completed through 31 January 1940

1.	Murals in all media—allocated	316
2.	Sculpture in all media (including wood carving, ceramics, etc.)	563
3.	Easel paintings, all media, completed	4,923
4.	Posters and applied arts completed (posters, graphs, charts, illustrations, etc.)	750,362
5.	Dioramas and models	47
6.	IAD plates	448
7.	Photographs	9,932
8.	Exhibitions throughout the state	235
9.	Attendance at exhibitions	606,000
10.	Art and Craft classes	

 a. Held at settlement houses or other nonprofit edu- 56
 cational and recreational institutions
 b. Number of classes per week 230
 c. Average attendance per week 3,500
11. Public agencies the IAP has served 650

Illinois Art and Craft Project Approved Orders, 7 January to 30 June 1943

TABLE H-1
Approved Orders: Orders in Process

Sponsor	Description	Estimated Completion Date	Delivered
Air Force Technical School, Stevens Hotel	1 display	31 January 1943	
Army Medical School, 13th General Hospital, 808 S. Wood St., Chicago, Illinois	50 medical plastic models	28 January 1943	
	100 medical charts	31 May 1943	Partially Delivered
Federal Security Agency, Office of Defense, Health & Welfare, 105 W. Adams St., Chicago, Illinois	1,050 silk screen charts	1 May 1943	
Great Lakes Naval Training Station, Great Lakes, Illinois	22 charts "Principles of A.C. Motors"	15 January 1943	

Source: Illinois Art and Craft Project "Approved Orders," 7 January to 30 June 1943, Fred Biesel Papers, Archives of American Art.

TABLE H-1 — *Continued*

Sponsor	Description	Estimated Completion Date	Delivered
	5 schematics of electric hydraulic control	20 Januray 1943	
	22 charts "Principles of A.C. Motors"	February 1943	
	5 charts "Browning Machine Gun"	25 March 1943	
	13 charts "Browning Machine Gun"	25 March 1943	
	60 torpedo charts	15 May 1943	Partially Delivered
	300 naval machinery ordnance charts	1 June 1943	Partially Delivered
	60,000 covers for insurance booklets	30 June 1943	Partially Delivered
	60,000 recruiting hand books	30 June 1943	Partially Delivered
Illinois Department of Health	300 line-drawing illustrated pamphlets	30 June 1943	Partially Delivered
Naval Aviation Training School, Navy Pier, Chicago, Illinois	42 charts "History of Aeronautics"	1 March 1943	
Naval Instructional Training School, 89th & Anthony, Chicago, Illinois	30 charts, "Cross Section Cuts of Fuel Pump"	18 March 1942	Partially Delivered
	1 projectile chart	7 January 1943	
	2 charts, "Goodyear Hydr. Disc Brakes"	1 February 1943	Partially Delivered

TABLE H-1 — *Continued*

Sponsor	Description	Estimated Completion Date	Delivered
	14 charts, "Vickers Power Brake-Cross Section"	1 February 1943	
	16 charts, "Hydraulic Control of Aircraft Brake"	1 February 1943	Partially Delivered
	3 models "Sperry Gyro Indicator"	1 February 1943	
	17 aviation ordnance charts	15 February 1943	
	21 charts "History of Aeronautics"	1 March 1943	
	48 charts, "Cross Section of Airplane Carburetors"	25 March 1943	Partially Delivered
	10 Charts, "Landing Gear Power Brake"	10 April 1943	Partially Delivered
	9 charts, "Cross Section Cuts of Holley Aircraft Carburetor"	1 May 1943	
	24 charts, "Clearance Diagram of Holley Aircraft Carburetor"	1 May 1943	
O.C.D., 25 N. Wacker Dr., Chicago	12,000 educational and defense posters	1 February 1942	975 Delivered

TABLE H-1 —*Continued*

Sponsor	Description	Estimated Completion Date	Delivered
Operating & Training Div., 6th Service Command, New Post Office, Chicago	1 globe model 15 terrain charts	1 January 1943	Partially Delivered
	2 bomb models, 18 charts "Vessicant of Bombs" model	25 January 1943	Partially Delivered
Savanna Ordnance School, Proving Ground, Illinois	125 camouflage charts	1 February 1943	Partially Delivered
	1800 ammunition component charts	28 February 1943	Partially Delivered
	36 charts "Landing Operations & Supply Lines"	1 June 1943	
State Director Service Division, Merchandise Mart, Chicago	480 camouflage charts	1 June 1943	
University of Illinois, 800 S. Wood St., Chicago, Illinois	8 models "Human Deciduous Teeth"	31 January 1943	
U.S. Coast Guard, Public Relations, 610 S. Canal St., Chicago, Illinois	14 model buoys — 2 shipping cases	10 January 1943	Partially Delivered
	4 lighthouse models	1 February 1943	
	1 diorama — 4' x 5' x 18"	28 February 1943	
	100 charts	15 March 1943	30 Delivered, No Spec. on balance
U.S. Naval Armory, Ft. Randolph St., Chicago, Illinois	300 charts "Venereal Disease"	15 June 1943	Partially Delivered

TABLE H-1 — *Continued*

Sponsor	Description	Estimated Completion Date	Delivered
U.S. Naval Training Station, Great Lakes, Illinois	500 rating charts	1 March 1943	
Visual Aid, 510 N. Dearborn St., Chicago	48 charts & 24 manuals on camouflage	30 June 1943	
War Services Program, 510 N. Dearborn St., Chicago, Illinois	5 panels for "Social Diseases Combat Propaganda"	1 February 1943	

TABLE H-2

Approved Orders: Orders Not Started

Sponsor	Description	Estimated Completion Date	Delivered
Great Lakes Naval Training Station, Great Lakes, Illinois	1 chart "General Arrangement of 4″ Mount Mark XII"	1 February 1943	No Materials
	4 charts, practical electricity	1 February 1943	No Materials
	4 charts, steps in advancement	1 February 1943	No Materials
	4 charts, cable markings	15 February 1943	No Materials
	3 signal charts	10 March 1943	No Materials
	5 charts, miscellaneous instructional purposes	15 March 1943	No Materials
	26 alternating current charts	15 March 1943	No Materials
	50 charts, industrial & practical electricity	20 March 1943	No Materials
	18–24″ models naval training planes		No Materials
	4 charts, turret compartment	1 April 1943	No Materials
	23 charts, industrial electricity		No Materials
	4 miscellaneous instructional charts	1 April 1943	No Materials

Source: Illinois Art and Craft Project "Approved Orders," 7 January to 30 June 1943, Fred Biesel Papers, Archives of American Art.

TABLE H-2 — *Continued*

Sponsor	Description	Estimated Completion Date	Delivered
	66 charts, alphabet & code	1 April 1943	No Materials
	1 topographical map of Great Lakes	30 June 1943	No Materials
Naval Instructional Training School, 89th & Anthony, Chicago, Illinois	6 arc welding charts	1 February 1943	Awaiting specifications and materials
	9 charts, maintenance of gyro instrument	15 March 1943	No Materials
	2 charts, cross section Holley & Stromberg Carburetor	1 April 1943	No Materials
Navy Inspector Dept., Recruiting Service, Board of Trade Bldg., Chicago, Illinois	1,000 charts, naval rating badges	20 March 1945	No Materials
Savanna Ordnance School, Savanna, Illinois	12 charts, enlarged photos and cut profilm		No Materials
	1 ammunition rotating display stand	1 February 1943	Insufficient Data Waiting Materials
	24 peg boards, 500 pegs, 5 frames	30 June 1943	Awaiting specifications and materials
U.S. Coast Guard, 610 S. Canal St., Chicago	25 shipping cases	1 February 1943	Awaiting specifications and materials
	2 life saving station models, 2 shipping cases	15 February 1943	Awaiting specifications and materials
	2 beach cart models, 2 shipping cases	15 February 1943	Awaiting specifications and materials

TABLE H-2 —*Continued*

Sponsor	Description	Estimated Completion Date	Delivered
	7 wooden ship models, 7 shipping cases	15 February 1943	Awaiting specifications and materials
Visual Aids, War Services Program, 510 N. Dearborn St.	250 models, communication separators	1 February 1943	Awaiting specifications and materials
	30 radio school log locators	1 February 1943	Awaiting specifications and materials
War Information Center, War Services Program	200 cardboard posters, patriotic designs		Awaiting approval of designs

Notes
Bibliography

1. William McDonald, In *Federal Relief Administration and the Arts: The Origins and Administrative History of the Arts Project of the WPA* (Columbus: Ohio State University Press, 1969), 422–79, notes that the three-pronged thrust of FAP efforts were in art production, art education, and art research (see p. 422). Within the art production category was a variety of designations that included projects, divisions, departments, units, sections, and components. Rarely were these consistently applied, but they were flexible enough to meet the demands and abilities of each state's pool of available artists and sponsors.

Coupled with the confusion over headings is the question of just how many of these productive activities there were. Cahill in the WPA pamphlet *Federal Art Project Manual* of October 1935 (see pp. 10–19), identifies ten "working procedures" (see p. 10), including a catch-all "Other" for the possibility of adding later efforts in drafting, chart and graph making, model making, stage and costume design, and so on (see p. 19). It is clear from our research that these ten "working procedures" (see p. 10) did not suit every state's needs. *The Illinois Manual for Federal Project No. 1* of 15 December 1937 (see p. 4), indicated twelve project units: Mural Painting; Easel Painting; Sculpture; Applied Arts; Posters, Signs, etc.; Arts and Crafts; Photography; Lectures, criticism, and preparation of Catalogs and Pamphlets; Circulating exhibitions of art; Art teaching; Operation of experimental art galleries; Index of American Design; and Other. The Illinois Art Project had a variety of designations that were at variance with the *Illinois Manual*. Early letters, such as one from Holger Cahill to Increase Robinson 5 February 1936, DC61 Archives of American Art and another, Increase Robinson to Thomas Parker 14 October 1936, DC61 Archives of American Art, used "projects" to designate the artistic endeavors (Easel, Mural, Sculpture, Diorama, and Poster Projects) and, equally confusing, the I AP itself. A flyer, "Many Chicago Artists Employed by W.P.A.," August 1936, Chicago Public Library, indicated nine "departments." Clark Sommer Smith in his "Nine Years of Federally Sponsored Art in Chicago: 1933–1942," master's thesis, University of Chicago, 1965, states from a 1938 Art Institute catalogue, *Art for the Public,* that there were twelve "Divisions" of the I AP (see p. 18). A June 1939 exhibition catalogue of the Illinois WPA Federal Art Gallery indicated ten "divisions."

Strictly for clarification purposes, we will use the word "division" to designate the larger category of artistic activity such as Mural, Easel, Sculpture, etc., and "unit" to designate a particular production activity (i.e., the

Wood-Carving Unit of the Sculpture Division). The number of divisions within the IAP, at any given time, varied, but over the life of the IAP one can identify sixteen different divisions: Easel, Mural, Sculpture, Diorama, Poster, Ceramics, Exhibition, Index of American Design, Photography, Graphic Arts, Advertising Design, Painting in Colors, Wood Carving, Prints, Stained Glass, and Mosaic.

INTRODUCTION

1. See the "Books" section of the Bibliography below.

2. David A. Shannon, ed., *The Great Depression* (New York: Prentice Hall, 1964), ix.

3. Shannon, 52.

4. Shannon, 14.

5. Ray Lyman Wilbur and Arthur Mastick Hyde, *The Hoover Policies* (New York: Charles Scribner's Sons, 1937), 434; Robert S. McElvaine, *The Great Depression: America, 1929–1941* (New York: New York Times Books, 1984), 90; and Shannon, 35.

6. Herbert Hoover, *The Memoirs of Herbert Hoover: The Great Depression, 1929–1941,* vol. 3 (New York: Macmillan Co., 1952), 143.

7. Hoover, 150–51.

8. Hoover, 107–11; Wilbur and Hyde, 427–34; Edwin P. Hoyt, *The Tempering Years* (New York: Charles Scribner's Sons, 1963), 77 and 44–76 for a general background on Hoover's years as President; and William McDonald, *Federal Relief Administration and the Arts: The Origins and Administrative History of the Arts Projects of the WPA* (Columbus: Ohio State University Press, 1969), 15–16.

9. McElvaine, 88.

10. For more information on Edward Bruce, see Williams Ayrshire, "The Diversity of Edward Bruce," *International Studio* (December 1927); L. M., "The Art of Edward Bruce," *American Magazine of Art* (February 1930); and "Portrait of a Contented Man," *Fortune* (May 1931).

11. McDonald, 366; Richard D. McKinzie, *The New Deal for Artists* (Princeton: Princeton University Press, 1973), 27; and Holger Cahill, "Artists in War and Peace," *The Studio,* 130 (628) (July 1945): 1–16.

12. McDonald, 68.

13. This controversy has been addressed by a number of authors. See Edward C. Banfield, *The Democratic Muse* (New York: Basic Books, 1984); McDonald, 70, 100–1, and 112–13; and McKinzie, 8, 18, 21, and 32.

14. McDonald, 191–92.

15. McKinzie, 37–38.

16. Arthur M. Schlesinger, Jr., *The Politics of Upheaval* (Boston: Houghton Mifflin Co., 1960), 345.

17. McDonald, 117 and 370 (final allocation, $771,521); and McKinzie, 39–42.

18. Olin Dows, "The New Deal's Treasury Art Programs: A Memoir," *Arts in Society,* 2 (1963): 69.

19. McKinzie, 39; and McDonald, 117.

20. McDonald, 117.

21. McDonald, 140.

22. McDonald, 383.

23. George Mavigliano, "Federal Art Project: Holger Cahill's Program of Action," *Art Education,* 37 (3) (May 1984) 26–31.

24. McDonald, 381–82.

25. Estimates vary for the number of FAP artists hired. See McDonald, 384, more than 6,000 artists; Gerald M. Monroe, "Artists as Militant Trade Union Workers During the Great Depression," *Archives of American Art Journal,* 14 (1974): 7, 5,000 artists; Gerald M. Monroe, "The 30's: Art, Ideology, and the WPA," *Art in America,* 63 (1975): 64, more than 12,000 artists on the FAP; and McKinzie, *The New Deal for Artists,* 179, "10,000 or so" artists on the FAP.

CHAPTER 1

1. "Needy Chicago Artists to Go to Work for Us," *Chicago Tribune,* 15 December 1933, 9.

2. Richard D. McKinzie, *The New Deal for Artists* (Princeton: Princeton University Press, 1973), 13.

3. Avery Johnson correspondence with the authors, 12 November 1984.

4. Oliver W. Larkin, *Art and Life in America* (New York: Holt, Rinehart and Winston, 1960), 408.

5. A widely circulated story during the 1930s and clearly having a kernel of truth had to do with an elegantly dressed gentleman who happened to pass a down-on-his-luck artist who was sitting at the curb of a street. The gentleman inquired about the reason for his depression, and the artist explained that he was a painter, but he had neither a gallery to display his work nor a clientele to buy it. Rather than starve, he was considering joining the newly created Federal Art Project where, in return for one painting per month, he could earn seventy to eighty dollars. "Who gets the painting?" inquired the gentleman. "The government," replied the artist. "I'll tell you what," said the gentleman, "I'll give you one hundred dollars per month, and you give me the paintings." Many fine collections were said to have been formed in just this manner during the thirties.

6. Olin Dows, "Art for Housing Tenants," *Magazine of Art,* 31 (November 1938): 616–23.

7. Letter, Cahill to Robinson, 12 October 1935, Microfilm DC-73, Archives of American Art; McKinzie, 13; "Needy Chicago Artists," 9, indicates that Brewster was still heading the PWAP; Clark Sommer Smith, "Nine Years of Federally Sponsored Art in Chicago: 1933–1942," masters thesis, University of Chicago, September 1965, 3; Edward Rowan, "Will Plumbers' Wages Turn the Trick?" *American Magazine of Art,* 27 (February 1934): 83, indicate that Brewster is still the director of the PWAP in Illinois; and Letter, Holger Cahill to the All-Illinois Society, 4 January 1936, Microfilm DC61, Archives of

American Art, indicates that Robinson had directed the PWAP in Illinois.

8. "Needy Chicago Artists," 9.

9. McKinzie, 13.

10. George Josimovich correspondence with the authors, 12 November 1984. See note 13.

11. Paul Stoddard interview with the authors, 13 October 1983.

12. William McDonald, *Federal Relief Administration and the Arts: The Origins and Administrative History of the Arts Projects of the WPA* (Columbus: Ohio State University Press, 1969), 195.

13. McDonald, 364; and McKinzie, 13. The National Personnel Records Center's employment records for Illinois artists do not indicate the $42.50 wage that McDonald cites or that Josimovich states. McKinzie was closer to the actual salary paid to artists.

14. Erica Beckh Rubenstein, "The Tax Payers' Murals," Ph.D. Diss., Harvard University, 1944, xiv.

15. "PWAP Exhibition Proves Worth," *Chicago Tribune,* May 11, 1934, 9.

16. Clarence Joseph Bulliet, "American Art and Propaganda for American Art," *Art Digest,* 9 (11) (15 November 1934): 3.

17. McDonald, 367.

18. Letters, Increase Robinson to Arthur Goldschmidt, 27 July 1935 and 21 August 1935, Microfilm DC61, Archives of American Art; Holger Cahill to Increase Robinson, 12 October 1935, Microfilm DC73, Archives of American Art; and Holger Cahill to Increase Robinson, 21 May 1936, Microfilm DC61, Archives of American Art.

19. The WPA districts differed from those of the IAP. For example, District 5 of the WPA was centered in Marion, Illinois, and the same district for the IAP was centered in the Springfield area. When the Illinois Art and Craft Project (IACP) was organized, the administrative districts were changed once again.

20. Robert I. McKeague interview with authors, 15 August 1980; and McDonald, 130.

21. McKeague interview with the authors.

22. McKeague interview with the authors.

23. Nicola Victor Ziroli interview with the authors, 26 March 1966.

24. McDonald, 173–74.

25. Microfilm DC72 and DC74, Archives of American Art; Folder 651.3, National Archives; and McDonald, 179.

26. Microfilm DC72 and DC74, Archives of American Art; Folder 651.3, National Archives; and McDonald, 179.

27. National Archives, General File, Box 1235: Letters, (1) Artists Union to Holger Cahill, 11 August 1936; and (2) Artists Union to Holger Cahill, 11 November 1936. Archives of American Art: Letters, (1) Mervin Jules to Holger Cahill, 23 August 1936; (2) Sidney Loeb to Holger Cahill, 23 August 1936; and (3) Sidney Loeb to Holger Cahill, 29 March 1938.

28. McDonald, 178.

29. McDonald, 179.

30. McDonald, 199.

31. Raymond Moley, *After Seven Years* (Lincoln: University of Nebraska Press, 1939), 373–76.

32. Louis Cheskin correspondence with the authors, 22 February 1981.

33. Cheskin correspondence with the authors.

34. Cheskin correspondence with the authors.

CHAPTER 2

1. *Christian Science Monitor*, 6 November 1930; and Jean Crawford Adams interview with the authors, 26 November 1966.

2. Robert I. McKeague interview with the authors, 15 August 1980.

3. Increase Robinson's printed announcement, "Lectures on Art of the Past and Present," Esther G. Robinson Collection.

4. Aaron Bohrod correspondence with the authors, 16 September 1984.

5. Letter, Robinson to Cahill, 1 October 1935, Microfilm DC61, Archives of American Art.

6. Letter, Cahill to Robinson, 12 October 1935, Microfilm DC73, Archives of American Art; Clark Sommer Smith, "Nine Years of Federally Sponsored Art in Chicago: 1933–1942," master's thesis, University of Chicago, September 1965, 5 and 15; National Personnel Records Center, Increase Robinson; Letter, Jacob Balcon to Robert Dunham, 10 October 1935, Microfilm DC73, Archives of American Art; and in an answering letter, Holger Cahill to the All-Illinois Society, 4 January 1936, Microfilm DC61, Archives of American Art.

7. Harry Mintz correspondence with the authors, 12 December 1983.

8. Donald S. Vogel correspondence with the authors, 2 September 1983.

9. Letter, Edith G. Halpert, director of The Downtown Gallery, to Mitchell Siporin, 28 September 1936, Mitchell Siporin tapes, 2011, Archives of American Art. Memorandum, Florence Arquin to all Easel Project artists, 14 November 1936, Mitchell Siporin tape, 2011, Archives of American Art. Brass tags labeled WPA were affixed to the frames, and paper tags were glued to the backs of works whose frames could not accommodate the brass tags. Artworks were framed depending on their quality and demand. Late in 1936, Florence Arquin, following the national office's request, tried to bring a measure of uniformity to Easel Division production. First, she formalized the labels attached to the back of the paintings to show the following information: artist's name, title of work, date brought in, and dimensions. Memorandums, Florence Arquin to all Easel Project artists, 15 and 25 January 1937, Mitchell Siporin tape, 2011, Archives of American Art. Arquin passed along requirements for sizes and prices for easel pieces. The same standards applied to the Graphic Arts Division. Sponsors' costs included: for oils, $20'' \times 24''$, \$4.00; $22'' \times 24''$, \$5.00; $24'' \times 30''$, \$6.50; $30'' \times 36''$, \$7.50; $30'' \times 40''$, \$9.00; and $40'' \times 60''$, \$10.50; and for watercolors $12'' \times 15''$, \$2.00. Mat sizes for watercolors were to be $30'' \times 36''$, $36'' \times 40''$, and $40'' \times 60''$.

10. "The New Federal Art Gallery," Bulletin of the Easel Division, 1, (5) (June 1939). Fred Biesel Papers, Archives of American Art.

11. Nicola Victor Ziroli interview with the authors, 26 March 1966.

12. Edward Millman, unpublished article for *Art for the Millions,* manuscript, 3, Archives of American Art; and see Belisario R. Contreras, *Tradition and Innovation in New Deal Art* (Lewisburg: Bucknell University Press, 1983).

13. Mitchell Siporin, BBC interview, 1976, Mitchell Siporin tape, 1332, Archives of American Art.

14. Siporin, BBC interview, 1976.

15. Letter, Mitchell Siporin to Margit Varga, *Life,* 24 August 1942, Mitchell Siporin tape, 2011, Archives of American Art.

16. Letter, Siporin to Varga.

17. Erica Beckh Rubenstein, "The Tax Payers' Murals," Ph.D. Diss., Harvard University, 1944, xix.

18. Barbara Bernstein, "Guide to Chicago Murals," *Chicago Tribune,* 2 December 1973, 88.

19. Edgar Britton, unpublished article for *Art for the Millions,* manuscript 4, Archives of American Art.

20. Clark Sommer Smith, 33.

21. Merlin F. Pollock correspondence with the authors, 19 September 1984.

22. Clark Sommer Smith, 31.

23. In those circumstances, artists who were accepted for major murals had to secure a performance bond. Millman and Siporin paid $52.50 for an annual bond for their St. Louis Post Office mural. Letter, Edward B. Rowan to Mitchell Siporin, 26 September 1940, Mitchell Siporin tape, 2011, Archives of American Art.

24. Microfilm DC74, Archives of American Art.

25. Bernstein, 8.

26. *A Catalogue of New Deal Mural Projects in Iowa,* 1982, 11.

27. Bernstein, 81.

28. Bernstein, 11 and 81, and V.A. Sorell, *Guide to Chicago Murals: Yesterday and Today* (Chicago: Council on Fine Arts, 1979), 11.

29. Merlin F. Pollock correspondence with the authors, 8 November 1981, in which he enclosed a Xeroxed copy of a letter he sent to Marlene Park and Gerald Markowitz, October 1979.

30. Avery Johnson correspondence with the authors, 20 November 1981.

31. Bernstein, 80.

32. Millman, unpublished article, 4.

33. Letter, Oak Park School to George Thorp, August 1941, Microfilm DC74, Archives of American Art.

34. Matthew Baigell, *The American Scene* (New York: Praeger Press, 1974), 82.

35. Ralph Henricksen, *Retrospective Catalogue, 1942,* The Kresge Art Center Gallery (East Lansing: Michigan State University, 1980), 14.

36. Siporin, BBC interview, 1976.

37. Letter, Holger Cahill to Mitchell Siporin, 11 May 1942, Mitchell Siporin tape, 2011, Archives of American Art.

38. The final epitaph for the Mural Division came from an article by Charles Leroux, which was sent to us (without a date). He spent much of his time traveling around the country locating and photographing FAP murals. "Over the succeeding years, the bloom faded. Frescoes suffered water damage. Canvases ripped and rotted. Murals were painted over, plastered over, paneled over. Ceilings were lowered, obscuring the art. Post Offices moved from downtown areas to the suburbs, sometimes leaving their murals behind in the scrap." Charles Leroux, "Prof Won't Let Post Office Murals Become a Lost Art," *Chicago Tribune.*

39. William McDonald, *Federal Relief Administration and the Arts: The Origins and Administrative History of the Arts Projects of the WPA* (Columbus: Ohio State University Press, 1969), 433; and Elizabeth Olds, "Prints for Mass Production," *Art for the Millions,* ed. Francis V. O'Connor (Boston: New York Graphic Society, 1973), 142.

40. McDonald, 433–34.

41. McDonald, 433.

42. Memorandum, Florence Arquin to all Illinois graphic artists, 15 January 1937, Mitchell Siporin tape, 2011, Archives of American Art.

43. Memorandum, Arquin, 15 January 1937.

44. Jacob Kainen, "The Graphic Arts Division of the WPA Federal Art Project," *The New Deal Art Projects: An Anthology of Memoirs,* ed. Francis V. O'Connor (Washington, D.C.: Smithsonian Institution Press, 1972), 155, 162, and 173.

45. *The Silk-Screen Process.* WPA Technical Series Public Activities Circular No. 20, Art Circular No. 6, 22 July 1941, Washington, D.C., A2789, Section 2, 2.

46. *Production News,* 1 (1) (1940), 1.

47. *Let the Artists Speak,* Teachers Broadcast Handbook, Chicago Public Schools, September 1941–January 1942, 2.

48. Andrene Kauffman correspondence with the authors, 15 September 1983.

49. Bohrod correspondence with the authors.

50. "Increase Robinson Paints a Story of Corpus Christi," *The Corpus Christi Caller-Times,* 14 November 1943.

51. Patricia Hills, *Social Concern and Urban Realism: American Painting of the 1930's* (Boston University Art Gallery, 1983), 12.

52. The major stylistic tendency in American art just prior to and during the depression had been American Scene, which was best represented by the regionalists. For further documentation see Milton Brown, *American Painting from the Armory Show to the Depression* (Princeton: Princeton University Press, 1955); and Matthew Baigell, *The American Scene.*

53. Letter, Robinson to Cahill, 25 May 1936, Microfilm DC73, Archives of American Art.

54. Mitchell Siporin, BBC interview, 1976; Mitchell Siporin tape, 1332, Archives of American Art.

55. Vogel correspondence with the authors.

56. Franz Schulze, *Fantastic Images: Chicago Art Since 1945* (Chicago: Follett Publishing Co., 1972), 5.

57. McKeague interview with the authors.

58. John Walley's unpublished statement on the formation of the Artists Union of Chicago, 1965. *Selected Papers: John E. Walley, 1910–74*, University of Illinois at Chicago.

59. Walley, Artists Union statement.

60. McDonald, 441.

61. Flyer, Increase Robinson, Garnett Biesel Papers, Archives of American Art.

62. Roy Rosenzweig, *Government and the Arts in Thirties America* (Fairfax, VA: The George Mason University Press, 1986), 9.

63. McDonald, 443.

64. McDonald, 443; Hildegarde Crosby Melzer and Kurt Melzer interview with the authors, 15 September 1982; and Letter, Florence Kerr to Ellen Woodward, 16 March 1938, National Archives, Box 1236.

65. Flyer, Increase Robinson.

66. Melzer interview with the authors. It is surprising that Melzer was selected. Having graduated from the University of Chicago with a degree in philosophy and having no background in art history or the applied and decorative arts, Crosby, with the encouragement of an old artist friend of the family, interviewed for the job and secured it.

67. McDonald, 444–45.

68. Melzer interview with the authors.

69. Richard D. McKinzie, *The New Deal for Artists* (Princeton: Princeton University Press, 1973), 137.

70. McDonald, 450–51; and the editors of Time-Life Books, *Color* (New York: Time-Life Books, 1970), 67.

71. McDonald, 451; and *The New York Times*, "Art Section," on the IAD, 19 March 1939, 9.

72. McDonald, 445.

73. Letter, C. Adolph Glassgold to Increase Robinson, 5 October 1936, National Archives, General File, Box 1235.

74. McDonald, 450.

75. Flyer, Increase Robinson.

76. Letter, Kathleen Calkins to Robinson, 4 June 1936, Microfilm DC73, Archives of America Art.

77. McDonald, 447.

78. Melzer interview with the authors.

79. McKinzie, 130.

80. Hildegarde Crosby Melzer, unpublished manuscript for *Art for the Millions*, Archives of American Art.

81. Hildegarde Crosby Melzer's total from our interview and from "Comprehensive Index of American Design Exhibit Opens at Field's March 15," *Downtown Shopper* (Chicago: 15 March 1937), 9. McDonald states that there

were well over one thousand plates exhibited, 453.

82. Melzer interview with the authors.

83. Gerald M. Monroe, "The '30s: Art, Ideology, and the WPA," *Art in America*, 63, (6) (November–December 1975): 64–67; Gerald M. Monroe, "Artists as Militant Trade Union Workers During the Great Depression," *Archives of American Art Journal*, 14, (1) (1974): 7–10; Gerald M. Monroe, "The Artists Union of New York," Ph.D. Diss., New York University, 1971, 50–51; and McDonald, 405.

84. According to Walley, it was a meeting of the Artists Union. But, there is the possibility that this was an organizational meeting, which led to the formation of the union by November 1935 and to recognition by the State of Illinois in July 1936. Loeb wrote Cahill, 9 January 1936, that the Artists Union had been formed, Microfilm DC61, Archives of American Art.

85. Walley, Artists Union Statement.

86. Merlin Pollock correspondence with the authors, 13 November 1984.

87. John Edwin Walley interview with the authors, Spring 1966.

88. Gerald M. Monroe, "The '30s," 65.

89. Vogel correspondence with the authors.

90. Walley interview with the authors.

91. Walley interview with the authors.

92. Walley interview with the authors.

93. Robert Wolff, "Chicago and the Artists Union," *Art for the Millions*, 241.

94. Walley, Artists Union statement; and Monroe, "Artists," 9.

95. Monroe, "Artists," 9.

96. Walley, Artists Union statement.

97. Seymour Korman, "Critics Assert WPA Art Is Ugly and Subversive," *Chicago Tribune*, Part III, 21 December 1940, 12; and Margaret Burroughs and Bernard Goss interview with the authors, 17 March 1966.

98. Monroe, "Artists," 7 and 9–10.

99. Letter, Aaron Bohrod to Harry Hopkins, 7 November 1935, National Archives. Another letter, Amelia M. Hammer to Holger Cahill, 3 August 1936, National Archives, castigated Robinson for her remarks "that employment would be a basis of quality and that need would not be considered, that artists of a controversial disposition would not be retained on the project."

100. Letter, Chicago Artists Committee to Holger Cahill (enclosure), National Archives.

101. McDonald, 190–92.

102. Walley interview with the authors.

103. Ziroli interview with the authors.

104. Paul Stoddard interview with the authors, October 1983.

105. Pollock correspondence with the authors.

106. Barbara Bernstein, "Federal Art: Not Gone, Just Forgotten," *Chicago Tribune*, 2 December 1973, 122.

107. Ziroli interview with the authors.

108. George Carr interview with Robert Kessler, March 1978.

109. Arthur Osver and Bernadine Betzberg interview with the authors, 13 October 1983.

110. Ziroli interview with the authors.

111. Letter, Joseph Meyers to Works Progress Administration, Washington, D.C., National Archives, and Microfilm DC75, Archives of American Art.

112. Osver and Betzberg interview with the authors.

113. Vogel correspondence with the authors.

114. Osver and Betzberg interview with the authors.

115. Artists Union of Chicago statement sent to the national WPA offices.

116. Letter, Sidney Loeb to Holger Cahill, 8 December 1937, Microfilm DC74, Archives of American Art; and John Walley interview with the authors, in which he stated the gallery had opened on 24 November 1937.

117. Walley, Artists Union statement.

118. Wolff article, 242.

119. Walley, Artists Union Statement.

120. Letter, Morris Topchevsky to H. K. Seltzer, district director of the Works Progress Administration, 27 September 1938, National Archives.

121. Walley interview with the authors. Walley felt that this case was interesting because he was also a project official as well as an artist and a union activist. Increase Robinson never got over the fact that, at one moment, Walley might be out on a picket line and the next he would drop his sign and march into the office to attend to his administrative duties.

122. Letter, Sidney Loeb to Holger Cahill, 11 November 1936, National Archives.

123. Ziroli interview with the authors.

124. Letter, Karl Metzler to Ellen Woodward, 23 June 1937, Microfilm DC74, Archives of American Art.

125. Letter, Increase Robinson to Holger Cahill, 1937, Microfilm DC74, Archives of American Art.

126. Ziroli interview with the authors; and Jean Crawford Adams interview with the authors, 26 November 1966.

127. Walley interview with the authors.

128. Holger Cahill interview, Archives of American Art.

129. Letter, T. A. Rovelstad to Jacob Baker, 6 December 1936, Microfilm DC74, Archives of American Art.

130. Letter, Gregory Orloff to Holger Cahill, 21 August 1937, Microfilm DC74, Archives of American Art.

131. Letter, Robert Wolff to R. O. Carpenter, labor relations advisor, 20 May 1937, Microfilm DC74, Archives of American Art.

132. McKeague interview with the authors; and "Sentence U.S. Art Teacher on Morals Charge," *Rockford Register-Republic*, 83, (258) (13 December 1937): 1.

133. Conference, Cahill and Robinson, Microfilm DC74, Archives of American Art.

134. McKeague interview with the authors; and letter, Ralph Light to Roger Cahill, 11 August 1937, Microfilm DC74, Archives of American Art.

135. Microfilm DC74, Archives of American Art.

136. McKeague interview with the authors; and Letter, Ralph Light to Holger Cahill, 11 August 1937, Microfilm DC74, Archives of American Art.

137. *Rockford Register-Republic* (13 December 1937), 1.

138. Letter, Increase Robinson to Thomas Parker, 9 December 1937, Microfilm DC74, Archives of American Art.

139. "Probe Suicide of Art Teacher," *Rockford Register-Republic,* (259) (14 December 1937): 1.

140. McKeague interview with the authors.

141. Letter, E. H. Wold to Mrs. Eleanor Roosevelt, 11 January 1938, Microfilm DC74, Archives of American Art.

142. Letter, Thomas Parker to Increase Robinson, 2 February 1938, Microfilm DC74, Archives of American Art.

143. Letter, Dr. Eugene Murray Aaron to Holger Cahill, 2 May 1937, National Archives.

144. Holger Cahill communicated with Increase Robinson between 5 and 12 May 1937. She responded with a letter, Increase Robinson to Thomas Parker, 14 May 1937, National Archives, Box 1235.

145. A summary of findings: Microfilm DC75, Archives of American Art.

146. Letter, Lawrence S. Morris to Ellen Woodward, 23 April 1938, Microfilm DC74, Archives of American Art.

147. Letter, Florence Kerr to Ellen Woodward, 16 March 1938, National Archives, Box 1236.

CHAPTER 3

1. Letter, Thomas Parker to George Thorp, 28 February 1938, Microfilm DC74, Archives of American Art.

2. Letter, Thomas Parker to Robert McKeague, 12 March 1938, National Archives, Box 1236.

3. Letter, Thomas Parker to Charles E. Miner, 8 March 1938, Microfilm DC74, Archives of American Art.

4. Nicola Victor Ziroli interview with the authors, 26 March 1966.

5. William McDonald, *Federal Relief Administration and the Arts: The Origins and Administrative History of the Arts Projects of the WPA* (Columbus: Ohio State University Press, 1969), 408.

6. Samuel Cashwan, "The Sculptor's Point of View," *Art for the Millions,* ed. Francis V. O'Connor (Boston: New York Graphic Society, 1973), 88.

7. Olin Dows, "The Art of Housing Tenants," *Magazine of Art,* 31 (November 1938): 618.

8. Charles Umlauf telephone conversation with the authors, 9 December 1984.

9. Sculptors who have been interviewed remembered the Stone Yard, but they have differed about its exact location.

10. Mary Anderson Clark correspondence with the authors, 8 November 1984.

11. Umlauf telephone conversation with the authors.

12. Barbara Bernstein, *Sculpture of the 1930's: Federal Art Project* (Chicago: Rider Dickinson, Inc., No Date), 5.

13. Bernstein, 5–6.

14. Bernstein, 6.

15. Richard D. McKinzie, *The New Deal for Artists* (Princeton: Princeton University Press, 1973), 118.

16. Olin Dows, 618.

17. Bernstein, 28.

18. Clark correspondence with the authors.

19. Robert Cronlach, "The New Deal Sculpture Projects," *The New Deal Art Projects: An Anthology of Memoirs*, ed. Francis V. O'Connor (Washington, D.C.: Smithsonian Institution Press, 1972), 136.

20. Hildegarde Crosby Melzer and Kurt Melzer interview with the authors, 15 September 1982.

21. Andrene Kauffman correspondence with the authors, 15 September 1983.

22. Fred Biesel was reclassified as assistant state director. Letter, Thomas Parker to George Thorp, 27 January 1939, Microfilm DC74, Archives of American Art.

23. George Thorp, "The Art of Supervising Artists." Unpublished article for *Art for the Millions*, Archives of American Art.

24. Thorp, 2.

25. Robert I. McKeague interview with the authors, 15 August 1980.

26. See McKinzie, 149, for a detailed account of events.

27. "The Emergency Relief Appropriations Act," House Joint Resolution 326, 76th Congress, 1st Session (1939), *United States Statutes at Large*, 53, Part 2 (Washington, D.C.: The U.S. Government Printing Office, 1939), Chapter 252, 927–39.

28. McKinzie, 164.

29. McKeague interview with the authors.

30. Newsletter from Sidney Loeb to all members of the Artists Union, 1 July 1940.

31. Public Announcement by Mayor Edward J. Kelly, 30 June 1941.

32. Letter, Thorp to Parker, 19 December 1938, National Archives. The new quota for 15 January 1939, was 370; Thorp wanted 425, leaving 55 to be negotiated.

33. Letter, Mary Gillette Moon to Florence Kerr, 29 November 1939, Fred Biesel Papers, Archives of American Art; McDonald, 415.

34. McDonald, 462.

35. John Edwin Walley interview with the authors, Spring 1966.

36. *Planning Manual,* Illinois Art and Craft Project, 1940, Fred Biesel Papers, Archives of American Art.

37. We have no information about whether districts 7 through 11 ever existed. These districts may have been left open for future expansion of the project as needed.

38. John Walley, "Speech to the Artists Union, 1940," *Selected Papers: John E. Walley, 1910–1974,* University of Illinois at Chicago, 18.

39. Walley, Speech, 19; and McDonald, 417–18, indicates that the FAP no longer had administrative or budgetary control over the IACP, but it extended its influence by increasing the technical skill of the crafts personnel.

40. Walley interview with the authors.

41. Walley, Speech, 22.

42. John Walley, "The Influence of the New Bauhaus in Chicago: 1938–1943," *Selected Papers: John E. Walley, 1910–1974,* University of Illinois at Chicago.

43. *Planning Manual,* IACP.

44. Walley, Speech, 21.

45. *Production News,* 1 (1) (1940): 1.

46. *Production News,* 1 (1) (1940): 2.

47. Walley, "The Influence," 78.

48. Walley, "The Influence," 76.

49. This adventure is discussed in John Walley's *Selected Papers* and in Clark Sommer Smith, "Nine Years of Federally Sponsored Art in Chicago: 1933–1942," master's thesis, University of Chicago, September 1965, 53–54.

50. John Walley, WPA Design Furniture Workshop document, "Record of Program Operation and Accomplishment, 1935–1943," 7, Fred Biesel Papers, Archives of American Art.

51. Clark Sommer Smith, 55.

52. Clark Sommer Smith, 48.

53. Burnett Shryock interview with the authors, 22 January 1966.

54. George Thorp, "Summary of Recommendations and Proposed Reductions," Work Projects Administration, Illinois Art and Craft Project, Fred Biesel Papers, Archives of American Art.

55. Letter, George Thorp to Fred Biesel, 22 October 1941, Fred Biesel papers, Archives of American Art.

56. Letter, Thorp to Biesel.

CHAPTER 4

1. Letter, George Thorp to Fred Biesel, 22 October 1941, Fred Biesel Papers, Archives of American Art.

2. Garnett Biesel telephone conversation with the authors, 1 August 1985; Fred Biesel's résumé, 24 January 1944, Fred Biesel Papers, Archives of American Art; and John Edwin Walley interview with the authors, Spring 1966.

3. Walley interview with the authors.

4. Letter, Fred Biesel to E. E. Shumake, 24 January 1944, Microfilm, Archives of American Art.

5. Garnett Biesel interview with the authors. Given his grandfather's artisan background, Fred Biesel came to this interest naturally.

6. Letter, Increase Robinson to Holger Cahill, 29 January 1936, National Archives, in which she indicated "In practically all of the down-state districts, replies to my frequent inquiries as to persons certified for WPA employment, professionally qualified to work as artists in any capacity, are consistently negative. As no doubt you are aware, there is an unusually strong anti-New Deal feeling in the down-state districts and, therefore, it seems quite impossible for us to break through. However, were there a qualified art personnel, we should not hesitate to make a serious attempt to put such persons to work, rather than allowing them to become absorbed in various recreation projects. In such cities as Peoria, Decatur, Springfield, and Rockford, the only art interest is that which is superficially maintained by Women's Clubs, and in such cities there are a few native sons of mediocre talent who have been kept from a relief status by local interest."

7. "Penny Cent, Artist," *The Evansville Press,* 14 August 1938, 10c.

8. National Personnel Records Center, Penny Cent.

9. Richard A. Lawson and George J. Magvigliano, *Fred E. Myers, Wood-Carver* (Carbondale, Illinois: Southern Illinois University Press, 1980), 33.

10. *Fred E. Myers, Wood-Carver,* 33–34.

11. George Carr interview with Robert Kessler, March 1978.

12. Garnett Biesel interview with the authors.

13. Museum Program document, Fred Biesel papers, Archives of American Art.

14. *Fred E. Myers, Wood-Carver,* 32 and 34–37; and Moreau S. Maxwell telephone conversation with the authors, 21 May 1988.

15. Maxwell telephone conversation with the authors.

16. Museum Program document.

17. Museum Program document.

18. *WPA Technical Series,* Art Circular No. 1, 8 October 1937, 1.

19. Photograph, Community Art Center poster, in authors' possession.

20. William McDonald, *Federal Relief Administration and the Arts: The Origins and Administrative History of the Arts Projects of the WPA* (Columbus: Ohio State University Press, 1969), 467 and 469.

21. Scripts appear under the "Great Artist" series, Vol. 1–3, Ryerson Library, Art Institute of Chicago.

22. "Great Artist Series," Ryerson Library, Art Institute of Chicago.

23. Richard D. McKinzie, *The New Deal for Artists* (Princeton: Princeton University Press, 1973), 145.

24. Margaret Burroughs and Bernard Goss interview with the authors, 17 March 1966.

25. Holger Cahill interview, Archives of American Art.

26. Burroughs and Goss interview with the authors.

27. Nicola Victor Ziroli interview with the authors, 26 March 1966.

28. Letter, A. L. Foster to Florence Kerr, 13 March 1941, National Archives.

29. Burroughs and Goss interview with the authors.

30. Creilly Pollack telephone conversation with the authors, 25 July 1984.

31. This information is based on hiring records at the National Personnel Records Center in St. Louis, Missouri.

32. Walley interview with the authors.

33. Burroughs and Goss interview with the authors.

34. Burroughs and Goss interview with the authors.

35. Burroughs and Goss interview with the authors.

36. Alain Locke, "Chicago's New Southside Art Center," *The Magazine of Art,* 34 (August 1941): 370–71.

37. Paul Stoddard correspondence with the authors, 20 August 1981.

38. Burroughs and Goss interview with the authors.

39. John B. Harrison, *This Age of Global Strife* (New York: J. B. Lippincott Co., 1952), 51–52, 83–84, and 147–53.

40. Memorandum, War Services Division to the IACP, *The Central Exhibition Unit,* Fred Biesel Papers, Archives of American Art.

41. *WPA Art Program: Conference of State Art Supervisors,* Washington, D.C., 27–28 January 1941, Fred Biesel Papers, Archives of American Art.

42. A small sample includes: Letter, Frank O. Wood to Miss M. A. Fowler, 6 March 1941; Letter, G. S. Bond to Ralph Graham, 3 September 1941; Letter, James L. Smathers to Ralph Graham, 4 September 1941; Letter, John V. Sandberg to O. A. Kirby, 25 October 1941; Letter, Catherine Olson to Fred Biesel, 26 November 1941; and C. Paul Staler to Ralph Graham, 12 November 1941, Fred Biesel Papers, Archives of American Art.

43. Letter, G. S. Bond to Ralph Graham.

44. Letter, Catherine Olsen to Fred Biesel.

45. *Report,* Conference called by George Thorp, 25 March 1941, 18, Fred Biesel Papers, Archives of American Art.

46. Peter Pollack, *Proposed Plan for Continuance of South Side Art Center,* Fred Biesel Papers, Archives of American Art.

47. Letter, Florence Kerr to George Field, 1 August 1942, National Archives, Box 1225.

48. *Report,* Conference called by George Thorp, 4.

49. *Report,* Conference called by George Thorp, 7.

50. *Report,* Conference called by George Thorp, 11.

51. *Report,* Conference called by George Thorp, 11.

52. *Report,* Conference called by George Thorp, 10, 15, 19, and 21.

53. Statement of the Illinois Craft Project, University of Illinois at Chicago, 9–12.

54. IACP *Newsletter,* 2 June 1941, Fred Biesel Papers, Archives of American Art.

55. Clark Sommer Smith, "Nine Years of Federally Sponsored Art in Chicago: 1933–1942," master's thesis, University of Chicago, September 1965, 54.

56. John Walley, "The Influences of the New Bauhaus," *Selected Papers: John E. Walley, 1910–1974,* University of Illinois at Chicago.

57. Robert I. McKeague interview with the authors, 15 August 1980.

58. McKeague interview with the authors.

59. IACP *Newsletter.*

60. IACP *Newsletter.*

61. IACP *Newsletter.*

62. Donald S. Vogel correspondence with the authors, 2 September 1983.

63. Ralph Graham, "The Poster in Chicago," *Art for the Millions,* ed. Francis V. O'Connor (Boston: New York Graphic Society, 1973), 181.

64. McDonald, 433–34.

65. Christopher DeNoon, *Posters of the WPA* (Los Angeles: The Wheatly Press Publishers, 1987), 22.

66. Walley interview with the authors.

67. Letter, Holger Cahill to Increase Robinson, 5 February 1936, Microfilm DC61, Archives of American Art.

68. McDonald, 439.

69. Graham, 179–80, 181, and 182.

70. IACP *Newsletter.*

71. *Report,* Conference called by George Thorp, 12.

72. Letter, Frank J. Follmer to Mrs. Geneva Smith, 23 January 1942, Fred Biesel Papers, Archives of American Art.

73. Telegram, Fred Biesel Dorothy Miller, 23 February 1942, Fred Biesel Papers, Archives of American Art.

74. Transcript of Conference on *Military and Naval Training Aids,* Washington, D.C., 22–24 September 1942, Fred Biesel Papers, Archives of American Art.

75. *Military and Naval Training Aids.*

76. *Military and Naval Training Aids.*

77. *Military and Naval Training Aids.*

78. Garnett Biesel interview with the authors.

79. Walley interview with the authors.

80. "End of WPA Art: Canvasses Which Cost Government $35,000,000 sold as Junk," *Life,* 16 (16) (17 April 1944): 85–86.

81. McKeague interview with the authors.

82. Ziroli interview with the authors.

83. Walley interview with the authors.

84. Louis Cheskin correspondence with the authors, 22 February 1981.

85. George Biddle, 20 February 1943, Mitchell Siporin tape, Microfilm 2011, Archives of American Art.

86. Letter, Franklin D. Roosevelt to General Fleming, 4 December 1942, Fred Biesel Papers, Archives of American Art.

87. Letter, Roosevelt to Fleming.

88. Letter, Fred Biesel to Evelyn S. Byron, 15 May 1943, Fred Biesel Papers, Archives of American Art.

89. Letter, Holger Cahill to Edgar Richardson, 30 June 1954, printed as "Document," Archives of American Art.

90. Arthur Osver and Bernadine Betzberg interview with the authors, 13 October 1983.

91. Letter, Cahill to Richardson.

92. Gerald M. Monroe, "The 30s: Art, Ideology and the WPA," *Art in America*, 63 (6) (November –December 1975), 64.

93. Edgar Britton, unpublished article for *Art for the Millions*, manuscript 4, Archives of American Art.

APPPENDIX A

1. Letter, Andrene Kaufman, 15 September 1983, in authors' possession. "Some of the wealthiest artists worked voluntarily without pay just to be part of the movement (PWAP). Some of these stayed on the Easel project of the WPA, later."

2. Francis O'Malley, "WPA: We Produced Art," *Chicago Daily News*, 9 October 1965, 4.

APPPENDIX F

1. William McDonald, *Federal Relief Administration and the Arts: Origins and Administrative History of the Arts Project of the WPA* (Columbus: Ohio State University Press, 1969), 183.

2. McDonald, 177.

BOOKS

Baigell, Matthew. *The American Scene*. New York: Praeger Publishers, 1974.

Balfe, Judith H., and Margaret J. Wyszomirski, eds. *Art Ideology, and Politics*. New York: Praeger Publishers, 1985.

Banfield, Edward C. *The Democratic Muse*. New York: Basic Books, 1984.

Bernstein, Irving. *A Caring Society*. Boston: Houghton Mifflin Co., 1985.

Brown, Milton. *American Painting from the Armory Show to the Depression*. Princeton: Princeton University Press, 1955.

Bruce, Edward, and Forbes Watson. *Art in Federal Buildings: An Illustrated Record of the Treasury Department's New Program in Painting and Sculpture*. Washington, D.C., 1936.

Contreras, Belisario R. *Tradition and Innovation in New Deal Art*. Lewisburg: Bucknell University Press, 1983.

DeNoon, Christopher. *Posters of the WPA*. Los Angeles: The Wheatly Press Publishers, 1987.

Dollard, John. *Caste and Class in a Southern Town*. New York: Doubleday, 1949.

Flanagan, Hallie. *Arena*. New York: Duell, Sloan and Pearce, 1940.

Harris, Ruth G., and Girolamo Piccoli. *Techniques of Sculpture*. New York: Harper and Bros., 1942.

Harrison, John B. *This Age of Global Strife*. New York: J. B. Lippincott Co., 1952.

Hoover, Herbert. *The Memoirs of Herbert Hoover: The Great Depression, 1929–1941*, vol. 3. New York: Macmillan Co., 1952.

Hoyt, Edwin P. *The Tempering Years*. New York: Charles Scribner's Sons, 1963.

Lane, Marie, and Francis Steegmuller. *America on Relief*. New York: Harcourt, Brace and Co., 1938.

Larkin, Oliver W. *Art and Life in America*. New York: Holt, Rinehart and Winston, 1960.

Larson, Gary O. *Reluctant Patron: The U.S. Government and the Arts, 1943–1965*. Philadelphia: University of Pennsylvania Press, 1983.

Lawson, Richard A., and George J. Mavigliano. *Fred Myers, Wood-Carver*. Carbondale: Southern Illinois University Press, 1980.

Lindin, I., and Archie Thompson. *Bishop Hill Colony*. Chicago: Index of American Design, 1937.

MacMahon, Arthur W., John D. Millett, and Gladys Ogden. *The Administration of Federal Work Relief*. Chicago: Public Administration Service, 1941.

Mangione, Jerre. *The Dream and the New Deal: The Federal Writers' Project 1935–1943*. Boston: Little Brown, 1972.

Marling, Karal Ann. *Wall-to-Wall America*. Minneapolis: University of Minnesota Press, 1982.

McDonald, William. *Federal Relief Administration and the Arts: The Origins and Administrative History of the Arts Project of the WPA*. Columbus: Ohio State University Press, 1969.

McElvaine, Robert S. *The Great Depression: America, 1929–1941*. New York: New York Times Books, 1984.

McKinzie, Richard D. *The New Deal for Artists*. Princeton: Princeton University Press, 1973.

Moley, Raymond. *After Seven Years*. Lincoln: University of Nebraska Press, 1939.

O'Connor, Francis V., ed. *Art for the Millions*. Boston: New York Graphic Society, 1973.

———. *Federal Support for the Visual Arts: The New Deal and Now*. Connecticut: New York Graphic Society, 1969.

———. *The New Deal Art Project: An Anthology of Memoirs*. Washington, D.C.: Smithsonian Institution Press, 1972.

Ogden, August Raymond. *The Dies Committee*. Washington, D.C.: The Catholic University of America Press, 1945.

Park, Marlene, and Gerald Markowitz. *Democratic Vistas: Post Offices and Public Art in the New Deal*. Philadelphia: Temple University Press, 1984.

Patterson, James T. *Congressional Consideration and the New Deal*. Lexington: University of Kentucky Press, 1967.

Roseboom, Eugene H., and Alfred E. Eckes, Jr. *A History of Presidential Elections*. New York: Macmillan Co., 1979.

Rosenzweig, Roy, ed. *Government and the Arts in Thirties America*. Fairfax, Virginia: The George Mason University Press, 1986.

Schlesinger, Arthur M., Jr. *The Politics of Upheaval*. Boston: Houghton Mifflin Co., 1960.

Schulze, Franz. *Fantastic Images: Chicago Art Since 1945*. Chicago: Follett Publishing, 1972.

Shannon, David A., ed. *The Great Depression*. New York: Prentice Hall, 1964.

Sorell, V. A., ed. *Guide to Chicago Murals: Yesterday and Today*. Chicago: Council on the Fine Arts, 1979.

Stewart, Ruth Ann. *WPA and the Black Artist: Chicago and New York*. Chicago: The Council on Fine Arts and the Chicago Public Library, 1978.

Tinkham, Sandra Sheffen. *The Consolidated Catalog to the Index of American Design*. Cambridge: Chadwyck-Healey Ltd., 1980.

Walley, Jano, ed. *Selected Papers: John E. Walley, 1910–1974*. Chicago: University of Illinois, 1975.

White, John Franklin, ed. *Art in Action: American Art Centers and the New Deal*. Metuchen, New Jersey, and London: The Scarecrow Press, Inc., 1987.

Wilbur, Ray Lyman, and Arthur Mastick Hyde. *The Hoover Policies*. New York: Charles Scribner's Sons, 1937.

JOURNAL AND MAGAZINE ARTICLES

"A la Thomas Moran." *Art Digest* 11 (September 1937): 15.

"American Bauhaus." *Architectural Forum* 64 supp. (January 1936): 17+.

"Art Project Highlights Living American Art at New York Fair." *Art Digest* 14 (1 June 1940): 10–12.

"Art Project Work Exhibited, Museum of Modern Art." *Parnassus* 12 (April 1940): 39.

"Artists of Illinois on the Federal Payroll." *Art News* 36 (5 March 1938): 14.

Ayrshire, Williams. "The Diversity of Edward Bruce." *International Studio* (December 1927).

Benson, E. M. "Chicago Bauhaus." *Magazine of Art* 31 (February 1938): 82–83.

Biddle, George. "The Federal Arts Bill Snag." *Magazine of Art* 31 (1938): 156+.

Bulliet, Clarence J. "American Art and Propaganda for American Art." *Art Digest* 9 (15 November 1934): 3.

Cahill, Holger, "Artists in War and Peace." *Studio* 130 (July 1945): 1–16.

―――. "American Art Today and in the World of Tomorrow." *Art News, 1940 Annual* 38 (25 May 1940): 49–51.

―――. "Mural America." *Architectural Record* 82 (September 1937): 63–68.

Carr, Sister Eleanor. "New York Sculpture During the Federal Project." *Art Journal* 31 (Summer 1972): 397–403.

"Chicago Examines WPA Federal Art—Now in Its Third—'Balanced' Phase." *Art Digest* 12 (1 August 1938): 5–6.

Davis, Perry R. "Art for the People, by the People." *Chicago Magazine* 33 (May 1984): 120–25.

Dows, Olin. "Art for Housing Tenants." *Magazine of Art* 31 (November 1938): 616–23.

―――. "The New Deal's Treasury Art Programs: A Memoir." *Arts in Society* 2 (1963): 50–88.

"End of WPA Art: Canvasses Which Cost Government $35,000,000 Sold as Junk." *Life* 16 (16) (17 April 1944): 85–86.

Evans, Robert J. "Federal Art Project of the 1930's." *The Living Museum* 35 (November–December 1973).

"Exhibits for Circulation." *Museum News* 20 (15 February 1943): 1+.

"Federal Art Project Is Outlined in Detail by Its Supervisors." *Art News* 34 (19 October 1935): 13.

"Federal Sculpture." *Art Digest* 12 (1 April 1938): 10.

Frost, Rosamund. "Political and Architectural Monuments by WPA Sculptors." *Art News* 36 (2 April 1938): 8.

Gardner, A. T. "Art for the Public." *Magazine of Art* 31 (September 1938): 526–33.

"Government Inspiration." *Time* 27 (2 March 1936): 2.

"I.B.M. and WPA at the Fair." *Magazine of Art* 33 (June 1940): 367.

"Incalculable Record." *Magazine of Art* 32 (August 1939): 460–71.

"Index of American Design." *Design* 44 (May 1943): 17.

Jewell, Alden. "Some Came to Praise." *Art Digest* 12 (15 May 1938): 29.

"Lauds Federal Art." *Art Digest* 13 (1 May 1939): 17.

Lewis, David Levering. "The Politics of Art: The New Negro, 1920–1935." *Prospects* 3 (1977): 237–61.

Locke, Alain. "Chicago's New Southside Art Center." *Magazine of Art* 34 (August 1941): 370–74.

M., L. "The Art of Edward Bruce." *American Magazine of Art* 21 (February 1930): 75–81.

Mavigliano, George. "Federal Art Project: Holger Cahill's Program of Action." *Art Education* 37 (3) (May 1984): 26–31.

Monroe, Gerald M. "Artists as Militant Trade Union Workers During the Great Depression." *Archives of American Art Journal* 14 (1974): 7–10.

———. "The 30's: Art, Ideology, and the WPA." *Art in America* 63 (6) (1975): 64–67.

Pezet, A. "The Middle West Takes Up the Torch: The Land of Pioneers Fosters a Native Culture." *Forum* 96 (December 1936): 285–89.

"Portrait of a Contented Man," *Fortune*, May 1931.

"Prints for the People Reveal Work of WPA in Graphic Media." *Art Digest* 11 (1 January 1937): 23.

"Prints of the Thirties: Reflections on the FAP." *Artists' Proof* 11 (1971): 34–41.

"Production in Chicago." *Magazine of Art* 35 (March 1942): 116–17.

Rourke, Constance. "Traditions for Young People." *The Nation* 145 (1937): 562.

Rowan, Edward. "Will Plumbers' Wages Turn the Trick?" *Magazine of Art* 27 (February 1934).

Rutledge, A. "Negro and the New Deal." *South Atlantic Quarterly* 39 (July 1940): 281–89.

Taylor, Frances H. "Pork Barrel Renaissance." *American Magazine of Art* 31 (1938): 157 + .

Thwaites, J., and M. Thwaites. "Seeing the Shows in Chicago." *The Magazine of Art* 30 (1937): 576 + .

———. "Two Chicago Events." *Magazine of Art* 31 (January 1938): 39.

"Unemployed Arts." *Fortune* 15 (May 1937): 108–17 and 168–75.

Wellman, Rita, and Holger Cahill. "American Design: Historic Examples from Index of American Design." *House and Garden* 74 (July 1938): 15–43.

Whiting, F. A., Jr. "Five Important Years." *Magazine of Art* 32 (December 1939): 676–82 + .

"WPA Art Report." *Art Digest* 13 (1 January 1939): 15.

"WPA Museum Projects." *Museum News* 15 (1 January 1938): 7–8.

"WPA Provides Museums with 2,744 Workers." *Museum News* 15 (15 March 1938): 4.

"WPA Rainbows." *Literary Digest* 22 (4 July 1936): 23.

"WPA's Premiere at Chicago Institute." *Art News* 36 (17 September 1938): 10.

NEWSPAPER ARTICLES

"Art of the 1930's at State Museum." *The State Journal-Register.* 28 October 1973, 27.

"Bear River." *Christian Science Monitor,* 6 November 1930, 9.

Bernstein, Barbara. "Federal Art: Not Gone, Just Forgotten." *Chicago Tribune,* 2 December 1973, 80 and 122.

———. "Guide to Chicago Murals." *Chicago Tribune,* 2 December 1973, 8, 11, 80–81, and 88.

Byers, Margery. "Some Survived the Depression, Some Did Not" (Smithsonian News Service). *Southern Illinoisan,* 5 December 1980.

Christian Science Monitor, 6 November 1930.

"Increase Robinson Paints a Story of Corpus Christi." *The Corpus Christi Caller-Times,* 14 November 1943.

Korman, Seymour. "Critics Assert WPA Art Is Ugly and Subversive." *Chicago Tribune,* Part III, 19, 20, and 21 December 1940, 1, 12, and 18.

Levy, Beatrice. "Pays Tribute to Increase Robinson." *Chicago Sun,* 31 January 1942, 16.

"Needy Chicago Artists to Go to Work for Us." *Chicago Tribune,* 15 December 1933, 9.

The New York Times. "Art Section." 19 March 1939, 9.

O'Malley, Francis. "We Produced Art." *Daily News,* 9 October 1965, 4.

"Penny Cent, Artist." *The Evansville Press.* 14 August 1938, 10c.

"Probe Suicide of Art Teacher." *Rockford Register-Republic,* 83 (259), 14 December 1937, 1.

"PWAP Exhibition Proves Worth." *Chicago Tribune,* 11 May 1934, 9.

"Relief Artists Absorb Spirit of Good Ol' WPA." *Chicago Tribune,* 8 November 1935, 3.

Rich, Daniel Catton. "Letter to the Chicago Tribune." *Chicago Tribune,* 28 December 1940, 6.

"Sentence U.S. Art Teacher on Morals Charge." *Rockford Register-Republic,* 83 (258), 13 December 1937, 1.

"Skokie School's Mystery Mural on View at Last." *Chicago Tribune,* 28 July 1934, 5.

"Wall to Mask Skokie School's Mooted Mural." *Chicago Tribune,* 1 August 1934, 6.

Winn, Marcia. "Art Takes a Plunge into Social Service." *Chicago Tribune,* 7 February 1936, 3.

U.S. GOVERNMENT DOCUMENTS:
MICROFILM AND LETTERS

The All-Illinois Society of the Fine Arts, Inc. To Holger Cahill, 30 December 1935. National Archives.

Anonymous. To M. H. McIntyre, 25 February 1938. Microfilm DC74, Archives of American Art.

Arquin, Florence. Memorandum to all Easel Project Artists, 14 November 1936. Mitchell Siporin tape, 2011, Archives of American Art.

———. Memorandum to all Illinois Graphic Artists, 15 January 1937. Mitchell Siporin tape, 2011, Archives of American Art.

———. Memorandum to all Easel Project Artists, 15 January 1937. Mitchell Siporin tape, 2011, Archives of American Art.

———. Memorandum to all Easel Project Artists, 25 January 1937. Mitchell Siporin tape, 2011, Archives of American Art.

Artists Union. To Holger Cahill, 11 August 1936. General File, Box 1235, National Archives.

———. To Holger Cahill, 11 November 1936. General File, Box 1235, National Archives.

Balcon, Jacob. To Robert Dunham, 10 October 1935. Microfilm DC73, Archives of American Art.

Biddle, George. To Mitchell Siporin, 20 February 1943. Mitchell Siporin Tape, 2011, Archives of American Art.

Biesel, Fred. To Evelyn S. Byron, 15 May 1943. Fred Biesel Papers, Archives of American Art.

———. To E. E. Schumake, 24 January 1944. Microfilm, Archives of American Art.

———. Telegram to Dorothy Miller, 23 February 1942. Fred Biesel Papers, Archives of American Art.

Bohrod, Aaron. To Harry Hopkins, 7 November 1935. National Archives.

Bond, G. S. To Ralph Graham, 3 September 1941. Fred Biesel Papers, Archives of American Art.

Cahill, Holger. Conference with Increase Robinson (not dated). Microfilm DC74, Archives of American Art.

———. To the All-Illinois Society, 4 January 1936. Microfilm DC61, Archives of American Art.

———. To Edgar Richardson, 30 June 1954. Printed as "Document," Archives of American Art.

———. To Increase Robinson, 12 October 1935. Microfilm DC73, Archives of American Art.

———. To Increase Robinson, 5 February 1936. Archives of American Art.

———. To Increase Robinson, 21 May 1936. Microfilm DC61, Archives of American Art.

———. To Increase Robinson, 2 June 1936. Microfilm DC61, Archives of American Art.

———. To Increase Robinson, 4 June 1936. Microfilm DC73, Archives of American Art.

———. To Increase Robinson, 13 January 1937. National Archives.

———. To Mitchell Siporin, 11 May 1942. Mitchell Siporin Tape, 2011, Archives of American Art.

Calkins, Kathleen. To Increase Robinson, 4 June 1936. Microfilm DC73, Archives of American Art.

Chicago Artists Committee. To Holger Cahill (enclosure). National Archives.

Employment Quotas. Folder 651.3, National Archives.

Employment Quotas. Microfilm DC72, Archives of American Art.

Employment Quotas. Microfilm DC74, Archives of American Art.

Follmer, Frank J. To Mrs. Geneva Smith, 23 January 1942. Fred Biesel Papers, Archives of American Art.

Foster, A. L. To Florence Kerr, 13 March 1941. National Archives.

Glassgold, Adolph C. To Increase Robinson, 5 October 1936. General File 1235, National Archives.

Halpert, Edith G. To Mitchell Siporin, 28 September 1936. Mitchell Siporin Tapes, 2011, Archives of American Art.

Hammer, Amelia M. To Holger Cahill, 3 August 1936. National Archives.

Jules, Mervin. To Holger Cahill, 23 August 1936. Archives of American Art.

Kerr, Florence. To Ellen Woodward, 16 March 1938. National Archives, Box 1236.

———. To George Field, 1 August 1942, National Archives.

Light, Ralph. To Holger Cahill, 11 August 1937. Microfilm DC74, Archives of American Art.

Loeb, Sidney. To Holger Cahill, 9 January 1936. Microfilm DC61, Archives of American Art.

———. To Holger Cahill, 23 August 1936. Archives of American Art.

———. To Holger Cahill, 11 November 1936. National Archives.

———. To Holger Cahill, 8 December 1937. Microfilm DC74, Archives of American Art.

———. To Holger Cahill, 29 March 1938. Archives of American Art.

Metzler, Karl. To Ellen Woodward, 23 June 1937. Microfilm DC74, Archives of American Art.

Meyers, Joseph. To Works Progress Administration, Washington, D.C. National Archives and Microfilm DC75, Archives of American Art.

Moon, Mary Gillette. To Florence Kerr, 29 November 1939. Fred Biesel Papers, Archives of American Art.

Morris, Lawrence S. To Ellen Woodward, 23 April 1938. Microfilm DC74, Archives of American Art.

Murray-Aaron, Dr. Eugene. To Holger Cahill, 2 May 1937. National Archives.

Oak Park School. To George Thorp, August 1941. Microfilm DC74, Archives of American Art.

Olsen, Catherine. To Fred Biesel, 26 November 1941. Fred Biesel Papers, Archives of American Art.

Orloff, Gregory. To Holger Cahill, 21 August 1937. Microfilm DC74, Archives of American Art.

Parker, Thomas. To Robert McKeague, 12 March 1938. National Archives.

———. To Charles E. Miner, 8 March 1938. Microfilm DC74, Archives of American Art.

———. To Increase Robinson, 2 February 1938. Microfilm DC74, Archives of American Art.

———. To George Thorp, 28 February 1938. Microfilm DC74, Archives of American Art.

———. To George Thorp, 27 January 1939. Microfilm DC74, Archives of American Art.

Pollock, Merlin F. To Barbara Bernstein, 1975. Archives of American Art.

Robinson, Increase. To Holger Cahill, 1 October 1935. Microfilm, DC61, Archives of American Art.

———. To Holger Cahill, 29 January 1936. National Archives.

———. To Holger Cahill, 25 May 1936. Microfilm DC73, Archives of American Art.

———. To Holger Cahill, 1937. Microfilm DC74, Archives of American Art.

———. To Arthur Goldschmidt, 27 July 1935. Microfilm DC61, Archives of American Art.

———. To Arthur Goldschmidt, 21 August 1935. Microfilm DC61, Archives of American Art.

———. To Thomas Parker, 14 October 1936. Microfilm DC61, Archives of American Art.

———. To Thomas Parker, 14 May 1937. National Archives. Box 1635.

———. To Thomas Parker, 9 December 1937. Microfilm DC74, Archives of American Art.

———. Transcription of telephone conversation with Holger Cahill, 19 December 1935. Microfilm DC61, Archives of American Art.

Roosevelt, Franklin D. To General Fleming, 4 December 1942. Fred Biesel Papers, Archives of American Art.

Rovelstad, T. A. To Jacob Baker, 6 December 1936. Microfilm DC74, Archives of American Art.

Rowan, Edward B. To Mitchell Siporin, 26 September 1940. Mitchell Siporin Tape, 2011, Archives of American Art.

Sandberg, John V. To O. A. Kirby, 25 October 1941. Fred Biesel Papers, Archives of American Art.

Siporin, Mitchell. BBC Interview, 1976. Mitchell Siporin Tape, 1332, Archives of American Art.

———. To Margit Varga, *Life,* 24 August 1942. Mitchell Siporin Tape, 2011, Archives of American Art.

Slater, C. Paul. To Ralph Graham, 12 November 1941. Fred Biesel Papers, Archives of American Art.

Smathers, James L. To Ralph Graham, 4 September 1941. Fred Biesel Papers, Archives of American Art.

Strain, Frances. To Editor, *Life,* 25 April 1944. Fred Biesel Papers, Archives of American Art.

Summary of findings of the Artists Union vs. Increase Robinson. Microfilm DC75, Archives of American Art.

Thorp, George. To Fred Biesel, 22 October 1941. Fred Biesel Papers, Archives of American Art.

———. To Thomas Parker, 19 December 1938. National Archives.

Topchevsky, Morris. Open letter, 24 October 1937. Archives of American Art.

———. To H. K. Seltzer, district director, Works Progress Administration, 27 September 1938. National Archives.

Walley, John. To a meeting of artists, 19 January 1945. Fred Biesel Papers, Archives of American Art.

Wold, E. H. To Mrs. Eleanor Roosevelt, 11 January 1938. Microfilm DC74, Archives of American Art.

Wolff, Robert. To R. O. Carpenter, labor relations advisor, 20 May 1937. Microfilm DC74, Archives of American Art.

Wood, Frank O. To Miss M. A. Fowler, 6 March 1941. Fred Biesel Papers, Archives of American Art.

CATALOGS

After the Great Crash: New Deal Art in Illinois. Springfield: Illinois State Museum Society, 1983.

Art for the Public. Chicago: Art Institute of Chicago, 1938.

Art of the 1930's. Springfield: Illinois State Museum, 1973.

The Artist in Defense. Chicago: Ryerson Library, Art Institute of Chicago, 1941.

Delong, Lea Rosson, and Greg R. Narber. *A Catalog of New Deal Mural Projects in Iowa,* 1982.

"The Emergence of Modernism in Illinois, 1914–1940." Organized by the Illinois State Museum, Springfield, Illinois, 1976.

Exhibition of IAP Painting. Chicago: Federal Art Gallery, 1939.

The Federal Art Project: American Prints from the 1930's. Ann Arbor: The University of Michigan Museum of Art, 1985.

Henrickson, Ralph. *Retrospective Catalogue, 1942.* The Kresge Art Center Gallery, East Lansing: Michigan State University, 1980.

Hills, Patricia. *Social Concern and Urban Realism: American Painting of the 1930's.* Boston: Boston University Art Gallery, 1983.

Illinois Artists and Photographs of Shaker Culture. Boston: Federal Art Gallery, 1939.

Index of American Design, 1936–1942. Chicago: Ryerson Library, Art Institute of Chicago, 1942.

Mavigliano, George. *The WPA Revisited.* Carbondale: Southern Illinois University Gallery, 1973.

Mecklenburg, Virginia. *The Public as Patron: A History of the Treasury Department Mural Program.* Baltimore: University of Maryland Art Gallery, 1979.

Murals from the Illinois Art Project. Chicago: Ryerson Library, Art Institute of Chicago, 1940.

National Exhibition of Art by Public Works of Art Project. Washington, D.C.: Corcoran Gallery of Art, 1934.

Painting and Sculpture Designed for Federal Buildings. Washington, D.C.: Corcoran Gallery of Art, 1939.

Painting and Sculpture for Federal Buildings. Washington, D.C.: Corcoran Gallery of Art, 1936.

Paintings of the Illinois Art Project. Chicago: Ryerson Library, Art Institute of Chicago, no date.

Photographs of Illinois Tombstones of the 19th Century. Chicago: Ryerson Library, Art Institute of Chicago, 1938.

Remembering the Thirties: Public Works Programs in Illinois. Chicago: Illinois Humanities Council and National Endowment for the Humanities, 1980.

Van Liere, Eldon N. *Henricksen 1907–1975: An After Image.* East Lansing: Michigan State University Publications, 1980.

Veto, Janine M. *Chicago Art Project: A Selection of Works Produced by WPA Illinois Art Project from 1935 to 1943.* Chicago: The Chicago Artist-in-Residence Program, no date.

WPA and the Black Artist: Chicago and New York. Chicago: The Chicago Council on Fine Arts and the Chicago Public Library. 22 March–23 April 1978.

GOVERNMENT PAMPHLETS

Cahill, Holger. Works Progress Administration, *Federal Art Project Manual.* Washington: WPA Pamphlet No. 7120, October 1935. The Art Institute of Chicago, the Ryerson and Burnham Libraries.

————. *Report on Art Projects.* Washington: WPA Pamphlet No. 8236, 1936.

The Carborundum Print. Washington: WPA Technical Series, Art Circular, No. 5, 1940.

Instructions for Index of American Design. Washington: Supplement No. 1 (8060) 1936.

National Art Week. Washington: Mimeographed Announcement No. 4–2186, 1940.

Parker, Thomas, and Daniel S. Defenbacher. *Federal Sponsored Community Arts Centers.* Washington: WPA Technical Series No. 1, 1937.

PWAP Report of the Assistant Secretary of the Treasury to Federal Emergency Relief Administrator. Washington: U.S. Government Printing Office, 1934.

The Silk-Screen Process. Washington: WPA Technical Series Public Activities Circular, No. 20, 1941 (Art Circular No. 6, 22 July 1941, Washington, D.C., A2789, Section 2).

WPA Technical Series, Art Circular No. 1, 8 October 1937.

IAP/IACP-RELATED DOCUMENTS

Art for the Public by Chicago Artists. 1938 [Art Institute Catalog]. See Clark Sommer Smith's master's thesis, p. 18, in Dissertation and Theses section.

Biesel, Fred. Résumé, 24 January 1944. Fred Biesel Papers, Archives of American Art.

Britton, Edgar. Unpublished article for *Art for the Millions,* Archives of American Art.

Flyer. "Many Chicago Artists Employed by W.P.A.," August 1936. Chicago Public Library.

IACP *Newsletter,* 2 June 1941. Fred Biesel Papers, Archives of American Art.

Illinois Manual for Federal Project No. 1, 15 December 1937.

Loeb, Sidney. Newsletter to members of the Artists Union, 1 July 1940.

Melzer, Hildegarde Crosby. Unpublished article for *Art for the Millions*. Archives of American Art.

Memorandum. War Services Division to the IACP. *The Central Exhibition Unit.* Fred Biesel Papers, Archives of American Art.

Millman, Edward. Unpublished article for *Art for the Millions*. Archives of American Art.

Museum Program Document. Fred Biesel Papers, Archives of American Art.

"The New Federal Art Gallery." Bulletin of the Local Division. 1, (5) June 1939. Fred Biesel Papers, Archives of American Art.

Planning Manual. The Illinois Art and Craft Project, 1940. Fred Biesel Papers, Archives of American Art.

Pollack, Peter. *Proposed Plan for Continuance of South Side Art Center*. Fred Biesel Papers, Archives of American Art.

Production News, 1 (1, 2, and 3), 1940.

"Record of Program Operation and Accomplishment, 1935–1943." Fred Biesel Papers, Archives of American Art.

Robinson, Increase. Flyer. Garnett Biesel Papers, Archives of American Art.

———. "Lectures on Art of the Past and Present." Printed announcement. Esther G. Robinson Collection.

Statement of the Illinois Craft Project. University of Illinois at Chicago.

Thorp, George. "The Art of Supervising Artists." Unpublished article for *Art for the Millions*. Archives of American Art.

———. *Report.* Conference called by George Thorp, 25 March 1941. Fred Biesel Papers, Archives of American Art.

———. "Summary of Recommendations and Proposed Reductions." Work Progress Administration, Illinois Art and Craft Project. Fred Biesel Papers, Archives of American Art.

Walley, John. "The Influences of the New Bauhaus in Chicago: 1938–1943." *Selected Papers: John E. Walley, 1910–1974*. University of Illinois at Chicago.

———. "Record of Program Operation and Accomplishment, 1935–1943." WPA Design Furniture Workshop Document. Fred Biesel Papers, Archives of American Art.

———. "Speech to the Artists Union, 1940." *Selected Papers: John E. Walley, 1910–1974*. University of Illinois at Chicago, 18–19.

———. Unpublished statement on the formation of the Artists Union of Chicago, 1965. *Selected Papers: John E. Walley, 1910–1974*. University of Illinois at Chicago.

DISSERTATIONS AND THESES

Boyens, Charles W. "The WPA Mural Projects: The Effects of Constraints on Artistic Freedom." Ph.D. Diss., Columbia University Teachers College, 1984.

Carr, Mother Eleanor M. "The New Deal and the Sculptor: A Study of Federal

Relief to the Sculptor on the New York City Federal Art Project, 1935–1943." Ph.D. Diss., New York University, 1969.

Contreras, Belisario. "Treasury Art Programs: The New Deal and the American Artist, 1933–1943." Ph.D. Diss., American University, 1967.

Mavigliano, George J. "The Federal Art Project: A Governmental Folly?" Master's thesis, Northern Illinois University, 1967.

Monroe, Gerald M. "The Artists Union of New York." Ph.D. Diss. New York University, 1971.

Pietan, Norman. "Federal Government and the Arts." Ph.D. Diss., Columbia University, 1949.

Rubenstein, Erica Beckh. "The Tax Payers' Murals." Ph.D. Diss., Harvard University, 1944.

Smith, Clark Sommer. "Nine Years of Federally Sponsored Art in Chicago: 1933–1942." Master's thesis, University of Chicago, 1965.

Sparks, Esther. "A Biographical Dictionary of Painters and Sculptors in illinois: 1808–1945." Ph.D. Diss., Northwestern University, 1971.

QUESTIONNAIRES RETURNED TO THE AUTHORS

Bennett, Rainey. No date.
Burroughs, Margaret, and Bernard Goss. No date.
Coen, Eleanor. 4 December 1984.
Fabion, John. No date.
Josimovich, George. 12 November 1984.
Kahn, Max. 4 December 1984.
Kauffman, Andrene. No date.
Kelpe, Paul. 12 November 1984.
Mintz, Harry. No date.
Osver, Arthur. No date.
Pollock, Merlin F. 7 November 1981.
Purser, Stewart. No date.
Ruvolo, Felix. 19 November 1981.
Scapicchi, Erminio A. No date.
Skupas (Cooper), Anthony J. No date.
Vogel, Donald S. No date.
Woelffer, Emerson. No date.

INTERVIEWS AND TELEPHONE CONVERSATIONS
WITH THE AUTHORS

Adams, Jean Crawford. Chicago, 3 February 1966. Tape not available. Transcript in the authors' possession.

Benton, Thomas Hart. Interviewed by Robert Randall. Kansas City, Missouri, Spring 1974. Tape in authors' possession.

Biesel, Garnett. Chicago, 15 September 1982; telephone conversation with authors 1 August 1985.

Burroughs, Margaret, and Bernard Goss. Chicago, 17 March 1966. Tape in authors' possession.

Cahill, Holger. Archives of American Art. No date.

Carr, George. Interviewed by Robert Kessler. Harrisburg, Illinois, March 1978.

Haydon, Harold. Chicago, March 1966. Tape not available. Transcript in authors' possession.

Maxwell, Moreau S. East Lansing, Michigan. Telephone conversation with authors, 21 May 1988.

McKeague, Robert I. New Lennox, Illinois, 15 August 1980. Tape in authors' possession.

Melzer, Hildegarde Crosby. Chicago. Telephone conversation with authors, 31 July 1981.

Melzer, Hildegarde Crosby, and Kurt Melzer. Chicago, 15 September 1982. Tape in authors' possession.

Osver, Arthur, and Bernadine Betzberg. St. Louis, Missouri, 13 October 1983. Tape in authors' possession.

Pollock, Creilly. New York City. Telephone conversation with authors, 25 July 1984.

Shryock, Burnett. Chicago, 22 January 1966. Tape in authors' possession.

Siquieros, David Alfro. BC1734, Spring 1974. Pacifica Tape Library, 5316 Venice Boulevard, Los Angeles, California.

Soyer, Raphael. "Beauty in Disarray," BC2260, 1975. Pacifica Tape Library, 5316 Venice Boulevard, Los Angeles, California.

Stoddard, Paul. St. Louis, Missouri, 13 October 1983. Not taped.

Umlauf, Charles, Austin, Texas. Telephone conversation with authors, 9 December 1984.

Walley, John Edwin. Chicago, Spring 1966. Tape in the authors' possession.

Ziroli, Nicola Victor. Urbana, Illinois, 26 March 1966. Tape in the authors' possession.

LETTERS TO GEORGE MAVIGLIANO IN POSSESSION OF THE AUTHORS

Bennett, Rainey. 14 October 1983.

Bohrod, Aaron. 16 September 1984.

Cheskin, Louis. 9 December 1980; 22 February 1981; and 30 March 1981.

Clark, Mary Anderson. 23 September 1983; 23 October 1984; and 8 November 1984.

Johnson, Avery. 20 November 1981; 1 October 1983; and 12 November 1984.

Josimovich, George. 18 November 1981; and 12 November 1984.

Kauffman, Andrene. 25 August 1983; and 15 September 1983.

McKeague, Robert I. 4 September 1980; 12 July 1981; 20 January 1982; 23 February 1982; 3 March 1982; and 27 March 1982.

Mintz, Harry. 12 December 1983.

Orr, Elliot. 25 July 1977; and 1 November 1981.

Pollack, Creilly. 17 April 1981.

Pollock, Merlin F. 8 November 1981; 2 July 1984; 19 September 1984; 13 November 1984; and a copy of a letter sent by Pollock to Barbara Bernstein in 1975.

Robinson, Esther G. 3 March 1982; 31 March 1982; and 10 May 1982.

Stoddard, Paul. 18 January 1981; and 20 August 1981.

Umlauf, Mrs. Charles. 16 November 1984.

Vogel, Donald S. 2 November 1981; and 2 September 1983.

Walley, John. Spring 1966.

RELATED UNCLASSIFIED DOCUMENTS

Bernstein, Barbara. *Sculpture of the 1930's: Federal Art Project.* Chicago: Rider Dickerson, Inc. No date.

Biddle, George. 20 February 1943. Mitchell Siporin tape, 2011, Archives of American Art.

"Comprehensive Index of American Design Exhibit Opens at Field's March 15," *Downtown Shopper.* Chicago, 15 March 1937, 9.

"The Emergency Relief Appropriations Act." House Joint Resolution 326, 76th Congress, 1st Session (1939). *United States Statutes at Large,* 53, Part 2, chapter 252, 927–39. Washington, D.C.: U.S. Government Printing Office, 1939.

"Great Artists" Series. Vol. 1–3. Chicago: Ryerson Library, Art Institute of Chicago.

Kelly, Mayor Edward J. Public Announcement. 30 June 1941.

Let the Artist Speak. Teachers' Broadcast Handbook, Chicago Public Schools, September 1941–January 1942.

Melzer, Kurt, and Hildegarde Crosby Melzer. Scrapbook of Index of American Design news releases. In possession of the authors.

Military and Naval Training Aids, Conference transcript. Washington, D.C., 22–24 September 1942. Fred Biesel Papers, Archives of American Art.

Millar's Chicago Letter. 2 (16) 24 April 1940.

Work Progress Aids (A Pictorial Journal of Cooperative Effort). No. 5. WPA, April 1939.

WPA Art Program: Conference of State Art Supervisors, Washington, D.C., 27–28 January 1941. Fred Biesel Papers, Archives of American Art.

George J. Mavigliano is Associate Professor of Art History and Associate Dean of the College of Communications and Fine Arts at Southern Illinois University, Carbondale. He is the author of *On Painting, Sculpture and Architecture* and coauthor, with Richard A. Lawson, of *Fred E. Myers, Wood-Carver.* He has published numerous articles on various aspects of federally funded art programs during the 1930s. His current research interests are the late-nineteenth-century painter Constantino Brumidi, his patron Lieutenant Montgomery Meigs, and their joint work on the U.S. Capitol Building.

Richard A. Lawson is Associate Professor of English at Southern Illinois University, Carbondale. He is the coauthor of *Fred. E. Myers, Wood-Carver,* as well as the author of articles on Thomas Pynchon and on literature and still photography. His current research interests are interdisciplinary, dealing primarily with the combined possibilities of literature and still photography. In addition, he has held a number of one-man shows of still photography since 1983.